CULTURE WAR

ART, IDENTITY POLITICS
AND CULTURAL ENTRYISM

Alexander

Introduction by
Theodore Dalrymple

Illustrated by the author

SOCIETAS
essays in political
& cultural criticism

imprint-academic.com

Published in the UK by
Imprint Academic Ltd., PO Box 200, Exeter EX5 5YX, UK

Distributed in the USA by
Ingram Book Company,
One Ingram Blvd., La Vergne, TN 37086, USA

ISBN 9781845409982 paperback

A CIP catalogue record for this book is available from the
British Library and US Library of Congress

By the same author

Verse

Three Strikes (2011)
Seahorse (2013)
The Crows of Berlin (2013)
On Dead Mountain (2015)
On Art (2018)

Fiction

Letter About Spain (2016)
Berlin, October (2016)
London, Winter (2017)
Selima in the Orchard (2018)

Art

Works on Paper (2004)
Noctes (2005)
Icarus (2005)
Ruins and Landscapes (2007)
Paintings on Paper (2008)
New Gouaches (2010)
Portraiture (2013)
Nouvelles Peintures (2018)

Contents

Theodore Dalrymple

Introduction

Like many people, I thought that with the downfall of the Soviet Union there would be an end to ideological ways of thinking. How wrong, how naïve, we all were! Far from disappearing, ideological ways of thinking have proliferated, Balkanised so to speak. Various groups of ruthless monomaniacs now seek to impose their views on and of the world, accepting no discussion, let alone dissent. They seek to reinterpret everything through the monocular lens of their own obsession, and make the rest of us do likewise. Their influence is out of all proportion to their numbers: their numbers for now, that is…

It must be admitted that resistance to the bullying and name-calling of these monomaniac groups has been extremely feeble. At first their arguments seem so absurd that they are hardly worth arguing against; then, once they have succeeded in recruiting enough of the *bien pensant* intelligentsia to their cause, it is too late. What might have seemed unthinkable only a few years before has been transformed into an unassailable orthodoxy to question which is heresy at best, a sign of moral depravity at worst.

One might have supposed, or at least hoped, that the visual arts would be relatively immune from the attentions of the monomaniacs. This, alas, is far from the case. We are, or were, accustomed to thinking of art as a relatively autonomous field of human endeavour, with its own standards of comparison and criteria of worth, albeit that our appreciation and

understanding might be deepened by an understanding of the historical, cultural and economic context in which a work of art was produced.

But such relative autonomy has yielded with surprising speed to the ideological obsessions of race, class and sex, with predictably deleterious effects. Nothing epitomises the complete degeneration of our artistic life better or more succinctly than the appointment of Maria Balshaw as Director of the Tate Gallery, with her complete mastery of publicly-funded, ideologically-flavoured arts-apparatchik drivel. If anyone supposes that I exaggerate, I suggest that they consider Dr Balshaw's statement: "I think taking large artistic risks is part of the job of a good director of any arts organisation. If I think back to moments where I experienced that as a really acute and intense feeling of fear and even horror at the level of risk that we were taking as an organisation, it boils down to an experience of watching a really marvellous artist, Kira O'Reilly, rolling very slowly down the stone stairs of the Whitworth Art Gallery."[1] Even worse, consider her speech at Hampton Court Palace, 16 October 2017.[2]

In this book of crystal-clear essays, which I am sad to say must have taken some courage to write, Alexander Adams, an artist, art critic and essayist, dissects, and one might say eviscerates, the doctrinal obsessions of our time that are so inimical to appreciation of art or true artistic endeavour. He does not prescribe what art must or must not be; or what artists must or must not believe in order to be good artists; he has no positive doctrine to propose. What he is against is the deeply impoverishing orthodoxies that (if I may for a moment be slightly Marxist) serve the interests of a bureaucratic elite that is talentless in everything except the search for power. What he writes has implications for fields other than art; but for anyone who cares for the visual arts in this country, his book is essential reading. The realisation of what is happening is the beginning of recovery, or at least an essential precondition of it.

Foreword

The first five essays in this collection were written independently and published separately. At the time of writing, I did not see them as connected in any way other than that they covered aspects of politics in current culture, although "On the Western Canon" was an expansion upon the discussion of why there is a drive to undermine the Western canon by Marxists and allied movements (most obviously by feminists), a subject which had come up in the discussion of remedial arts programming in the preceding essay, "On Quota Programming". "On Reparations" (the fifth and last independent essay) was written in the knowledge that it would be included in this collection. The sixth and seventh essays were written for this book.

Rather than reshaping this material into a single text, I have kept the essays discrete, largely in their originally published forms and presented in the order in which they were written. There seemed merit in allowing the reader to see the writer gradually discovering how seemingly unrelated aspects of culture were actually deeply connected and discovering those things along with him. Subjects are examined separately in the first five essays; two final essays investigate in greater detail what motivates those involved in identity politics and how those individuals seek to influence culture through a practice I define as "cultural entryism".

I should stress that although the main focus of this book is leftist[3] activism within the arts, many of my observations apply to authoritarian idealism of the far right and—to a lesser extent—religious extremists. (The left–right political axis is discussed in "On Identity Politics".) I see most value in discussing leftist activism in culture because it is currently the most prominent and widespread type of cultural activism in the West. Moreover, this activism goes largely

unacknowledged and unchallenged by liberals, political moderates and the unaffiliated, so it seems particularly important to draw to the attention of these groups exactly how destructive this activism is. Activists and the majority of the population consider this activism (when they notice it at all) to be motivated by good intentions and producing good outcomes. The truth is that much of the ideology is brutally dehumanising, the actions motivated by vanity and the outcomes often cruelly damaging. I understand many readers will receive this conclusion with anger and denial. To conclude that leftist activism in the arts is benign or beneficial would have been a great comfort to me, given how powerful and pervasive it is, yet after considerable thought I cannot reach that conclusion.

August 2018

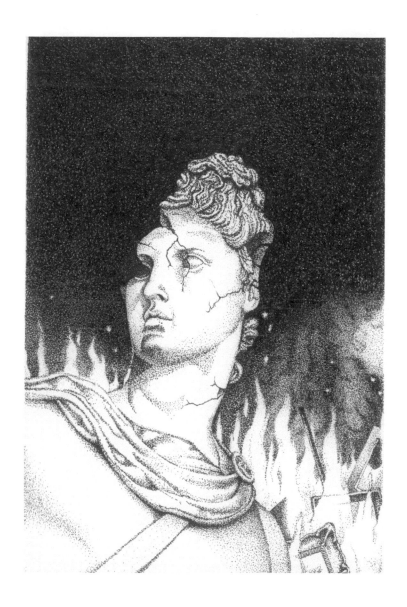

On Islamism
and the Arts

"One person with a belief is equal to a force of 99 who have only interests." – John Stuart Mill

On 14 February 2015 an Islamist gunman attacked a café in Copenhagen where a debate on free speech was being held. Speaking at the meeting was Swedish artist Lars Vilks, who had been issued with death threats because in 2007 he drew cartoons of the prophet Mohammed that were considered insulting by some Muslims (and some non-Muslims). Vilks was unhurt but a documentary filmmaker Finn Nørgaard was killed. The gunman was later shot dead. This came in the month following the Islamist murders of cartoonists at *Charlie Hebdo* in Paris. On one level, the Danish attack was prosaically ineffective. The attacker could not gain entry to the building so he sprayed bullets at the meeting through a glass door. On another level, it marks a new standard, where anyone associating with "insulters of the prophet" can expect to be a target for extremists.

This essay will not discuss the cartoons of Vilks and *Charlie Hebdo*. That has been done elsewhere. We should, perhaps, evaluate what recent assaults on controversial art and satirical journalism — and the assaults yet to come — will mean for arts in the West. It is worth considering how Islamists — some of them born and raised in wholly (or largely) secular European countries — have rejected Western values but have also absorbed particular aspects of secular culture. This essay cannot be a full account and is merely an outline with much deliberately passed over. Though arguments and positions

here are simplified, they are not—hopefully—misrepresented. Endnotes have been kept to a minimum, omitting many news sources and much background material.

In this essay "Islamism" is used to refer to "the assertive application of Islamic principles to political and social spheres" as differentiated from Islam practised as a private ethical code; "extremist" is a person who will use violence and threat of violence to achieve his aims; "post-liberal"[4] is used as an adjective to describe the uneasy consensus between mainstream socio-political strands in Western[5] societies, one which accommodates identity politics and encourages constraints on speech, voluntary and otherwise.

Civility and Censorship

In recent weeks a common refrain of many commentators and journalists has been "The murder of the *Charlie Hebdo* cartoonists was wrong but...". Many felt that the cartoonists who had the freedom to ridicule Mohammed should not have exercised that right. The inference is that the freedom to be irresponsible is not freedom from the consequences of irresponsibility. Some of the cartoons were puerile and juvenile but there is plenty of material in that class; public lavatory walls and internet websites are full of it. The difference is that the cartoons had authors' names attached and there was a particular address where they could be found.

It seems that today people who deliberately set out to insult Islam can expect reprisals. Although there is a case to put that we should protect those reckless individuals as a matter of principle—and this essay will not argue against that—it is more important we consider the murders as (at least partly) an extreme manifestation of the climate of accommodation that already compromises our liberty and affects us as citizens, readers and makers of art.

As we have seen in the pages of arts journals (notably *The Jackdaw* and *The Art Newspaper*) and on the website *Spiked*, the practice of pre-emptive censorship has become an ever-present

reality. Nowadays, institutions do not react to criticism but anticipate it. Formerly (in what we must now consider a brief post-war heyday), we relied on institutions to promote and protect difficult art because it was the sort of material that was not nurtured commercially. Institutions introduced new stimulating art and would defend it. At the very least, difficult art would be shown, allowing us to judge for ourselves. Now institutions fight shy of presenting anything which might cause "community tension". What has happened to John Latham's collage of Bible, Talmud and Koran[6] owned by the Tate? Will it ever go on public display?

What goes undiscussed is the self-censorship which occurs daily in the lives of satirists, artists and writers. We have all held our tongues in everyday life when we thought speaking out would cause more harm than it would do good. In some respects that is human nature—the desire to avoid conflict and let sleeping dogs lie. When standing up for one's ideas involves placing others in harm's way, one naturally grows more tentative. Where you might risk your own safety, you often find you cannot risk that of your family and colleagues. This is something everyone from school bullies to mafia godfathers understand. If intimidators intend to become martyrs, and there is no certain way to protect the lives of you and those dear to you, speech seems impossibly dangerous—which is the calculated effect. Though—in at least some cases—isn't the protecting-my-colleagues/family defence (albeit a legitimate one) actually a way of excusing oneself from taking an unpopular stand?

One problem with the on-your-heads-be-it reasoning is that it implicitly accepts that violent retaliation to an actual (or perceived) slight is regrettable but inevitable. Does that line of reasoning also apply if militant Jews were to firebomb publishers of the Koran or radical socialists were to murder British National Party members? Doesn't such reasoning, however indirectly, excuse intimidation and vengeance by any self-identifying group of victims against their putative insulters? Are Muslims not to be held to the same standards as the society

they are a part of?[7] Are we to consider Muslims incapable of exercising self-restraint or obeying state laws? On-their-heads-be-it reasoning implies Muslims are less in control of their emotions than non-Muslims and have a tendency to react with violence in response to provocation.[8] This sounds similar to patronising colonialist stereotypes about "savage natives" and "inferior races". Yet this special pleading — that outsiders can never understand members or culture of a subset, something which renders that culture unknowable and beyond universal principles — is very much a part of identity politics which robs individuals of autonomy, turning them into puppets of social conditions and hereditary circumstance.

Another problem with pre-emptive censorship for protection is that it is effectively impossible. The *Charlie Hebdo* cartoonists knew they were creating provocative images and could expect a backlash. Consider the case of Salman Rushdie; his *The Satanic Verses* is a work of literary fiction. The novel included references to Mohammed dreamed by a fictional character in a delirium. The novel led to a fatwa being issued against its author and subsequent attacks against publishers and the murder of a Japanese translator. Rushdie and his colleagues had no reason to expect that instances of blasphemous delirium in a work of fiction might provoke violent hostility.[9] Due-caution caveats cannot be applied in practice as there is no way of predicting how any work of fiction or art touching upon Islam may be represented or misrepresented by extremists. The only way to be safe from extremists is to never say anything that touches upon religious culture, never associate with anyone who has and never be in the vicinity of an exploding bomb.

But even that position will not hold.

Even if you avoid opposing extremists, the restrictions they force on others will affect you. Furthermore, accommodation will not work because Islamist demands will never end. Even if another image of Mohammed is never exhibited or published in the UK again, extremist pressure will continue, applied in

other areas of the arts. Images seen as denigrating Muslims (especially Muslim women) will be targeted; "disrespectful" art by artists of Muslim heritage will be threatened; artists who take an avowedly atheist stance will be subject to violent protest; school books with images of pigs will be censored.[10] There is no way of following "rules of safe speech" because extremists make rules arbitrarily, opportunistically and unilaterally.[11] What may be *halal* today may tomorrow be retrospectively considered *haram*[12] with no possibility of reasoned appeal.

To understand the demands and expectations of Islamism as a political movement we must examine the psychology of the extremist.

The Psychology of Extremism

For the pious man, religious teaching gives a feeling of superiority through wisdom; ritual gives his life structure; repetition brings comfort and order;[13] moral injunctions give him an ethical framework. He observes dietary restrictions, prays at the prescribed times using exactly the wording necessary. He is fastidious about cleaning, fasting and the way he dresses. Infraction causes him to experience guilt and shame. An extremist is a pious man driven by anger, often prompted by injustice.[14] He is angry at society for failing to be sufficiently pious; he is angry at himself for failing to meet impossible standards of thought and deed; most of all, he is angry at constraints which prevent him from remaking the entire world in the mirror image of the ideal world in his head. Even should he perfect himself — which is never possible — it is the imperfection of those around him which antagonises him most. He cannot bear to exist surrounded by lack of belief and observance. This seems to him an insult to his beliefs. For the Muslim, his religion urges him to jihad — a struggle to change the world around him. In an extremist's case, he chooses not to perform acts of charity but to combat impiety through any means available to him.

Whereas a moderately (or even very) religious person can live in relative contentment in a secular society, an extremist never can. The extremist cannot avert his gaze or turn his cheek. Religious extremists cannot be accommodated within a secular society by way of reasonable concessions because religious extremism is essentially unreasonable in that it rests on belief not reason. A religious extremist can never be satisfied because he lives in a perpetual state of discontent and anger. He abhors doubt and seeks to eradicate it. He encounters obstacles in the form of co-religionists who do not follow his outlook and in secular laws and values which fail to recognise divine truth. He takes pride in being more dissatisfied than his co-religionists, whom he considers complacent. Every day he is constantly provoked by his failure to remake reality. A religious extremist's struggle is unending because there will always be ways in which the world falls short of the ideal. Hence the religious extremist will never be checked by practical concessions because his aspirations are nothing less than total control and complete obedience to holy laws.

Enabled by the fiat of imams and encouraged by fellow jihadists, the extreme Islamist becomes so dissociated from the norms of society that he ceases to recognise the legitimacy of any restraint other than his own beliefs. The extremist is capable of the most astounding brutality, avenging a catalogue of injustices which have humiliated him. He becomes desensitised to violence, even relishes committing atrocities in order to lose his humanity and, driven to ecstasy, he becomes a holy instrument of God.[15] An extremist defines his existence by being at the extreme of his society. If he lived in an Islamic theocracy, he would be the enforcer of religious observance; he would volunteer to be an executioner. His devotion can only be proved by the extremities he can endure and which he can impose on others. Practical concessions made by a secular society will never gratify (or even satisfy) an Islamist because his ideology dictates nothing less than a theocracy can be his aim.

Compared to the executions in ISIS territory, the dispatching of a few cartoonists is a very small matter to Islamists. The Islamist admits no responsibility for the violence—it is the actions of the blasphemer which prompted the inevitable vengeance and if innocent blood is spilled then that is the fault of the transgressor.[16]

How can such an apparently alien outlook find any succour in secular Western society? Firstly, we should look at the Western Marxist's attraction to Islamism. Secondly, to understand how an extremist can be nurtured by a schismatic environment—part Muslim immigrant culture, part secular European—we have to consider the way social discourse in modern Britain changed in the 1970s and 1980s.

Fatal Attraction

For the left, the Muslim in the West is a weak minority who experiences marginalisation; the Muslim in the East is a citizen of a weak state subject to capitalist and imperialist domination. In both domestic and international terms, leftists have a tendency to view Muslims through the lens of the victim narrative. The left seeks common cause with the Muslim on the basis of the belief that Muslims are weak and marginalised and thus natural allies of those in the West opposed to capitalism.

The West sustains a persistent narrative that non-Western cultures have an essential truth and harmony that is absent in the materialist West. The phrase "the mysteries of the Orient" embodies this conception of the spiritual wisdom and innate nobility of the Oriental civilisation.[17] According to Marxists, all disharmony, inequality and war in non-Western countries is a legacy of colonial interference, capitalist exploitation and missionary Christianisation, exacerbated by secret plots of Western governments. This is a power fantasy because it suggests that the West controls every meaningful aspect of world culture. This view reduces the non-Westerner to the status of a dupe manipulated by forces he does not understand, robbed of agency; it is the informed thinker in the West who

sees and understands these forces. This is no different in essence to the snobbery of chauvinist colonialism. The existence of long-standing religious enmities, local conditions, political factionalism, private actors, unique national and regional histories and sheer chance is secondary in the minds of the leftist to the near supernatural power of global capitalism and imperialist meddling. Granted, such interference does exist. However, the vast and unmeasurable power assigned to the West extends beyond Western manipulation both proved and likely, becoming akin to a paranoid fantasy. The pious man sees all suffering as caused by sin; the feminist sees all inequality as caused by patriarchy; the anti-Semite finds at the heart of every problem Jewry; the Marxist traces all problems in the developing world to imperialist capitalism.

The outlook of a religious fanatic is essentially different and unfamiliar to most non-religious or mildly religious people, especially if those latter live in secular Western societies. Sam Harris has noted[18] that secular people have trouble believing that religious people genuinely believe in extraordinary claims or consider severe punishment for crimes of sin to be justified. He notes that the pious genuinely do believe the things they say and act accordingly. Once the precepts of a religion are accepted then consequent narratives and behaviour are completely consistent and logical. If one believes one's children are in danger of eternal damnation for falling into sin, then it is entirely reasonable to punish, silence or kill the person who spreads sin. In fact, it would irresponsible and sinful to fail to punish the sinner who threatens the innocent.

Assigning to the religious radical a political impetus is beside the point. The fact that influential religious figures use religion to advance political agendas or to gain material benefits does not mean those figures are not actually religious. In personal life it is rarely a case of "either/or". Two states or motivations can co-exist, mingled or fluctuating in importance. An Iranian ayatollah may be genuinely outraged by a cartoon of Mohammed and can also use popular outrage to advance

the theological influence of Iranian-led Shia Islam. A Western politician can cause the invasion of a Muslim country in order to establish Western-style democracy and can also personally benefit by receiving financial donations from defence contractors. Mixed motives are common and exist in every aspect of daily life.[19]

The fact that members of nascent Islamist movements and Arab nationalists derived tactics from French Marxists in the 1960s has misled Western intellectuals into thinking Islamism is a socio-political movement rather than what it is: a religious movement using socio-political means to achieve religious goals.[20,21] Islamist tenets of anti-colonialism, anti-capitalism, anti-globalism, anti-Zionism[22] and national liberation have further misled Western leftists into finding common ground with Islamists, and have led to Islamo-leftism. The leftist deludes himself into thinking of Islamism as Arab anti-imperialism.[23] It is not. It is a religious movement. The leftist sees anti-colonialism as the goal; the Islamist sees anti-colonialism as a stage in a process towards establishing a Eurasian (or worldwide) caliphate. The leftist's secular outlook prevents him from understanding the depth of feeling the Islamist has and the literalness of the Islamist's stated beliefs.[24] For the leftist there is comfort in the belief that the real enemies of peace and prosperity are capitalism and Western democracy, so strong is their attachment to the victim narrative. Perversely, leftists discount plain explanations for Islamist violence made by Islamists, members of a group they consider unjustly patronised and oppressed; leftists would rather hold to the comforting power fantasy of Western omnipotence and a socio-political model of human society than confront the uncontrollable power of religious ideation.[25]

Identity Politics

Identity politics came to prominence in the late 1960s as a response to the failure in the West of agitation by the political left for fundamental social and economic reform. The dis-

illusionment with the ideology and Marxist economic analysis of the old left—particularly after the failed protests of 1968 and in the light of increasingly militant civil-rights and gay-rights movements—gave birth to the new left. The new left broke with old left principles of universality, as extolled by the Enlightenment, which held that inalienable rights sprang from shared humanity.[26] Rather than the Enlightenment principle that one could make allegiances by choosing a political stance rather than conforming to oppressive and debilitating division along national, gender and religious lines, the new left believed that rights reform relating to sub-groups could be a more effective means to drive social change.[27] This switch in emphasis from universal suffrage to factional interest allowed the incorporation of new non-European immigrants into the leftist movement without detaching them from their national and religious backgrounds.

From this point on, social conventions began to change in ways which have been accepted even by the political right. People are increasingly identified and evaluated as constituents of subset classification by race, ethnicity, national origin, religion, gender, disability and sexuality. Labels which were previously grounds for discrimination become the tokens played to gain advantage or demonstrate disadvantage. Social constraints that were loathed by the universalist old left are fetishised by the factionalist new left. Certain subsets are resented by the right, other subsets resented by the left but what neither side does is question the validity of identity politics, merely the value of advantaged/disadvantaged groups and which factional interests should be resisted/ promoted.

Crucially, these determining labels are matters which individuals have little or no agency over. Humanity is no longer seen as a uniting quality; the worth of an individual is measured by the assumed privilege[28] or disadvantage of his or her subset(s). When individuals' worth is measured by their birth subsets, individuals become essentially passive. People no

longer gain respect and authority through education, skills, building relationships and contributing to society. Identity politics is exactly the opposite of empowerment—it infantilises by reducing individuals to passive victims in need of protection.[29] The idea of betterment becomes problematic as it suggests some changing allegiance or that one's birth state is not ideal. Where the old left had "class traitors", the new left has "birth traitors".[30] Individuals are encouraged to reduce themselves to sheer helplessness. They become unable to avoid distasteful material, unable to bear the thought of others experiencing it, unable to allow it to even exist; and that final sentiment leads to censorship.

Starting a sentence with the statement "As a woman/ African American/Muslim/gay man, I..." is used as *a priori* authority for subsequent statements. Being a member of minority subsets lends supposed authoritative or authentic insight and leads the speaker to demanding redress as a victim of systematic oppression, institutional discrimination or casual offence. Conversely, certain subsets (male, heterosexual, white) are viewed by post-liberals as less authentic and valued due to historically inherited privilege. The language of victimhood now dominates political discourse. The statement "I am offended by..." now carries weight in debates when all it demonstrates is the capacity of the speaker to articulate a temporary and subjective position that is as incontrovertible and inarguable as it is substantially meaningless. Rather than points being argued between equals on the basis of logic and evidence, common discourse is now conducted between representatives of inherently unequal subsets and hinges on depth of feeling.[31] In debates, markers of identity are established and compared; social advantages of subsets are weighed up in a court of emotion and historical injustice; the ideas of empirical deduction and evidence have been disposed of, truth becoming a relative concept.

Now that emotional response has been accorded the status of a legitimate, quasi-legal grievance, why should a religious

person who expresses genuine (or tactical) offence be denied redress? When a fundamentalist is denied parity by authorities that advocate "a respect agenda" but cannot legally curtail blasphemy, is it any wonder he sees double standards? Muslim appeals often fall foul of post-liberal skittishness. Post-liberal identity politics promises emotional justice but betrays partiality by supporting favoured minorities under the auspices of "hate speech" but hesitating to censor blasphemy. Encouraging individuals to validate themselves through identifying with cultural subsets and maintaining a double standard separating anti-religious speech from hate speech are both practices that strengthen the agenda of Western Islamists.

The way to establish impartiality and strengthen free speech is 1) for state organisations and politicians to disengage from identity politics and to refuse to endorse emotional grievance as a matter for civil or criminal legislation, and 2) for the rescinding of laws regarding hate speech, prevention of "glorification of terrorism", blasphemy and all restrictions on speech which fall short of incitement, with existing laws on harassment, threatening behaviour and other criminal acts being applied to those who infringe the safety and liberty of others.[32]

There is little likelihood of this suggestion being taken up, as these changes conflict with the will of the (apparent) majority of the populace and political class. Notwithstanding, the principles of identity politics and restrictions on free speech deserve to be opposed because they are intellectually flawed, morally invidious and practically counterproductive.

Towards Thought Reform

If that picture of identity politics and policed civility seems exaggerated, think back twenty or thirty years. Would you then have expected people to be sacked from positions in public and private organisations for expressing contentious political or social opinions, even in private settings? Would the use of certain forbidden words have led to public outcries which

would force the speaker to publicly recant? Aren't those accused of infractions of civility offered the possibility of rehabilitation only if they express sufficient contrition? Don't those sound like the tactics of totalitarian regimes, where enforced self-criticism and public shaming were used to suppress dissent and discredit troublesome individuals? Aren't these now the norms we have grown to expect in Western democracies? Isn't "hate speech" today akin to the catch-all terms such as "counter-revolutionary activity" used to smother political criticism in dictatorships? In today's Britain it is unremarkable to be publicly shamed for a drunken remark, not so much for the words but the thought they express. Whether or not speech crime is punished as a matter of politics or politesse makes no practical difference. Likewise, it is immaterial whether punitive sanction is enforced by legal authorities or social opprobrium. It is the imposition of the tyranny of the majority on the minority who express harmless (albeit unpleasant) ideas.[33]

The point is not whether we adjudge racism, creationism, Islamism, banning abortion and so forth to be wrong; what matters is whether we are allowed to discuss such things openly because once we forfeit our right to speak (and listen to) controversial matters we forgo our critical intelligence. We delegate our discretion when we permit others to decide what are permitted ideas and what are forbidden ideas. In allowing the limitation of free speech we give up an important part of what makes us human and such a restriction will soon enough be used against the leftists and liberals who champion enforced civility.[34] Listening to a foolish opinion is not "giving it legitimacy" in the post-liberal parlance, for how can we test our ideas without arguing for them and against their opposites?[35] How is an untested principle qualitatively different from an inherited prejudice? How can we know the truth without investigating a spectrum of possibility? How can we improve and educate ourselves without encountering new ideas, even incorrect ones?

We live in a multicultural society where people seldom mix but live parallel lives surrounded by their own kind, educated in single-faith schools, at a time when the public arena has become ever more anodyne. This is today's political and social climate, where rather than ridicule and out-argue opinions we consider wrong, we suppress them. The Enlightenment principle of freedom for people to speak as they wish within the law is now supported by only a minority of politicians. Rare is the Conservative who will share a platform with a jihadist, likewise a Labourite will rarely debate an English Defence League activist. University debate societies have a "no platform" policy for politically radical speakers, when speech is seen as so dangerous and hurtful it cannot be tolerated. In class, American academics issue "trigger warnings" which flag up potentially disturbing material so students can absent them-selves in order to avoid experiencing distress. Books, maga-zines and songs are banned from campuses and student-union speech codes forbid the use of certain words. As Greg Lukianoff puts it, students demand not freedom of speech but freedom from speech.[36]

This essay's argument looks illogical, yoking as it does apparent opponents—religious fundamentalists and propo-nents of socially progressive policy. Yet if one examines the tendencies, it is possible to see they overlap. Both groups believe their moral certainties trump the rights of others to contest those certainties. Both are attached to emotional ideas of justice rather than application of rationalism. Both believe ends justify means and are strongly paternalistic. Both use group pressure to suppress dissent. Neither considers free speech an inviolable right and both seek to use legal means to outlaw transgressive speech and action.[37] Both believe that there are correct ways not only of acting but of thinking.[38] Neither wishes to examine too deeply their *idées fixes*. Both are averse to reassessing core ideas in the light of new information.[39]

This is not all: not only do these supposed opponents share common roots, they share aims and collaborate. Witness the

political alliance of Respect, a party of self-identifying Muslims (including a splinter of extremists) working alongside feminists,[40] environmentalists, disaffected Marxists and supporters of the new left. There are extensive formal and informal links between far-left groups and Islamic political organisations for the purposes of opposing imperialism and global capitalisation. On campuses, student unions and religious societies uneasily act in concert to oppose dissent through hate-speech policies. It is in the interests of both tendencies to maintain official mechanisms to gag criticism.

Resisting Enforced Civility

In many Western nations we are living under de facto *sharia* law with regard to the image of Mohammed. We are routinely told that "the depiction of Mohammed in any form is deeply offensive"; actually depictions of Mohammed were historically made by members of Shia and African Muslim traditions and were not considered offensive or even noteworthy. The prohibitions derive from interpretations in the *hadith*[41] rather than the Koran itself, and the common acceptance of the prohibition may be due to the influence of Wahhabism.[42] Yet despite this, museum curators in the UK censor historical images of Mohammed by Muslim artists, deleting images on museum websites and not publicly displaying examples.[43] British newspapers refused to reprint the Danish and *Charlie Hebdo* cartoons.[44] This rigid observance of a partial (and contested) cultural injunction displays the zealously cautious management of post-liberal-led institutions[45] and is an example of a concession to religion which has already curtailed freedom of expression.

Advocating voluntary restraint of speech (on grounds of common civility, community harmony or fear of violence) ultimately establishes a climate of silence in which any criticism of Islam can be dismissed as provocation (racism qua Islamophobia), a label which is used to discredit critics.[46] When valuable articulate comment of a critical nature needs to be

expressed it may search in vain for newspapers and book proprietors willing publish it. The cartoons of Mohammed were anything but reasoned critique, and may be considered to have "poisoned the well" for moderate critics, but extremists are not reasonable people. No Islamist will accept denunciation of his religious ideals or denigration of his holy figures.[47] If he can suppress such opinions, he will. Even non-violent religious extremists would like to prevent any public criticism of his faith. The extremist does not believe in the legitimacy of debate, only being the enactor of God's will on Earth, though he knows how to exploit post-liberal identity politics.[48] Extremists will use argument or legal recourse to further their cause but they do not consider these channels to have authority — only their God has authority — and some of them will burn buildings and books and cut throats.

In coming months and years, not only extreme but moderate Muslims too will press for blasphemy laws and warn that offensive material will (regrettably) be countered by acts of violence; post-liberals will urge restraint on speech for the sake of community harmony; satirists and critics will grow ever more cautious. If makers and consumers of the arts, and the public more generally, do not assert that free speech is non-negotiable and that any legal speech (even distasteful speech) is permitted, then post-liberals will offer further concessions and anti-free-speech activists will make further advances. Extremists, working towards complete control and unlimited expansion, will occupy any territory vacated by others.

While many of us may feel confident that the evident extremeness of religious fundamentalism means it will never make inroads into our way of life, we overlook the willingness with which post-liberals (who are in the mainstream of society and in positions of power) offer concessions to religious senti-ment and give away our freedoms to assuage their guilt, in a form of emotional reparations. Consider the way single-faith schools have not only been accepted but promoted with alacrity in the UK. The freedom to speak your mind has

already been snipped away by post-liberals, religious extremists, new left supporters, commercial lobbyists, social conservatives and paternalistic government.

The only way to preserve free speech is to exercise it. Otherwise, the opportunity to use it will be taken from you (by means both overt and covert), the channels of speech will atrophy, and when your time to speak comes you will be unable to do so.

On State Subsidies for Art

Imagine the most absurd and outrageous provocations about art that you can. For example: there is no such thing as a pure work of art; artists are unusually ill-informed; there is no market reward for good art; government subsidies make artists poor. Then examine your assumptions and reconsider.

Both defensive supporters of state funding and critical traditionalists will be muttering that art should not be viewed as an economic product or an investment; art and money should be separated; the influence of money in the art market is deleterious to the production/appreciation of art; the best art is produced regardless of expectation of material reward. Yet how many of these assumptions are accurate and where is the economic evidence back up any of these views?

Artist and social economist Professor Hans Abbing looks at the fine arts (encompassing dance, classical (not pop) music, opera and theatre but primarily concentrating on the visual fine arts) and sees an economy that does not function like any other. In *Why Are Artists Poor?*[49] Abbing seeks to understand how this singular market operates, drawing on anecdote, academic research and statistics. Some of Abbing's findings make profoundly uncomfortable reading for people who accept many common assumptions about the arts.

Here are Abbing's main findings:

Art is Used as a Social Marker

Abbing states that class largely determines one's attitude to high and low art. "As long as there is social stratification and as long as art products are used to mark a person's position on the

social ladder, an asymmetric judgment of art products will exist. People higher on the ladder look down on the art of people lower than them, while the latter do not look down on, but look up to the art of the former."[50] Those ascending the social ladder will wish to consume high art while those descending will cling to high art despite straitened circumstances. (This, incidentally, undermines the American definition of class as primarily income defined. It isn't. Class is primarily the adoption of distinctions in taste, education, occupational and social conventions generally facilitated by wealth.) This explains why a carpet tycoon in China buys an Andy Warhol as a symbol of his improved social status and great wealth, while an unemployed professor will still love Mondrian and Mahler even without his former position.

So far so good. Abbing infers a degree of deference that is not necessarily true, certainly internationally. Discuss high art with an uneducated person who is ignorant of it and one is more likely to encounter hostility, contempt and resentment towards that high art (and towards its middle-class supporters and consumers) rather than shamed apologetic incomprehension. Perhaps the Dutch are just more polite than the British. At the very least, we might expect consensus between lower educated Dutch and English people that high-brow high art is "not for them"; in other words, it is made for those of middle and upper classes.

Abbing admits in an appendix that attitudes towards the high/low divide are changing and that this lower-class deference and upper-class disdain has altered over recent years.

The Art Economy is Self-Deceiving

The sensitivity, self-deceit and hypocrisy about the connection between aesthetic appreciation and financial value are distinctive to the arts. This comes from the peculiarities of the special economy of high-status luxuries and the quasi-sacred status of items which are also commodities. We love and value

art because it seems to stand apart from monetary considerations; the more we love particular examples of art, the more valuable they become as commodities. Knowledge of the value of items makes us uneasy and suspicious of their quality as art. Yet we do not find the enormous value of rare gemstones impairs our aesthetic appreciation of them. A fan of gems would not decide to boycott a display of gemstones because they were too famous and valuable, yet art lovers often are swayed by such considerations. In the art economy so much is paradoxical.

Abbing puts forward anecdotes that I consider uncannily accurate. This one is about the artist's view of money in the art world.

- An artist (in these examples called "Alex" by Abbing) notices his friends denigrate the market as a barometer of quality when it favours art they scorn but when Alex's work sells they consider the market to be rewarding Alex for his skill.
- "Alex remembers that in his last two years at art school he and his classmates used to make a lot of jokes about becoming rich and famous. The chances of success of those who [are not professionally recognised immediately after graduation] are not quite zero, but certainly diminish considerably. For the majority their dreams of a career in the arts are over, though it will take some ten years to admit it."[51] The jokes both recognise that success is unlikely and also mock the idea that tangible rewards are more important than the satisfaction of making art.
- Alex gains social cachet and an aura of authenticity when people are made aware (by Alex or others) of the relative poverty he experiences because of his commitment to art. In the arts, poverty is seen not as an indicator of failure but of authenticity. Van Gogh's poorness is a marker of his art's originality and power; the great wealth of Michelangelo during his lifetime

does not detract from the lofty nobility of his art. Paradoxical thinking and hypocrisy dominate our attitudes towards the link between art and money.

Squeamishness about, or disdain towards, discussion about the financial value of art is partly an intellectual conceit designed to detach a person from acknowledging the reality of art as an economic article in order to preserve the notion of art as quasi-sacred, noble and beyond monetary worth. As Abbing points out, all aesthetic and intellectual judgments rely on comparative measures, so there is no reason why financial evaluations are necessarily damaging or irrelevant in the assessment of art. Happily, for the critic and historian, the value of an art work is largely irrelevant to aesthetic considerations.

The denial and veiling of market/value component in art product within the art world is a complex network of binaries: acknowledgement/concealment, pride/shame, modesty/ flaunting, realism/idealism, altruism/venality. This comes from the peculiarities of the special economics of a high-status luxury, the quasi-sacred status of something which is also a market commodity, and human nature. Abbing notes that denial of economic value (or sabotaging of marketability) is used to maintain/emphasise material's high-art status, though this often leads to the most self-abnegating behaviour driving up the value of the monetary value of an artist's products (for example, Josef Beuys or Marcel Duchamp, though in those cases most of the price inflation is posthumous). It is not necessarily (or even primarily) a deliberate economic strategy, though it could be used that way; it is most likely to be the result of scarcity pricing and the market's craving for iconic "authenticity". Greater non-marketability → increased perceived authenticity → elevated status → increased demand → increased price.

Winners Take All

The rewards of the arts are not proportionately distributed. If famous Anish Kapoor exhibits 100 art works at a venue, less famous Julian Schnabel does not get to exhibit 90 art works at that same venue (namely, 90% of Kapoor's recognition). Schnabel does not get an exhibition at all because the number of exhibition slots at that venue is limited and he is not sufficiently famous. (Perhaps instead, Schnabel exhibits at a second venue with much less prestige and many fewer visitors than the first venue.) Likewise, magazines and newspapers have a limited capacity to review exhibitions and averagely educated members of the public may recognise the names of only 10 contemporary artists. The difference in recognition between being 9 and 10 on that list is small; the difference between being number 10 and 11 on that list may be huge. Similarly, a graph of all living artists' income per annum would be flat at zero and near-zero for almost the entire X axis, grow slightly then reach a sheer wall for the tiny number of super-rich artists. This is a form of winner-take-all situation.

Abbing neglects to draw attention to the Pareto distribution, a commonly observed phenomenon found in social, scientific and actuarial statistical analyses. It states 80% of returns tend to accrue to 20% of a population, thus demonstrating a recurring, consistent and widespread phenomenon where rewards are distributed unequally. (See also Zipf's Law.)

Negative as that may seem, multiple instances of winner-takes-all conditions provide opportunity for great fame and income in contrast to the poverty of most practitioners, which in turn adds to the excitement and appeal of being an artist. Artists, especially professional ones, are risk-takers. If unionisation or an income-equalising scheme were proposed, neutral risk calculation suggests a way to equalise income disparity should be in most artists' best interests. However, human instinct being what it is, most artists will conclude that they are talented and lucky enough to benefit from a win-big economy

rather than a share-small one. It is the calculation of every
person who ever laid a wager.

Are Artists Just Ill-Informed Gamblers?

Abbing posits "more than other professionals, the average
artist is inclined to overestimate his or her skills"[52] and "the
average artist is less well informed [about his profession] than
other professionals".[53] Consider the way adolescents form an
attachment to art on an emotional rather than pragmatic basis,
without even the vaguest of overviews of the career prospects
available to artists. In a time when most of the standard
aesthetic measures are no longer indicators of potential success,
how can any art student assess his career prospects? In such
circumstances, the decision to enter the profession cannot be
anything other than a hopeful gamble made by people who
consider themselves unfit for "normal" jobs (even though
numerous artists actually have second jobs which they perform
competently). They cleave to a life in the arts not despite the
poverty but partly because of the poverty, which is a badge of
authenticity and unwillingness to compromise. The lack of
reward in a perverse way validates the career choice by
emphasising how uncommercial their art is and how deter-
mined they have been to stick with it. Entrants to art schools
are also ill-informed about the many hidden, informal and
unspoken-of barriers there are in the art world, with its web of
gatekeepers, conventions, rules and social contacts.

I would add that artists think they are more in control of
their careers than they actually are. Changing taste, external
market conditions and luck are all beyond an individual's
control.

Subsidies Create Poverty

The issue of money is critical. Money is necessary to fund
museums and temporary exhibitions in public venues; private
dealers need money to function—even if it is a loss-making

subsidy from an angel investor; artists need an income (from whatever source) to pay for materials.

A large number of artists earn nothing at all from their art; in fact a significant number incur overall debts to pay for material costs while failing to sell art (admittedly, some may not be offering art for sale). Abbing notes that often artists and their families subsidise the production of art, which is actually a net drain on the resources of its creators – even the skilful and semi-professional artists. In terms of income from gifts/subsidies compared to income from the market, for artists the former dominates the latter to degree unparalleled in any other profession (with the exception of the clergy – another example of low-earning professionals being subsidised for the public good). Thus the exceptionality of the art economy is again apparent.

The arts is a paradoxical economy because for a very long period (at least a century, probably 150 years) the majority of artists have had tiny incomes from art; according to economic theory this commonly known information should cause a contraction in the number of people entering the profession, which would lead the overall consumption of art being spread between a smaller number of producers, thereby raising the medium income. Yet, clearly, this has never happened. In fact, the reverse: there are ever more art graduates at a time when the average income of artists is low, which should discourage entry to the profession. Apparently, the social cachet, personal satisfaction and tiny possibility of great wealth outweigh the stark financial figures and probability statistics. Due to the general esteem in which the high arts is held, it is deemed socially beneficial to subsidise art and artists, partly in order to alleviate poverty. This is a contributory factor in establishing and maintaining a web of government support, patronage and material advantage afforded the arts.

During the centuries when guilds set prices, established standards and restricted entry into the art profession, artist incomes were more stable, more divergent and higher overall.

Collectors bought for decoration purposes, commissioned commemorative portraits and acquired on the basis of taste. Now many collectors buy as investment and the British state buys art to support artists who uphold certain standards of cultural Britishness and meet diversity quotas.

The State Encourages the Oversupply of Artists

The Dutch BKR plan bought art for local government bodies directly from artists as a form of subsidy from 1949 and 1987. Spending on the plan escalated to unsustainable levels as the number of participating artists grew. When the plan was cancelled there was a reduction in the number of students applying for fine-art courses, an increase in the number of artists leaving the profession and a lowering in the general increase in the number of artists joining the profession.

> "The total amount of financial assistance for artists has no effect on artists' incomes. [...] Irrespective of developments in spending, donations, subsidies and social benefits, the incomes of artists have remained relatively low throughout the West for more than a century now, and most pronouncedly since the Second World War. If there is a trend in the second half of the twentieth century, it is a downward one. [...] in countries like the Netherlands where there is extensive subsidisation of the arts, the artist's average income is the same or lower than of artists in countries like the US and England, where subsidisation levels are lower."[54]

The conclusion is a chilling one and one that contradicts most received wisdom: "if the sole aim is to reduce poverty in the arts then the best policy is to reduce overall subsidisation of the arts." That sets aside the issue of the social benefits of subsidisation. The bare figures suggest that if the purpose of government art subsidies is to benefit artists financially, it is not working.[55]

The past restrictions of academic and guild membership— which restricted the number of producers and set certain

standards and conditions and kept prices relatively high—no longer apply. Educational artistic qualification in terms of BA and MA degrees is abundant and easily obtained. Government policy is to encourage the provision of ever-wider art education, though admittedly this is also to harvest fees from foreign students to support universities financially. It is a social convention that "anyone should be able to become an artist, regardless of background/qualification"; severely restricting the production and consumption of art through legal barriers would be socially unacceptable.

The public subsidisation of the arts—insofar as it reaches artists directly—encourages people to join the art profession and contributes to commercially unsuccessful artists staying in their careers, which artificially sustains a high number of producers and perpetuates the impoverishment of artists in general. Also, income from the state allows artists to cut back on their second jobs to devote more time to artistic production. Although society as a whole considers sponsorship (direct and indirect) of artists a social benefit, it may actually be harming artists and swelling the production of art for which there is no market. Increased state funding increases the number of artists and art production but does not raise the overall income of artists in general.

Art Funding Goes to the Middle Class

The common goal of expanding the reach of the arts to groups which under-consume the arts is not efficiently met through public subsidy. Subsidies tend to disproportionately reach the middle-class white producers and consumers who are already engaged by the arts and thus sustain the status quo. Government arts policy may be explicitly oriented towards social outreach but its effects channel money into the arts that policy administrators already consume. The evidence of self-interest is clear. Even if the outcome is contrary to policy goals, the policy is still applied. To cut funding would damage the arts that have grown to rely on subsidies.

That most major museums in Britain are free entry is a cost HM Treasury is willing to bear through subsidies because it a) increases income associated with cultural tourism, b) acts as a symbol of socio-cultural standards and c) aids the meeting of targets for social outreach. The problem is that museum attendance capacity is not limitless and overcrowding at venues is not consequence free—as anyone exhausted and deafened by a recent visit to the British Museum can attest.

Thus we can see that government arts policy which is ostensibly to provide art access for all actually reduces the quality of the experience for those who participate. Yet to point this out and suggest ways of restricting access in order to improve the experience will likely be dismissed as elitist. So someone who is attempting to improve the experience for participants in the arts can be castigated as socially regressive. Where there are no direct measures to prevent political interference in programming and museum policy, publicly owned museums inevitably become tools of state social engineering.

The State has Artistic Preferences

The patronage system of local and central government and public arts bodies replaces the patronage of monarchy, nobility and church; nowadays the arts serve patrons in an indirect manner. When a king won a battle he would commission depictions to commemorate his triumph and impress visiting ambassadors; the British Council does not commission propagandist art but it does select art that conforms to certain expectations which it uses in a form of soft power in its cultural diplomacy. This art indirectly says "Britain is a liberal, tolerant, multicultural nation exploding with technical and artistic innovation (and is a great holiday destination and good place to trade with)". The art is made independently but is often chosen because it conforms to—or at least, does not contradict—the establishment consensus. State-supported art is national and domestic political marketing. We could imagine the Arts Council funding a theatre production excoriating white

patriarchal hegemony but it would be unthinkable that a White Supremacist play would be subsidised even though the latter might be more politically challenging and more in need of financial support. In the arts, "diversity" never means true diversity.

The effect of state sponsorship of the arts is a matter of allocation and quantity. Complete withdrawal of state sponsorship would be cataclysmic for the arts. Without state sponsorship, fully staged ballet and opera with live orchestras would become extinct. However, a reduction in grants allocated by the Arts Council that would entail the closure of Turner Contemporary, The Baltic and some other venues would result in Wolfgang Tillmans and Gillian Wearing exhibiting slightly less often, though they would not be forced out of the market. Certain preferred artists (often already financially successful) receive the kudos and publicity of public funding which confers prestige upon them in the commercial sector. Public subsidy is thereby converted into commercial gain.

Artists are much more impoverished today than in previous eras because they often function in a market where they are detached from selling. Artists who are essentially self-marketers, using appropriation, publicity stunts and a veneer of critical theory to provide credibility, are supported early in their careers by the state, which effectively acts as a promoter through its venues, publicity and publications. In a period when nationalised industries are perceived as inefficient and iniquitous, the state is effectively acting as manager, financier and agent for artists who fit a definition of "avant-garde" though they are actually makers of pastiches of genuinely avant-garde art of the 1970s and 1980s.[56]

As David Lee has suggested in *The Jackdaw*, the Arts Council in itself is not the problem; the problem is the narrowness of the art it perceives as worthy of subsidy and—even within that range, which he calls "State Art"—the grotesquely disproportionate favouritism shown to a handful of practitioners already well supported by commercial galleries and foreign

state sponsorship. State support theoretically allows creators to be more innovative but frequently arts bodies tend to subsidise "more of the same" rather than something genuinely radical or widely popular.

We should be aware that there is great variation within that group of State Artists. Damien Hirst came to prominence through his savvy self-promotion and the Freeze exhibition and was selling art to private collectors and dealers before he ever exhibited at a state-funded venue. His art — good or bad — is genuinely popular and it seems reasonable for it to be exhibited in public venues, though popularity should not be an overriding factor in that decision. The art of Gillian Wearing and Christine Borland have, to my knowledge, never sold especially well except to Arts Council-funded bodies and, after promotion by State Art bodies, to overseas collectors of such art.

Certain expectations are hardwired into the provision of funding. Employers tend to hire applicants similar to themselves in class, politics and taste. Thus the public arts bodies over time hire certain types of individuals and this tends to reinforce the political culture of the body. This in turn influences the types of projects, institutions and individuals that bodies allocate funding to. Individual officers assessing allocation of funds tend to have certain personal, social and professional sympathies, which influences their decisions. Individuals attracted to working in the arts tend to be higher in liberalness and open-mindedness (broadly neophilic). Thus through cumulative processes of social networking, hiring and cultural affiliation publicly funded arts organisations now massively favour art production that is liberal and radical. This evolution has now spread into art-historical museums, where the conservative (broadly neophobic) individuals had previously dominated. Thus both arts funding bodies and museums are increasingly favouring certain types of art.

The Amateur–Professional Divide

There is an important deficiency in Abbing's analysis, which he admits. What is the status of the amateur-art economy? All manner of visual art material is made, consumed and circulated — and in quantities that far outweigh the traded art in the professional art world — which does not obey the economic rules that apply to professional art. That art is children's art, hobby and recreational art, copying, private sketching, artefacts from art therapy and other types of art which generally go unexamined through professional channels. Talented amateurs often produce work as good as — or better than — their professional contemporaries and are often more risk-averse, financially savvy and better informed than others who have whole-heartedly committed to art-making as a profession.

Although Abbing states "in practice the distinction [between amateur and professional] is socially constructed",[57] I contend that there are measurable differences between the two fields, they just include factors that are too hard to quantify to include in viable economic models. Perhaps the emphasis should not be upon the status of the producer but the status of the economic activity.

Abbing makes a distinction between the fine arts and applied arts, noting that the income imbalances, reward range and oversupply of makers in proportion to consumers in the applied-art field are much closer to a normal economy than the singular fine-art economy — an intelligent distinction. Yet Abbing's approach does not deal with art that is produced for (relatively) private consumption and which has negligible monetary value. Is this amateur art also part of the same economy as art produced professionally or semi-professionally? Just because material has no measurable financial value does not mean it has no economic worth; economics embraces non-monetary transactions, as Abbing notes. Amateur art fulfils some of the criteria of (professional) fine art but does not fulfil other criteria. Amateur producers are often not professionally trained/qualified, produce erratically,

do not seek/receive income for producing, do not need the approval of venues/collectors, do not interact with the public, are ineligible for subsidies, prizes and public gifts, etc. Yet, in purely material terms, amateur producers can produce items identical to those made by professionals, albeit lacking the cachet and monetary value. Abbing suggests that low, amateur and poorly regarded fine art actually has greater aesthetic qualities than high—or what David Lee would call "State"— art. High-art producers are marked by their disregard for—or spurning of—aesthetic qualities, whereas others strive to create beautiful or attractive art involving the use of craft skills. Amateur artists are more likely to produce flower paintings than conceptual installations. Arts bodies acknowledge (or at least assume) that much high art fails to receive market support and is therefore in need of public support.

The most obvious answer to this conundrum is that the art economy is a spectrum rather than a distinct field, with amateur art falling between fine and applied arts (with artists periodically moving between amateur and professional statuses). This raises the difficulty of definition and whether or not Abbing's fine-art economic criteria apply in a binary fashion or in variable degrees. Abbing's thesis is that the fine-art economy is distinctly different because of a) the extreme degree of inequality, barriers to entry, the consumption and production, etc. in that field and b) the unique paradigms that apply to that field and not to others. Amateur art seems to contradict both distinctions of Abbing's posited economic model.

Conclusions

Abbing seeks to overturn many of our assumptions about the relationship between money and art. His book raises two questions: 1. How true/accurate are Abbing's conclusions (some of which he admits are in need of further data)? 2. Would interested parties be willing to accept his conclusions? The findings go against many of our common cultural

assumptions, vested interests and current socio-economic structures. It is quite possible that Abbing is right on many points—and logic, evidence and intuition suggest that most of the economic observations are correct—but that we simply refuse to accept them or act upon them.

Do not think that Abbing is pushing a political agenda in favour of free-market capitalism or abandonment of artistic subsidy. Abbing admits that there are many legitimate reasons why the arts are subsidised but he suggests that the many common justifications for art subsidies are spurious. What he demands is greater honesty and clarity about why we fund art and what we expect to get in return and the acknowledgment that subsidies have unintended negative consequences. The true reasons for art subsidies are rather too self-interested and elitist to be made plain. Self-deceit over public funding perpetuates a system of vested veiled interests even though—upon close analysis—the status quo may be iniquitous and damaging for artists. The most important point of this valuable and wide-ranging study is strong proof that the belief art subsidies intended to alleviate artist poverty actually do so is a fallacy; he provides evidence that in general they increase poverty on average.

One wonders if it will ever be possible to speak honestly about why we fund art and what we expect to get in return. The most important point of Abbing's valuable and wide-ranging study is strong proof that art subsidies increase poverty on average. *Why Are Artists Poor?* should be required reading for everyone in arts administration and planning, and is recommended reading for any serious-minded person thinking of becoming an artist.

On Quota Programming

Preface: an Allegory

Once upon a time there was a society which made objects that had meaning and that people enjoyed looking at. The society put these objects in museums so that more people could enjoy them. Then an elite of that society decided that the objects did not matter so much but the skin colour and reproductive organs of the object-makers mattered a lot. Displaying objects made by people of certain skin colours or possessing certain reproductive organs pleased other people and made them feel virtuous. The elite counted the numbers of museum objects made by people of certain skin colours or possessing certain reproductive organs. These statistics measured how virtuous the society was compared to other societies. More and more people were encouraged to visit the objects to display their virtue or to acquire virtue. The elite wanted all the people to visit the objects even though some people preferred to do other things. When the elite persuaded people of certain skin colours or possessing only small amounts of money to visit the objects, the elite said it made society better when actually all it did was make the elite feel less guilty. It was known that most people liked meaningful or beautiful objects but it was decided by the elite that the virtuous statistics were more important. The elite decided that people's unhappiness about the elite using people's money to buy museum objects that were neither meaningful nor beautiful was caused by people not being virtuous enough. Some people thought the idea of virtuous statistics was silly but most of them did not say that because it would have been rude.

Introduction

This essay seeks to explain how identity politics, feminism and New Criticism underpin the ideology of a generation of curators. It concludes by discussing the direction of the Tate under Dr Balshaw's directorship, appointed in the summer of 2017.

Murder Machines

This year a sculpture by Sam Durant entitled *Scaffold* was erected in a sculpture park managed by Walker Art Center, Minneapolis. The wooden sculpture juxtaposed elements of playground-activity structures and gallows. One minor aspect of *Scaffold* referred to the hanging of Dakota Native Americans in 1862 as part of struggles between the Dakota Nation and the American government. That reference had been missed until it was pointed out, at which time a campaign to remove the sculpture was begun by the Dakota. "This is a murder machine that killed our people because we were hungry," said a member of the Dakota Nation, equating *Scaffold* with actual gallows that hanged members of the Dakota. In May the museum destroyed *Scaffold* and the artist renounced his work.[58,59]

This year there was a protest by some black artists against the display at the Whitney Biennial of a painting of murdered black activist Emmett Till. Black activists lobbied to have the painting by Dana Schutz, a white artist, removed as offensive and hurtful. "The subject matter is not Schutz's," said one pro-testor, claiming ownership and authority over the representa-tion of a historical event.[60]

In these two cases, activists claimed ownership over aspects of history in order to suppress art works. In one case it resulted in the destruction of art. Pressure groups have noticed the weakness of curators, administrators and politicians and their unwillingness to protect art from censorship. Sympathetic towards notions of social justice, administrators sometimes

submit to emotional blackmail by groups which demand censorship.

Delacroix did not have to be Greek to paint *Massacre at Chios*; Singer Sargent did not have to be either British or a combatant to paint *Gassed*; Callot did not seek approval of relatives of hanged men before publishing prints. These are iconic touchstones for appreciating events in world history, yet according to supporters of identity politics such art should not be made now. Groups should own their histories, curb free speech and suppress or destroy art deemed offensive. There was a time, not so long ago, when we derided Soviet agronomists' dismissal of Mendelian genetics as "bourgeois" and Nazi ministers damning branches of science as "Jewish", yet today art can be "too white and male".

Identarianism

Identarianism (or identity politics) is a political belief system which has had huge influence over politics in Western countries for the last three decades.[61] It sprang from new left principles developed in the wake of failed attempts at revolution in 1968 and revelation of atrocities and failures of communism. It seeks to advance social justice and enforce relative equality through incremental advances in social capital of supposedly disadvantaged subsets such as women, ethnic and sexual minorities and so forth. There is commensurately punitive retraction of rights from supposedly advantaged groups such as men, white people and so forth.

Identarianism is essentially a political manifestation of Post-Modernism, acting by harnessing factional interests. In the same way Marxism co-opted movements of emancipation, workers' rights, anti-clericism, anti-colonialism and so on, Identarianism gathers factional interests under the umbrella of Post-Modernist relativism by promising social justice.

Here are some tenets of Identarianism:

1. Every person has involuntary affiliations from birth (ethnicity, sex, sexual orientation, physical ability, family religion, etc.) and shares a common identity with other members of his or her subsets. These identity subsets are not generally mutable. (Mutability of gender and sexual orientation are controversial issues within Identarianism.) Subset identities necessarily form a strong part in determining one's outlook. People do not have universal qualities (as in the Enlightenment model of universal rights) but have compound qualities derived from their subset identities. Equality is therefore relative not universal.
2. Subsets are subject to pervasive networks of personal, institutional and social prejudice, discrimination and disadvantage. This oppression is collective and endemic.
3. Social, legal, political and financial power — and its converse — are heritable.
4. Privilege and guilt are collective and heritable.
5. Subset members have a right to demand redress or reparations for collective discrimination and oppression by oppressing subset(s).
6. Subset members can work together to promote the fulfilment of their potential (called "equity"; see below) and to reduce power/privilege of other subsets. Subsets can work together to form tactical alliances in order to achieve social and legal change. Dialogue is power negotiation between inherently unequal subsets; compromise is acceptance of oppression.
7. Identities are formed of multiple subsets and these overlapping definitions are described as examples of intersectionality.
8. Some subsets experience more discrimination (or privilege) than others. This is (relatively) quantifiable. An individual's position is determined by his or her specific intersectionality.
9. Culture and language are sources of power/oppression and should be used to enact social justice. Social justice is either

a) the relative equalisation of power/privilege of subsets or
b) realisation of potential in unequal ways (see below).

10. One cannot understand or judge members of another subset. A subset culture is unique and the experience of its members is unfathomable. Only members of a subset have the right to speak about the experience of members of that subset.

11. It is injurious for a person to use or appropriate culture, history or language of another's subset.

12. One best understands—and is understood by—members of one's own subsets. Each subset has a shared culture. It is not expected or encouraged for a person to form voluntary personal affiliations across subset boundaries except for purposes of temporary political action. Strong affiliation for another's subset is akin to appropriation.

13. Exercise of imagination, empathy and fantasy are opportunities for potential (even unconscious) prejudice, misapprehension and distortion to occur and should therefore be avoided.

14. Any of the rules above can be broken to promote a subset, prove the truth of identity politics or to otherwise further the cause of Identarianism.

An example of rule 14 modifying rule 11 is that it would be fair for a black person to appropriate white Western culture because the black man is relatively disadvantaged. If a white man appropriates black culture this is an act of oppression. If a black man claims he is interested only in black art this is expected (rule 12). If a white man claims he is only interested in art by white men this is narrow-minded bigotry.

Never Fast Enough, Never Far Enough

Identarianism is not a fuzzy warm principle of being nice to people and treating others equally—quite the contrary. It demands people be treated unequally. It divides people into subsets, classifies individuals' worth minutely with matrices of

privilege and social status, undercuts individuals' autonomy and discourages (even curtails) individuals forming personal taste. It demands advancement of minority interests by authoritarian means.[62] It is incompatible with humanistic Enlightenment values. It accommodates factional interests and dehumanises opponents. It encourages tribalism. It sets up systems of patronage bestowed by the enlightened upon recipients who are expected to reciprocate by recognising the bestower of status as a "good ally". It seeks to suppress free speech and free thought.[63] Identarianism is dictatorial and dehumanising to its core; as an ideology it is riven by contradiction, hypocrisy and double-think. Identarianism is part nihilistic revolutionary movement, part narcissistic cult of selfhood, part religion of moral fury. It nurtures a culture of selfhatred, guilt and contempt for Western civilisation even — especially — among middle-class white people. This self-hating rationalises a middle-class white person having certain presumed advantages while at the same time getting the moral comfort of siding with the "oppressed class". The presumed advantages are never given up but are "paid for" in emotional reparations of guilt and anger.[64]

Look at the groups removing "politically objectionable" statues. Look at university-student mobs which shout down or assault public speakers. Look at student bodies which demand "safe spaces" and ban discussion as "hate speech". This is Identarianism in its purest form, where it expresses the mentality and emotional tenor of even those who consider themselves moderates. Most activists do not fully understand the origins, tenets and implications of their ideology. No matter. Consider the Cultural Revolution, when commissars harnessed the anger of young idealists to instigate an orgy of righteous cultural destruction. Identarianism is not simply another way of viewing society, which can co-exist with other outlooks; it is an entity which has evolved to suppress opposition and destroy cultural expression.

Identarians do not have much time for old art because a) its artists and subjects do not reflect the demographic profile of today's society, b) it rarely has a clear "socially progressive" message and c) it resists co-option to Identarian aims. Beyond justifying the general Marxist declaration that spousal portraits and paintings of livestock and land constitute evidence of the capital classes recording possession of chattels, old art cannot be used to further social justice. This is, to be fair, an accurate assessment in purely political terms if one has didactic aims and no aesthetic, cultural or historical curiosity. If I were a curator in the Identarian movement, I would be consigning old art to the vaults and lobbying for deaccession rights.

To Identarians, when change seems so gradual and the historic burden so outrageous, implementation of affirmative action (including (unstated) quotas) seems not only desirable but necessary and those who will be disadvantaged by quotas are unavoidable collateral damage. Individuals who advocate caution are revanchists. For a firebrand who believes he or she is on the right side of history, change cannot come fast enough or go far enough.[65]

New Criticism and Post-Modernism

To understand why Identarianism has such purchase inside the art world one needs to understand New Criticism.

New Criticism in art history is an outgrowth of Marxian[66] analysis of culture, broadly described as Critical Theory, based on the ideas of the Frankfurt School. New Criticism produces socio-economic critiques of art production/reception and is driven by theory in the fields of women's/black/queer/post-colonialist studies. New Criticism is leftist, more theoretical than historical and underpinned by French post-structuralist philosophy. New Criticism is at the core of most art-history university education, existing uneasily alongside traditional art history. A common strand in New Criticism is distrust of aesthetics, formalist analysis of art and anything that could be construed as connoisseurship. New Criticism, Post-Modernism

and identity politics began in the late 1960s and developed in parallel and in symbiosis.[67]

New Criticism is predicated upon the fracturing of the consensus in Western values. Post-Modernism states that an infinite variety of perspectives and interpretations means consensus is both impossible and irrelevant. ("All values are relative" is an unqualified assertion of an unconditional truth which negates itself—but never mind.) Where all values are relative there can be no society-wide standards for appreciation and evaluation of art; hence the development of multiple strands within New Criticism, each with different concerns, languages and value systems. Whereas Modernist art was judged carefully in terms of its visual content, Post-Modernist art exists in a zone free of all formalist analysis; its appearance is not only inscrutable and illegible but actually arbitrary and meaningless in visual terms.

Nowadays many art critics, curators and theoreticians do not enjoy art;[68] they do not like looking at art or discussing how it operates visually; New Criticism says that this is unimportant as only contextual power structures around art production and reception matter. This ideology breeds theoreticians with a positive disdain towards the visual qualities of art.[69] New Criticism and Identarianism are tools for identification of power structures and are antipathetic towards aesthetic appreciation, ambiguity, personal reflection, dissent, individualism and even pleasure. Pleasure in appreciation of form and technique, interest in creative decisions, appreciation of beauty, wonder at the experience of being transported into a different world or era, delight in discovery, joy through empathetic engagement—all these are alien to New Criticism and Identarianism.[70]

What Art is

While New Criticism can provide insights into aspects of art production/reception, it never comes close to describing (let alone explaining) our responses to art as a whole or delineating

why we respond more strongly to certain objects rather than to other similar objects. Syncretic criticism on a grounding of formalist analysis, traditional art history, aesthetics, iconography and literary and scientific knowledge—directed by self-scrutiny—is a more valuable approach to art criticism. To advocates of New Criticism that sounds suspiciously like bourgeois connoisseurship—perhaps it is.

I have previously given[71] the definition of fine art as follows: a non-utile physical object appreciated primarily for its appearance which can function on an aesthetic and emotionally engaging level when shorn of all original cultural context (e.g. cave painting, Cycladic art, African tribal objects viewed as art rather than religious devices, etc.). Technically, that means conceptual art is not art, but that's another subject. Although mythology, allegory, literary sources and biographical informa-tion can inform readings, they are never central or even pri-mary. It does not matter how sophisticated an argument is put forward in a work of visual art (a medium which by its nature is unsuited to conveying complex intellectual ideas), if a work of art is not appreciated on either a human/emotional level or aesthetic basis it will sink from view. Museum basements are full of prize-winning allegories which are unendurably tedious even for cultured visitors. Syncretic criticism can ably discuss and explain why certain works of art succeed or fail; New Criticism cannot, though—to be fair—its proponents do not believe art can succeed or fail.

Modernists and traditionalists should make common cause against Identarianism. While Modernists and traditionalists disagree about aesthetics, both groups care passionately about the appearance of art. Identarians do not. They do not believe that aesthetics exist. New Criticism (which subordinates art's visual character to political readings), feminism (which seeks redress for perceived historical injustice) and Identarianism (which states that culture is tool to be used to combat privilege) bolster curators who believe that art which cannot be turned to

political purposes should be dismissed, subordinated or suppressed.

Women's Art

Due to multiple causes, in terms of proportion, women artists working in major art fields were in a minority until the late 20th century. The lack of women in the Western canon is complex and relates to at least four social factors which led to one significant consequence:

A. Social pressure strongly discouraged women of upper and middle classes from pursuing manual crafts for income.
B. Women had difficulty in studying art because of restrictions on entering academies,[72] apprenticeships and gaining access to male life models, which led to few women gaining high-level skills, experience and qualifications.
C. Women were often barred from joining guilds and societies and were therefore impeded from engaging in professional commissions and making their livelihoods.
D. Childcare and domestic duties often restricted the amount of time women had to make art.

Consequently, women artists rarely practised large-scale history/religious oil painting and stone carving—genres and mediums that were central to art historical canons. Instead women artists often practised the "minor" arts of drawing, watercolour painting, pastel painting, crafts and folk art. These fields have traditionally been classed subsidiary to oil painting and stone carving—much to the chagrin of practitioners both male and female. Therefore there were relatively few women artists working at a professional level before the late 19th century and thus there is little historical art by women in museums.

Here is the sleight of hand which justifies affirmative action: "Look at the statistics on the paucity of art by women included in art-museum collections. This demonstrates there is an implicit masculine bias in judging what is suitable for art

canons and proves there is a campaign of exclusion and suppression which continues to this day." Historically, there were specific restrictions on women entering the fine arts. However, today cohorts of fine-art graduates are often female dominated. Many administrators, curators, tutors and scholars are women. In my experience, lower and middle ranks of arts administration are hugely dominated by women, who are rapidly rising to top positions. Of the journals I write for, half have female editors; every single editorial assistant is female. The staffs of publishing house press departments are almost all female. Roughly 90% of the museum press officers I have liaised with are female. I would love to meet a caste of oppressive bearded patriarchs in the arts so I could gaze upon them in wonder and curiosity. I could shake their hands and wish them farewell.

A statistical imbalance from a broad swathe of history is used to justify affirmative action applied to the current art scene where no exclusion exists. The just campaign for equal rights has been won; the new cause is for preferential rights. To the assertion that women/minorities faced worse discrimination in the past and that quota programming is a small price to pay, one can say two things: firstly, the price is heavy enough for individuals who have to bear the burden of this "historic redress" and, secondly, discrimination in the past was wrong and it is wrong today.

Equity not Equality

Equity is different from equality. Equality means parity and neutrality. Equity means reward determined by input or worth, not necessarily equal. Equality is problematic for Identarians and Post-Modernists because it produces inconvenient results. Despite decades of equal opportunity, certain demographic groups tend to choose particular academic subjects less often and—as groups—perform (on average) better or more poorly within their population cohorts.[73] So, faced with this situation, Identarians have reversed the target. No longer is it equality of

opportunity which is important, it is equality of outcome. This is equity, in Post-Modernist terms.[74]

Since oppressed individuals struggle against society, academia and privilege, they should be given preferential treatment to compensate for their disadvantages. The individual is valued as a victim, to be patronised and promoted regardless of his/her unique circumstances and actions. He/she is merely a figurehead, role model or token. The humanistic values of equality of worth, dignity and rights as ideals are nullified by a capricious and inscrutable system which not only denies equality as a target but even as a possibility.[75]

In employment this leads to affirmative action, in academia to equity recruitment, in culture to quota programming.

Quotas versus Art

Many feminists (including Dr Balshaw) suggest that active steps must be taken to increase the public presence of female artists.[76] Here are seven flaws to collecting and exhibiting art on the basis of statistics:

1. *Targets diminish art.* They reduce every artist (indeed every person) to a representative of subsets categorised by gender, race, etc. Artists become featureless interchangeable tokens in abstract calculations. It neglects the subject, quality and intellectual content of art and makes labels more important than art. It views artists as more important than art.

2. *Targets patronise artists.* The reputations of Barbara Hepworth, Gwen John, Frida Kahlo and many other women have risen as high in their fields as those of male counterparts. Their art has become recognised without quota programming, on its intrinsic merit as art. Fairly or unfairly, quota programming will cast a shadow over the new generation of female artists who will benefit from it.

3. *Targets patronise viewers.* A generation of viewers will be subject to second-rate art promoted through a quota system. It will teach the lesson: what you do is less important than

who you are. Inspiring examples of women (and men) attaining success through hard work, skill and invention will be replaced by the example of passive mediocre individuals who were selected because their skin colour or reproductive organs fulfilled a quota. A more dispiriting message is hard to imagine.

4. *Targets are unworkable.* Should half of all the art we view be produced by women? How would that be calculated: by number of artists or art works? What about unattributed works? Will living artists have to register data or will a committee verify data to prevent artists wrongly self-identifying in order to gain advantage? Who will arbitrate these matters?

5. *Targets are meaningless.* In what way is a museum which displays 50/50 male and female artists a good museum? Viewers who are engaged by art not artists would be content with museums completely filled with women's art if that art were the best art available. An obsession with statistics is the only fixed point in Identarian arts policy because all other issues — what is art, how can one judge art, what is art for — are all rendered unanswerable (or null) by Post-Modernism.

6. *Targets will be altered.* Once a quota system is in place, there will be pressure to alter quotas to favour certain groups. As Thomas Sowell notes in his examination of "affirmative action",[77] once established, systems designed to advance groups become subject to political manipulation and fraudulent claims. They will also — despite any assurances to the contrary — persist beyond the point where they could be described as temporary. Thus any system which is initially agreed will not be the system as it is implemented; it will not be abolished by its administrators, who will not abolish their own power and income.

7. *Targets reduce variety and competition.* As in all protected economies, artificial targets will prevent the superior from supplanting the inferior. Protected status will cause

favoured artists to become complacent and repetitive because they face restricted competition. This restriction happens already and any additional layer will exacerbate the problem. Consumers of art deserve to see the best art regardless of artificial restrictions regarding the identity of the producers.[78]

Art suffers a net loss: creators of unprotected classes are excluded or hobbled; creators of protected classes are advanced to positions they are not competent to hold; the public loses access to the best art that could be made.

Predictions

From statements made by Dr Balshaw, her track-record at the Whitworth Art Gallery and Tate's recent policies,[79] we can guess that her tenure will be marked by three aims: a) a drive to increase levels of attendance, b) attempting to alter visitor demographics and c) altering the demographics of artists represented. Here are some predictions:

1. Collection and exhibition of art will be increasingly driven by the imperative to promote female/minority artists regardless of aesthetic or formal qualities of their art. There will be a drive to pack the collection with art by women/ minorities in an attempt to reach arbitrary statistical targets. The contemporary collection will become a massive ever-inflating multi-million-pound experiment in social engineering grounded on untested principles, driven by ideology and set to utilitarian goals: to demonstrate virtue and make visitors virtuous.

2. As in all politically-driven economies which prioritise production and performance targets (centralised national economies, educational and healthcare systems, etc.), there will be an increasing tendency to distort, partially report and fabricate figures to suggest increased attendance and greater consumption of art by minorities and the poor.

Targets will be altered and definitions manipulated to compensate for poor results.

3. There will be an increase in the practice of piggybacking shows of lesser known female/minority artists by attaching them to shows of more popular artists, regardless of whether the linkage is artistically/aesthetically appropriate. Attendees of Tate Liverpool's exhibition of Leonora Carrington will remember a neighbouring room devoted to Cathy Wilkes. Both exhibitions were on the same ticket. Many visitors—seeing a room filled with contemporary art unrelated to Carrington—did not even enter the Wilkes room. However, Tate reports attendance of the Wilkes and Carrington shows as equal.

4. Space devoted to historical (pre-Modern) art in Tate Britain will be steadily reduced. Presentations of historical art will increasingly disregard art-historical standards. Curatorial staff and financial resources will be redirected towards contemporary art. Departing staff who handled pre-Modern art will not be automatically replaced.

5. Interpretative texts will reduce discussion of stylistic aspects and will highlight social dimensions of art. In an attempt to make texts as accessible as possible, they will be simplified to a degree that errors will become frequent, undetected by staff who will be under-informed about art history.

6. The Turner Prize will become an award driven by political ideology. Winners will be politically focused; collectives will win more often; women/minority artists will dominate shortlists and lists of winners; and painting will only be included if it is driven by political concerns. Critical commentaries on the Turner Prize produced by the Tate will neglect aesthetic discussion.

7. The Tate will be rebranded as a museum of world art. Western and British art will be marginalised in terms of space, funding, exhibitions and acquisitions. The museum staff will fight shy of using laudatory terms about Western art and there will be claims that Britain has historically

always been a largely multicultural nation and that its culture has always been deeply influenced by non-Western cultures.[80] Historical records will be suppressed and distorted to reflect this position. Liminal figures (from so-called minority groups) will be presented as crucial in artistic narratives precisely because they are liminal.

8. The Tate will buy art made by and portraying so-called minorities, paying over the odds and acquiring works of little aesthetic quality, in order to fill perceived gaps in the historical narrative advanced in point 7. A number of fakes and misattributed works will be acquired because of the museum's political drive to acquire work, its lack of interest in aesthetic quality and loss of connoisseurial skill due to the departure of knowledgeable staff.

The Fate of the Tate

The Tate has numerous problems. It has multiple subjects to cover (British, modern, contemporary and world art). It does too many things (maintaining and expanding a collection, hosting exhibitions, running a website, maintaining four venues and organising education/outreach programmes, publishing, conservation, research, hospitality, retail, fundraising, membership services, publicity and so on). It has too many staff. It has too much art. It must continually increase income. It must continually increase attendance. The Tate's fundamental problem is that it does not know why it exists; this is set to worsen during Dr Balshaw's era, with its promised blend of identity politics, populism, community events, pop culture and influx of school parties, not to mention a massive acquisition drive.

When the existence of museums depends on popular consent and museum funding depends on reaching a mass audience, curators tend to make art as approachable as possible. Yet the more art is presented as just another piece of everyday life, the more averagely-informed people wonder what the purpose of an art museum is. Making art more popular by

adapting it to ape pop culture (or by co-opting pop culture as art) increases engagement but decreases respect towards art. Pop culture in museums cannot help but be feeble, denatured mimicry of the pop culture that fills the rest of the world.

People are not helpless dolts. Many of them yearn to have new experiences, to learn, to overcome obstacles. Rather than saying "fine art means whatever you want and it's just ordinary life", tell them "fine art is complicated and dense but if you invest time and thought you will get unique rich experiences and insights into the world and human nature". If you were told (the lie) that fine art is just ordinary life, why would you bother with art?

In a Post-Modern multicultural age, cultural institutions lose morale and direction because they have no moral or intellectual underpinning. If museum staff do not believe fine art has intrinsic value as art (not just as a demographic signifier) then they cannot explain art. If even experts cannot explain why art is important, they (and their museums) deserve to go. Dr Balshaw, who studied English and Critical Theory not art history, is an arts-venue manager who has demonstrated little knowledge of art history and is thus in the worst possible position to put forward an intellectual and moral case for high art.

Instead of experiencing fascination slowly develop in a quiet gallery, today's teenager is inside a cultural mall facing a Sam Taylor Wood video installation in a noisy, overcrowded room. "Seen better on YouTube," he says and wanders off — and who would disagree? Frankly, I'd rather be watching YouTube too. Arts-venue managers (as opposed to art historians, who used to run museums) are terrified of silent static art, of allowing visitors to choose to engage or walk away, and — like an anxious mother — chop art into tiny morsels without context or jangle bright geegaws such as interactive experiences to capture attention. But that is exactly what everyone experiences elsewhere all the time. Why go to a museum to

bow your head over a museum-specific mobile-phone app when you could do that sitting at home? But surely those morsels entice visitors to learn more. Oh? Where? In a chaotic museum which cannot properly display that art, label it informatively or explain why it is important? Showing films, staging concerts, hosting performances, holding lectures, providing educational activities—all of these are done better, cheaper and smarter by cinemas, private galleries, concert halls and schools with facilities adapted to those purposes and staffed by professionals who are experts. The only thing an art museum does better than any other venue is displaying painting and sculpture. It could almost have been designed for that purpose.

The Tate's strategy will inevitably lead to it becoming second-rate in many areas and neglecting its core mission. A museum such as the Tate should conserve, present and explain art objects of the highest aesthetic quality and historical worth. Clarity, focus and excellence—and the respect that would generate—would secure the future for a slimmed Tate. But the circus must go. Exhibiting and collecting a cross-section of the entirety of the world's high and pop culture in its myriad manifestations in a museum barely capable of presenting its limited collection of British and Western Modernist art up to 1970 is not only impossible, it is insanity.

Accept that not everyone will be interested in fine art, as not everyone is interested in classical music, historical monuments and public gardens. So be it. High art has always been a minority interest. Is high art elitist? No. It returns as much as one is willing to put in, like all areas of the arts which require effort before providing rewards of lasting value. The drive to make high art a mass viewing activity is motivated by curatorial self-interest, cultural insecurity and financial necessity. It is not viable. If a museum has (due to poor decision-making) an unmanageably vast collection and an enormous number of staff and consequently locks itself into an unsustainable counter-productive cycle of performance targets

to attain ever-greater income simply to survive, then it deserves to fail.

I have no personal animosity towards Dr Balshaw. Certainly, anyone who has run a large arts venue financially successfully has admirable abilities. However, anyone whose approach to leadership is essentially managerial, whose principles are informed by identity politics and Post-Modernism, who has no apparent belief in the functions and value of high art (distinct from pop culture) and who cannot identify or defend the core mission of a national art collection will only worsen the situation at an already unwieldy, dysfunctional organisation. Instead of being the Tate's most suitable fundraising director, Dr Balshaw may, sadly, be the Tate's least suitable director.

On the
Western Canon

The canon of great art has never been the target of greater ire than it is today, but many leftist critics and their traditionalist opponents misunderstand the canon. The truth is unsettling for both groups. This essay seeks to clarify the nature of the canon at a time when it is an especially contentious subject.

Great Deeds against the Dead

Last year art history A-level was scrapped due to low take-up then, after a campaign to reverse the decision, it was reinstated. This allowed New Criticism to gain a foothold in school art-history teaching. When the new curriculum was developed, there was a downgrading of the master artists of Europe. Sarah Phillips, designer of the new art-history syllabus, said "It is a global specification. Students won't just study the work of dead white men. They will have the opportunity to study Islamic architecture and work by men and women of all colours and creeds."[81] Perhaps students will be tested on artist skin colour in exams.

"Art history is the study of power, politics, identity and humanity; it makes perfect sense to keep the exam,"[82] said Jeremy Deller. One doesn't envy students wanting to learn about painting only to be dragooned into political-education courses and harangued on the purported crimes of their forefathers, who were more likely to have been agricultural labourers toiling in fields than redcoats bayonetting babies in India. Perhaps A-level art history would have better remained decently defunct.

Leftist critics characterise the canon as a white male Christian club. That view excludes the ancient pre-Christians, undisclosed atheists/agnostics and recent additions to the canon but — those exceptions aside — white Christian men were ones making large-scale oil paintings and stone carvings up until recent centuries so Western European art is necessarily their art. Critics confuse corollary with cause. The canon has never been based on the identity of artists. Indeed, it is heedless of artist identity. Art in the canon is judged on intrinsic and extrinsic qualities without regard to maker. Numerous anonymous ancient and medieval art works are canonical. Only relatively recently was the *Avignon Pietà* attributed to a named artist. Other works will never be assigned to a maker by name. Imagine scientists discarding valid theories and research because their predecessors had skin "the wrong colour"...

Incidentally, dismissing art because of the maker's masculinity discards contributions of countless female models, patrons and collectors, not to mention wives, sisters and daughters who worked in studios and even painted parts of pictures. These women believed in and helped to make these paintings; if they could see activists agitating to have these paintings removed from sight they would likely be appalled and baffled at careless condemnation of art they loved.

The Exquisitely Efficient Machine

The canon is both the group of generally accepted masterworks (and, by inference, their makers) and the principles underlying that selection. Art historians, artists and knowledgeable enthusiasts have approximate lists of great essential art though details vary. There are major and minor figures in the canon and canons for specific countries and mediums.

The canon is a distillation of informed judgment over the course of centuries and thus a competence hierarchy. It is an exercise in both discrimination and tolerance as one accepts the whole without agreeing with every part. Crucially, the matter of personal taste is irrelevant. You personally may not care for

Rubens but he is important, influential and in some respects innovatory; he cannot be removed by you. Only if over a long period a large majority of experts and enthusiasts agree is an artist removed from the canon. The canon provides broad consensus while at the same time compelling no one to praise falsely. The canon cannot be imposed from above by either scholars or social activists. We give the canon its relevance and it endures despite fashion and politics but the contents of the canon are provisional.

Dissent regarding the stature of an artist does not damage the canon; on the contrary, it strengthens it by forcing supporters of an artist to examine and refute (or accept) criticism. This process of continual testing winnows substandard art from the canon and proves the fitness of that which remains. It is an exquisitely efficient (though slow) machine for refining our understanding of art.

The Exclusion Fallacy

In November, Agnews of London, one of the world's oldest dealing houses, opened an exhibition of German painter Lotte Laserstein (1898–1993). Lotte Laserstein was a Jewish artist. As conditions for Jews in Nazi Germany became ever more onerous she fled to Sweden, where she remained until her death. She was a realist painter, not strictly speaking part of the Neue Sachlichkeit movement but working parallel to that group. Her work is widely distributed in museums though she is not as famous as her Neue Sachlichkeit peers. Her work is excellent, sensitively observed and intelligently painted; it is well worth becoming acquainted with.

Agnews press release runs as follows:

> 27 years after Agnews staged the artist's last exhibition before her death, the gallery is delighted to announce Lotte Laserstein's Women an exhibition devoted to Lotte Laserstein's intimate and nuanced depictions of women. This will be the first exhibition in London dedicated solely

to Laserstein since the ground-breaking 1987 exhibition at Agnews, where the artist herself was present and a lively collaborator. A focus of the exhibition is to acknowledge and reinstate Laserstein as one of the great women artists in the canon of 20th century art from which she and many other women artists of the inter-war period have been excluded.[83]

The idea that women were—or still are—being systemically excluded from the canon is demonstrably false. The inter-war period—Laserstein's heyday—is rich with celebrated female artists: Gwen John, Frida Kahlo, Käthe Kollwitz, Tamara de Lempicka, Georgia O'Keeffe, Charley Toorop and others. Not only are these female artists highly esteemed, some are considered the leading practitioners in their fields. If there exists a patriarchy set on oppressing women, it is so ineffective it might as well not exist.

But of course it never did exist. The exclusions which restricted women from practising art were those regulating admission to guilds, academies and professional trade bodies. Guild rules were trade-protection measures against unlicensed practitioners rather than a campaign of patriarchal control. (Conversely, women were historically granted privileges not extended to men.) Limitations on artistic practice have not existed in the West for over a century. The art profession of today—ranging from artists to gallerists, publishers, editors, critics and collectors—is full of women. The art world's gatekeepers are women.

Legal regulations are codified and imposed; the canon is changeable, unregulated and disputed. The canon is a body of knowledge defining (for the purposes of education and pleasure) the most important art; it is cumulatively generated by multiple critics, authors and artists over many eras and is not controlled by any authority. Although the canon endures, its constituent artists are there only provisionally. There are no identity-dependent criteria which determine the artists (or, more strictly, works of art) which enter the canon. So long as

art is in the broad Western tradition, that art can enter the canon regardless of the maker. Female artists have entered the canon and more will enter if their art is acclaimed by a sufficient number of experts over a lengthy period.

Due to the way the canon is determined (simply by multiple instances of inclusion and omission), exclusion — that is, expressly barring an artist's entry to the canon — is impossible. No body or individual has power of veto over collective taste.

The reason Laserstein is not in the canonical list above is that her art lacks not distinction but distinctiveness. The output of above-listed artists can be crisply summarised. "O'Keeffe produced pioneering semi-abstract representations of natural phenomena characterised by curvilinear forms and broad areas of modulated tone." The same could be done with any other artists in the canon. Not so with Laserstein. "Laserstein produced sensitive portraits, mainly of women." It fails to give a characteristic impression of any unique contribution. Her art is not distinctive enough to easily enter the canon. Though accomplished, Laserstein's art is not novel and the canon craves novelty. Untold thousands of male artists as competent as Laserstein languish in obscurity for exactly the same reason. Gender plays no part in the matter.

The lie that women are excluded from the canon is doubly disproved by evidence and the nature of the canon. However, the lie of exclusion is useful when support is needed to promote a female artist or attract press attention. The lie that women are discriminated against in the contemporary art world is used as a lever to cynically extract favourable treatment, sales and exhibitions. This leads to the sinister mechanism of quota programming that is being imposed in our museums. At Tate Modern the newly opened wing exhibits art by men and women at a 50/50 ratio. The policy is arbitrary and artists are treated as interchangeable tokens only significant as markers of gender. Anyone criticising art introduced via quota is dismissed as a bigot regardless of how valid the analysis is. The unthinking acceptance by the public of the lie of female

exclusion makes possible political manipulation of public art collections.

The canon, far from being a machine of oppression and exclusion, is a meritorious mechanism for selecting the most important art on fairly universal principles for the purposes of the education and pleasure of everyone. The canon has no racial, gender, sexual or personal prejudice. It is regional but not nationalistic. It accepts the professional and amateur, the sacred and profane and art made in the humblest of circumstances.

What is this "Canon"?

There is no authoritative list of canonical works. The canon, by definition, cannot have a single fixed form. If you want to produce a list of canonical works, take all narratives on art history, starting with Pliny going through Vasari and ending today, add respected monographs covering individual art movements and books of masterpieces of art. Add up all mentions or illustrations of individual art works then remove the least frequently cited third of that list, remove all works made in the last 40 years, remove anything made by a living artist. What remains is the canon.

The weaknesses of this definition of the canon are that it gives greatest statistical weight to recent views, to published (rather than privately expressed) opinions and to works of which we have photographic images. Frequency of citations proves nothing and does not qualitatively measure works. Popularity proves nothing except itself. Notwithstanding limitations, this aggregated canon would make a fascinating read.

The canon is not democratic nor is it just. It rewards those with the audacity to steal and lie. The cuckoo which ejects the host's chick from the nest will survive and prosper, so too the brilliant adopter can displace a talented but flawed inventor. Justice has never informed the canon nor can it do so. The canon is a hierarchy of competence which reflects societal

appetite for exceptional achievement and it does not arbitrate historical priority or factual (or emotional) justice.

Canon Criteria

The presence of a single work (or body of works) produced by a now-deceased artist in the Western fine-art canon is due to it having at least one of three attributes still considered to apply today: (a) importance or influence, (b) originality or innovation, and (c) outstanding quality within an aesthetic field; with two minor attributes valued: (d) timeliness, and (e) lineage. To be a minor figure an artist needs only one of the minor attributes. Richard Dawkins describes the art canon as a persistent meme-plex—a complex of memes (self-replicating ideas passed down through generations).

Attributes (b), (d) and (e) need further comment. Originality need not be actual invention but being the outstanding exponent or populariser of a new material, style or subject. For example, no modern historian now assigns the invention of oil painting to the Van Eyck brothers but they were the first artists to bring the technique to perfection in panel painting and were historically credited as originators. Priority on its own is not enough. Hans Hofmann, Andre Masson or Max Ernst may have technically been first with the drip technique but it was Pollock who understood the technique's potential.

Timeliness is zeitgeist—encapsulating a particular culture during an era. J.-L. David's career is a perfect reflection of a turbulent era in French history and art, aside from his art's qualities. Lynn Chadwick is a minor canonical figure. His metal sculpture of the 1950s embodies the spirit of an age (post-war figurative sculpture) while it is not strong enough to make Chadwick a major artist.

Lineage is an attribute of the canon's traditional didactic purpose. Perugino, a figure on the periphery of the canon, would probably have sunk from our view if he had not taught Raphael. One cannot understand Raphael without knowing Perugino's art; thus Perugino must be considered even though

his art—competent and charming as it may be—does not make the grade on its own merits. Hans Hofmann is an important teacher of Abstract Expressionism whose work fails to meet the major criteria. Zeuxis is included on reputation alone as none of his paintings are extant but he was considered the greatest of ancient painters and emulated in his era. He is one of the few art-less artists in the canon, included not because of his identity but because of his reputed achievement. Regardless of his material contribution, it is his contribution as an example that makes him important. This is the case of much art described by Pliny which no longer survives.

Man Proposes, the Canon Disposes

There is something unusual about the way the fine-art canon operates, which may not have been remarked on before. Every artist who is—or has been—in the canon rises once and remains or sinks but he/she never rises for a second time. Although art goes through phases of popularity, the point of the canon is that it is robustly impervious to fashion. I cannot think of an example where an artist we regard as canonical has ever dropped out of the canon and later returned to the canon as significant as he/she was before. This is not a matter of fluctuating popularity but one of absolute neglect—a time when an artist was no longer taught or mentioned in general texts, only for that artist to be resurrected. It seems that once history has downgraded an artist gravely, it is a permanent change. I have never read this observation elsewhere.

During his lifetime Anton Raphael Mengs (1728–79) was considered a genius comparable to Raphael. His paintings displayed great skill; his life drawings are excellent. His place in history seemed assured yet Mengs disappeared from the canon quickly and is hardly more than a footnote in art histories. Viewers found Mengs' good qualities in other artists and nothing great or original to distinguish his art. Technical brilliance is no meal ticket to Parnassus.

Consider the case of Bernard Buffet (1928–99). In France, Buffet was the most lauded painter to mature in the immediate post-war period. He was very successful in Japan, where a Buffet museum was founded. For several decades Buffet was hugely famous, fabulously rich and perhaps the worst ever painter to be considered great. His work is as crude, ugly, bombastic, modish and shallow as anything that has been shown on museum walls. He was at most a purveyor of faddish 1950s magazine illustrations. Yet despite prizes and critical acclaim, by the time of his death Buffet was utterly forgotten; more than half of younger readers will never have heard his name let alone seen a Buffet painting in person.

The canon makes short work of poseurs such as Buffet and the technically gifted but banal, such as Mengs. So, if you despair of the artists of today who are promoted as living links to the canon, fear not.

Modernism and the Canon

Traditionalists beware: the canon is not a sword of truth which makes aesthetic distinctions and slays the dragon of Modernist art. There is no objective aesthetic standard which applies to all art in the canon. Even if we set aside Modernism, in aesthetic terms the canon ranges from the schematic (Byzantine), symbolic (cave painting), semi-abstract (Cycladic) and decorative/abstract (Celtic manuscripts) to the naïve (Fontainebleau school), idealistic (Michelangelo) and realistic (Caravaggio). There is no plastic or stylistic criterion for entry to the canon. Modernist art cannot be excluded from the canon; it has already entered it. The only aesthetic criterion is excellence within a defined field.

Poussin is in the canon partly because he is the greatest exponent of Classicism in painting, not because his paintings of —say—figures are better than those by his colleagues. In pure terms of accuracy, other Classical artists painted more persuasive figures than Poussin, but excellence in naturalistic depiction is no canonical criterion for any art other than an

example of naturalism or realism. Botticelli disregards naturalistic accuracy but is an ideal exponent of Italian High Renaissance painting, a school which is credited with advancing the creed of increased (though limited) verisimilitude.[84]

Those who state "Raphael is part of the canon; in aesthetic terms, Pollock cannot be compared to Raphael; therefore Pollock cannot be part of the canon" are in error. Consider the rules of the canon. Raphael and Pollock are comparable in that they are both great exponents of their schools; their art is artistically influential, culturally important, original and typical examples of art of their period and place. In strictly canonical terms, Raphael is closer to Pollock than to Raphael's own assistant Gianfrancesco Penni. Reverse engineering what the canon is, in order to exclude art one does not like, is dishonest. Consider: the canon exists as a collective enterprise regardless of any individual's personal taste. One can dislike Pollock; one can argue against his art; one cannot exclude Pollock from the canon *ex cathedra*. One can propose and advocate for additions or subtractions regarding the canon but propositions will be decided upon collectively over a lengthy historical period.

Bear in mind that the canon is not necessarily the best art ever produced. It is a collection of the best art that is commonly known and which it is vital (or useful) to be known by artists, scholars, art lovers and those more broadly interested in visual culture. The fact that you might have the world's most beautiful painting hidden in your attic does not invalidate the canon because the canon is a collective body of knowledge which is comparative, commonly understood, widely accessible and not entirely based on aesthetic worth. There are plenty of beautiful works which are not canonical and plenty of canonical works which are not beautiful. It is possible for ugly art to enter the canon, as there is no canon criterion for beauty. If an ugly work of art meets the criteria for inclusion then it can be included. I would propose Asger Jorn's more shocking "disfigurations" —

defacements of junkshop pictures — as examples of profoundly ugly art which has already entered the canon.

Counter-intuitive as it seems, it is a fact that no aesthetic criteria will fit the canon. Therefore, though aesthetic criteria are crucial to our judgment of art, aesthetic rules cannot generate a canon. Consider the cases of Mengs and thousands of gifted academicians whose art is tediously accurate and which will never supplant the wonky anatomies of Delacroix and Goya. In the article "New Order" (here "On Quota Programming") I suggested that viewers, curators and museum directors should continue the traditional approach of selecting and judging work on the bases of primarily aesthetic quality and secondarily historical value. This is not in conflict with the canon. Art appreciation is a personal matter which we practise every day; the canon is a collective endeavour which no individual (or single national or professional body) can arbitrate.

Excellence within any field is a sort of Darwinian fitness for purpose, an evolutionary process of absorption and rejection. Whatever is in the canon is suitable for inclusion, unless something comparable already holds that position in the canon. Inertia tends to win out when two roughly equivalent works are eligible — the better known piece takes priority.

Masterpieces and Blind Spots

Due to the way art is looked at and discussed, there is a tendency to highlight masterpieces. This is because masterpieces are usually influential, widely known and typical of an artist's overall achievement. They provide common reference points. The human memory has a limited capacity and books have limited pages, so (for the non-specialist) Cimabue's *Crucifixion* serves to stand for his whole output. However, the canon can select works which are atypical. Meret Oppenheim's *Fur Teacup* (1936) is an iconic work of Surrealism and is celebrated as such. It far surpasses the quality of all her other work. (Trust me. I've slogged through the monographs.) In that

respect *Fur Teacup* is actually atypical of Oppenheim's art, being so much better than her other work. The canon, being efficient as it is, has pared down her entire output to the only good thing she made. Likewise, Richard Oelze's masterpiece *Expectation* (1935–6) is the only work of his that is worth giving time to. The canon recognises masterpieces by journeyman artists.

Consider the converse. The canon also admits bodies of works when no masterpiece exists. Paul Klee is an established figure in the canon, but there is no single painting, or even handful of paintings, which sums up Klee's achievements. In Klee's case any typical painting serves as an introduction to the diffuse body of works.

The canon does have weaknesses, mainly due to its didactic aspect. It presents a story of progression. There are marginal cases of artists who do not fit easily into eras or schools. The canon tends to overlook remarkable outsiders. Balthus springs to mind. I would say Balthus deserves to be in a canon of Twentieth Century painting on merit but he could justifiably be left out as being "unnecessary" to explain any era or movement. William Blake and Stanley Spencer are only relevant to the story of British art and can be completely omitted from an overview of Western art of their times.

As the canon is necessarily summary, it can only deal with certain salient points of an important artist's output. This tends to be the most famous and earliest mature work—what made the artist's name during his/her lifetime, generally—to the detriment of the later work. This is not always the case (consider the attention given to the late work of Rembrandt, Titian and Monet) but it tends to be true.

Another weakness of the canon is it has historically under-valued secular subjects, such as the still-life, landscape and marine. Grand subjects often overwhelm intimate reflection in the hierarchy of genres. Generally, dramatic work catches the eye and stays in the memory the way less assertive work does not. A final series of weaknesses concerns the hierarchy of

mediums. Since the rise of the reproduction print and photographic illustration, sculpture has been forced to the margins while painting has taken centre stage. Likewise, while separate canons for printmaking, watercolour and drawing have developed, they are generally viewed as subsidiary to painting and find only marginal places in general histories of art.

Another weakness is not of the canon but of human limitations. We have a finite capacity for memory and attention. As new art is added, so minor figures of earlier eras drift into obscurity. Luca della Robbia and Pisanello are not today regarded any less but certainly less often.

There is a fundamental drawback to the canonical view of art in that it prioritises stylistic matters over thematic or intellectual concerns, largely because we judge art visually and comparatively. We have a tendency to simplify and construct narratives which seem plausible when retrospectively applied to very complex situations. Such summaries exclude many factors that become clear once one examines the socioeconomic context of production and the personal testimony of the artist, patrons and associates. The answer to this point is that the canon is a guide. It cannot be all-inclusive, it cannot include every work of interest and accomplishment and it cannot cover every element which influenced the production of a work of art. A good writer will acknowledge this in his/her survey. That qualification does not devalue the use of canonical summaries of art, for any narrative does not class excluded work as worthless or bad art. The canon is only a summary of essential highlights arranged in a comprehensible form, just as a school textbook on physics will gloss Newtonian and Einsteinian physics without dwelling on matters of quantum physics and more complex theories.

The validity of the concept of incremental progress in the development of art (as well as other fields) is a matter too broad for this essay.

Post-Modernists and the Canon

Post-Modernists loathe the canon for its specific qualities and its existence.[85] The canon accretes slowly and selectively; it cannot be changed for political reasons and it cannot be legislated upon. The fact it does offer recognition for the work of women/minority artists makes the canon even more hateful to Identarians. It is too slow and selective to comply with social-justice-activist demands that women/minorities be elevated en masse immediately and accepted universally. Identarianism is essentially authoritarian in character. The canon compels no one to like or respect art. The canon rewards accomplishment not identity and — in Identarian eyes — effectively "bribes" women/minority artists by offering recognition to any artist who accepts the status quo and who makes art worthy of the canon. Identarian opposition to the status quo precludes participation in any such system such as the canon which rewards application, patience, excellence and individuality; Identarians prioritise conformity, victimhood, impatience, birth rights and the right to demand instant change and exercise totalitarian control. The very existence of the canon is repugnant to Identarians, who feel it actively impedes social justice.

Feminists and Post-Modernists oppose the canon because so much within it explicitly or implicitly contradicts their suppositions: that women are as equally endowed with creative capacities as men are; that Western civilisation is uniquely cruel and destructive; that European culture is narrow and inhumane; that the values and freedoms of the West give rise to great art and allow individuals to flourish; that inequality can lead to great work which benefits mankind as a whole; that expressions of sexual desire within art can be ennobling and enlightening. When faced with such a weight of great achievements and overwhelming evidence, the only alternative is to destroy it through strategic argumentation against the validity of any canon. As individual achievements cannot be gainsaid,

the idea of achievement itself must be undermined. The very existence of a hierarchy is unendurably hateful.

There is no need to force women into the canon because the canon absorbs great art regardless of the artist's identity. One cannot write of twentieth century portraiture or the legacy of Symbolism without mentioning Frida Kahlo, likewise with abstract sculpture and Barbara Hepworth. Any discussion of Realism in British art must discuss Gwen John. There are many other examples. Berlinde de Bruyckere is the most original and powerful sculptor of the figure since Giacometti and it would be surprising if her art did not find her way into the canon. I suspect Jean-Michel Basquiat is also canon-bound. Traditional-ists dislike the speed with which art accretes to the canon and it offends them to see non-traditional schools appended to the Golden Age of (insert preferred artist/school/era here). Traditionalists should propose recent makers of great art and await history's verdict. The canon may discard all recent art and record a fallow period, as it has done for whole countries and eras.

Post-Modernists too reject accretion to the canon. For them the accretion is too slow. They have two views on the canon — that it must be abolished or rewritten. Neither of these authoritarian tendencies can be achieved in a permanent form. Abolition is impossible because people have a natural tendency to form groups, celebrate exceptional excellence and class things in terms of quality and thereby reach group consensus. Rewriting is impossible because no one group can dictate the canon and — as we have seen with political appointees such as Socialist Realist and national socialist artists — the canon rejects bad art.

Post-Modernists hate the canon partly because they do not believe in agreement reached by consensus. They do not believe that art progresses or that a narrative (other than a socio-economic one) can be drawn from art history. Post-Modernists contend that the idea that multiple groups and

individuals over eras can reach agreement is an illusion which conceals collusion, oppression and exclusion.

So, if abolition and rewriting are impossible, why now write an article addressing Post-Modernist attitudes towards the canon? Firstly, art-history students are suffering because they are not being taught the canon in a thorough way, thus limiting their understanding. The canon is an invaluable roadmap to understanding and memorising achievement in the visual arts. Even to oppose the canon you must at least know it. Secondly, we all suffer when political activists manipulate education and curation of art. Thirdly, elevation to the canon is a prize to be striven for and fame has inspired plenty of artists to perform to their best. As viewers of new art, we do not benefit from the canon's suppression. Fourthly, such symbolic changes, even ineffectual ones against weak opponents — and there are no weaker opponents than the dead — encourage further encroachment not just in the arts but in all areas of life.

Lastly, if traditionalists and moderates wish to oppose Post-Modernism effectively they should examine what the canon really is before they invoke it. If you support the canon you must acknowledge it as a whole, accepting that its totality will include schools and artists you dislike. You must accept it will accrete new art. As I have previously written, traditionalists who battle both Post-Modernism and Modernism will drive away Modernists and moderates, who are their natural allies in opposing Post-Modernism. Traditionalists, Modernists and moderates today all have common cause against Post-Modernist authoritarianism, quota programming and identity politics. They have differing tastes but their principles largely overlap.

In the past many Marxists agitated against the canon whilst covertly enjoying its art. They understood that dissidents savour the moral superiority of principled protest while enjoying the fruits of the system they ostensibly oppose. What is different now is that new left agitators are in positions of

power unopposed by conservatives or connoisseurs within institutions or the political class. They can alter curricula, refuse to fund research, decline grant applications, publish propaganda as art theory and take down pictures in museums; they are in a position to actually suppress and — in the case of historic statues — destroy.

The canon is nothing less than a manifestation of our civilisation. To learn from and contribute to the canon (as writers, makers and art lovers) is to contribute to civilisation and is to affirm our belief in collective wisdom, consensus and progress, regardless of our personal taste in art.

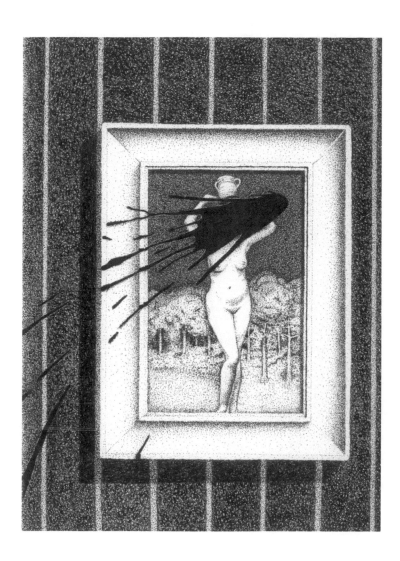

On Reparations

The essay will discuss reparations. The definitions of "restitution" and "reparations" used in this essay are as follows: restitution is the return of specific unlawfully acquired goods to the lawfully determined owner or descendants (or estate) thereof; reparations are the return of goods or payment of compensation by one state to another, punitive in basis, regardless of how legal the acquisition was. I do believe in the correctness of restitution of property stolen in the recent past and for which there is a provable provenance. Likewise, objects illegally acquired by looting or illegal excavation must be returned to the country of origin if there is some certainty about the point of origin, when the acquisition is recent. However, this essay will argue against reparations on the grounds of cultural inequity.[86] Items assigned new owners will not be called "returned" because (as discussed below) many of them will not be going back to rightful beneficiaries; these items will be described as "reparated". Advocates will be called "reparationists".

Recent disputes — and those which would emerge *en masse* if repatriation of artefacts were to become widespread — are closer to reparation rather than restitution, as the exact legality of the original acquisition is considered largely irrelevant by the claimants and campaigners, so this essay dwells of reparation. Additionally, restitution is widely accepted in legal and social terms and though there are fringe cases that are contentious, the principle seems just. The case for reparations is quite the contrary. This essay will not touch upon monetary reparations for historical matters. Many of the arguments below apply in some form to that subject.

Moral Victories Over the Dead

In November 2017, President Macron of France announced the return of artefacts from French public collection to Burkina Faso. This was lauded in an article titled "The Restitution Revolution Begins".[87] Note the triumphant activist tenor of the author, a professor of art history in Paris and Berlin universities.

There are some apparently reasonable grounds in favour of reparations: some cultural goods and human remains were taken from a people or territory without consent of the occupants; some artefacts were bought under duress or without fair compensation; and some artefacts were grievous losses to the communities which prized them for symbolic or religious reasons. There is a related subject of importance. The willingness of market regulators to accept the acquisition of antiquities by collectors is a stimulant for the trade in illegally sourced objects, exacerbating the practice of site plundering and theft from museums in source nations.[88] This latter issue relates more to objects which can fairly be restituted rather than reparated.

The claims for reparations are made by aggrieved groups, foreign states and anti-colonialists, especially leftists. The motivations are not as straightforward as they seem. It is not merely that artefact X is important to a non-Western culture and unfairly gained. For example (as we shall see below), the artefact is often not important to the claimant and was not gained unfairly. We must understand that reparations are symbolic victories over long-gone colonists, states and social attitudes by activists seeking emotional gratification. Specificities undermine the idea that any particular act of reparation is clear and just because the truth (legal and factual) is murky and not always in favour of the claimant. The truth does not matter to reparationists because reparation is a moral contest between today and yesterday. Each act of reparation is an act of courageous revenge upon an opponent that is dead

and mute. As long as we understand this, we can comprehend why the drawbacks of reparations do not deflect reparationists. Reparations are a form of retroactive historical justice. Another example is the recent mass pardoning of soldiers from the Great War executed for desertion.[89] It is reasonable to criticise the executions and wish that psychiatric medicine had been more advanced than it was. It is unreasonable to presume to apply standards of our era to actions of a long-past era. We assume that we would have acted differently in their place and that we can judge on a subject of which we know little set in a time of which we know less. Retroactive justice is founded upon monstrous hubris and vast ignorance. Retroactive justice is indicative of overweening vanity and a dearth of self-knowledge. The way to address previous perceived injustices that are beyond the reach of current legal resolution is to conduct our lives and shape our laws to prevent future injustices.

The dwelling upon historical injustice is one of the core tenets of ideological extremists who loathe the status quo.[90] Reparationists fixate upon symbolic repatriation of objects because it looks easy. Reparations derive from the concept of collectivist justice detached from any specific transaction. As Thomas Sowell writes, "Only where both wrongs and compensation are viewed as collectivized and inheritable does redressing the wrongs of history have a moral, or even logical, basis."[91] As we will see, reparations are as entangled, intractable and impossible to resolve as any aspect of historical justice.

Deaccessioning Leads to Reparations

In *Deaccessioning and Its Discontents: A Critical History*,[92] author Martin Gammon makes the case for deaccessioning as a financial necessity for museums.[93] One of the principle problems with deaccessioning is that it will breach the golden rule that museums do not deaccession items, something almost universally observed by British museums. If it becomes possible and increasingly common for museums to deaccession, we

would see an immediate intensification of claims upon non-Western artefacts in Western museums. If museums can give up items for financial reasons then they should give up items to rectify cultural imbalance, anti-colonialists will argue. There is no easy explanation to counter this, if reparations seem just. The pressure of anti-colonialist activists will increase against administrators and politicians who do not seem confident in the value of the Western civilisation. Presidents such as Macron will give away artefacts for a favourable headline. Politicians could hardly be bought more cheaply.

Consider if deaccessioning were to take place on a financial basis. There would be a clear incentive for individuals who are sympathetic to reparations to influence or control the selection of items for deaccessioning. There will be pressure for museums to offer items to associated foreign states or museums at artificially low rates so that they may reclaim their heritage. This is a form of subsidised reparation, supplementary to the process of absolute reparations conducted without recompense.

Deaccessioning would allow social activists to dispose of art they think should not be owned by public institutions: some non-Western historical objects (including human remains), nudes, hunting art, art donated by slave owners and a dozen other categories. If you think this is an exaggeration, consider what is commonly discussed in universities to glimpse the mindset of the next generation of curators and museum directors. For example, here is an abstract of a published paper from 2012:

> Anarchist and militant forms of social movement research serve as a starting point for theorizing ethically oriented and embedded social movement research, and theoretical connections with Gramsci's notion of the organic intellectual are set out. These positions are brought into conversation with an anti-colonial paradigm that recognizes colonialism as a continuing process of imposed and dominating relationships that needs to be both critiqued and

resisted in theoretical and activist spaces. This makes it possible to articulate an ethical conception of (militant) activist research with an anti-colonial orientation.[94]

Does any reader think that if such individuals had power in an era when deaccessioning were possible that they would not enact extensive reparations?

Gradations of Duress

If reparations are not to be arbitrary, there must be an effort to judge the legality of acquisition. A core tenet of reparationists is that any transaction between colonial power and subject is inherently unequal. According to a Marxist analysis, there is a fundamental disparity in power between coloniser and colonised; resultant economic systems are weighted in favour of colonisers. To the anti-colonialist, the system of empire is coercive and therefore the basis of colonisation is illegitimate. Thus any transaction which has legal sanction is not just unfairly weighted through its institutional, legal and economic disparities, it is actually illegal. This is not a position derived from actual analyses of situations but a goal-determined attack on colonialism. It is post hoc justification for an emotional position and is not a legal assessment.

Which law applies? Which jurisdiction applies? We enter the terrain of weighing up the legitimacy of societies of very different characters. Western colonisation was only one stage in a series of invasions. Colonies previously enslaved neighbouring territories and confiscated chattels. Anti-colonialists frequently overlook the invasion and colonisation by non-Western powers such as the Han, Mongols, Moors, Ottoman and so forth. Many of the items acquired from colonies were booty of that colony's own colonial imperialism. Anti-colonialism as an ideology (as we know it in the West) is not actually anti-colonialism; it is an analogue to Marxist anti-Western anti-capitalism.

If unfavourable trading situations, restrictions resulting from artificial exchange rates, proscriptive property laws and a number of other examples of disparity in trade law delegitimise transactions then almost every historical transaction becomes suspect, regardless of colonialism. How can we assess the correctness of a valuation or exchange rate in a distant historical period? We might consider the trading of a totem pole for a couple of axe heads to be unfair, yet the tribe may have considered the transaction very favourable to them. Perhaps the tribe took pride in having something of theirs taken to a foreign land to be venerated. Totem poles were traditionally left to decay to nothing. The only 19th-century totem poles in existence are those that were acquired by colonists, who preserved them from erosion. Who are we to speak on behalf of those other groups? Is that not simply another form of colonial presumptuousness? Likewise, what legitimacy do claimants today have to speak on behalf of the dead? Reparations will lead to claimants portraying fair acquisitions as cultural theft in order to gain material advantage.

The preceding discussion does not even touch on the thorny issue of the commodification and commercialisation of cultural heritage.[95] The issue is not a clear one. The obvious thoughts are that Western acquisitiveness and empirical attitudes see all cultural products as a collection of objects that can be detached from context, examined, classified, collected and traded. Yet also consider the massive commercial incentive that local peoples have to exploit what they see as a natural resource, no different to coal, metal ore, fisheries and so forth. Locals are often indifferent towards relics of a culture of which they know nothing and of which they care less. Attitudes within societies varied as they do in our own today. The builders of Egyptian tombs were also their robbers. Members of tribes would willingly deface sites and steal objects sacred to a neighbouring tribe. The idea of the existence of a uniform attitude towards cultural property among any sizeable group, and that such

attitude would be transmitted unchanged to distant descendants, is fallaciously simplistic. Often acquisition by outsiders preserved objects from destruction or simple erosion. Indeed, present local cultures are often hostile towards the culture and religions of former inhabitants of their land. How often have we seen Western archaeologists warn that modern inhabitants are destroying historical sites? Western campaigners project their own sentimentality and values on to peoples with very different attitudes. When it comes to dealing with non-Westerners making claims for reparations, Westerners are hamstrung by a fear of perceived racism, a fear which prevents them from acknowledging examples of fraudulent and duplicitous behaviour by non-Western claimants, who can be every bit as cynical and greedy as Westerners.

Gradations of duress are essentially arbitrary. The lines we draw accord to our political outlooks and practical goals rather than being determined by ethical principles or legal precedent.

Reparations are Arbitrary Justice

One of the core tenets of reparations is that the original owner of the object should have the benefits of ownership. How is that to be determined when the society, state or people have undergone radical change, been divided or disappeared? The recipient people or state may not be the same. There may be rival claimants. Reparation may not correct injustice but only vary the injustice because justice — in any meaningful sense — may be impossible.

Consider the fictional case of a French archaeologist who took a Celtic brooch from a barrow while on holiday in Ireland in 1910. The brooch was offered (without any provenance given) to a regional French museum, which accepted it. Should the brooch belong to the French museum or to the Republic of Ireland? Well, the latter surely. But Ireland was at that time territory of Great Britain, so perhaps it should go to London. Then the descendants of the land owners file a counter claim for the brooch. And so on. Reparations are a lawyers' paradise

and litigants' hell. Justice and law are different fields, not always congruent.

Consider the fictional case of a stone lion in the British Museum. It was commissioned by a Hittite tyrant. He conquered a neighbouring tribe and used their treasure to pay for the carving of sculptures to commemorate his victory. The lion sculpture was lost then later unearthed by the Greeks and taken to Byzantium. Byzantium was conquered by the Ottomans. In the late 18th century an English duke purchased the lion illegally from an official at the museum in Istanbul. The lion was taken to the duke's estate in England and eventually donated by his descendants to the British Museum. To whom does this lion rightfully belong? The British Museum, the museum in Istanbul, the regional government of Anatolia, the Greek state, the descendants of the Hittite king or the descendants of the defeated tribe? Exactly how far back is this moral accounting to go? One suspects it will go back only as far as is convenient. In other words, the beneficiary will ultimately be arbitrary. At this point, any assertion that reparations are moral recompense for the benefit of wronged parties becomes the obvious absurdity it always was. In retrospect, justice of our age will be understood as limited and self-serving as that of past ages.

Reparations Fuel Corruption

Any reparated objects would become the inalienable property of states or museums, which could legally sell the artefacts. This undermines the idea that reparations mean the returning of objects to the societies that previously owned them. Reparations might not lead to people of the recipient state having access to reparated artefacts. The people might not even benefit from proceeds of the sale of reparated artefacts. Many former colonies in the developing world have a serious problem with corruption. That is not to assert that corruption is not present in Western countries but it is widely disapproved of and legislated against here. Government ministers and museum

directors in the West cannot legally personally benefit in material fashion from sale of items in public ownership. Reparations are considered ethical but they would fund the unethical practices such as corruption. The effects of reparations would be to swell the bank accounts of dictators, support police states and fund covert wars. Reparations would deepen rather than alleviate the problems of recipient countries. Reparations allows reparationists to salve their consciences and allows dictators of former colonies to enrich themselves, while their people get nothing and centres of learning lose the core of their scholarship. The argument is not that we have a duty to interfere within any other state but that we have to consider the ethical consequences of reparations.

Reparations are Ineffective

Reparations will never be enough, because emotional hurt will be sustained for political advantage. Every political ideology has its own simplified narrative, with villains, heroes and shared aims. Reparations will feed into those narratives and artefacts will become cultural prizes, like flags to be captured in a board game. Rather than healing divisions, reparations will lead to endless struggle nurtured by politicians and activists.

Reparations will incentivise misrepresentation of history in order to win prizes. Rival states will compete for reparation of the same object, claiming to represent the descendants of the colonial territory. Museums and scholars will distort facts in order to support legal cases. Courts will have to decide between multiple interpretations of disputed research. States will divvy up spoils in bargaining processes divorced from notional justice. Far from rectifying injustice, reparations will multiply injustices. The squalor and inequity of reparations will match the ignominy of colonial acquisition.

Reparations will fuel social activism in the culture wars. In an age when many curators have little faith in the importance of their institutions and the value of Western civilisation, who will resist social pressure with rational and principled

argument? People on social media will swarm from one petition to another, seeking to strike against bastions of imperialism and restore artefacts to ancient noble societies. In reality, it is the gamification of cultural policy masquerading as justice. Individuals will click on a button to receive a jot of satisfaction, follow their nomination, gain pleasure when their nomination is reparated or experience indignation when their nomination is rejected, all the time not understanding anything of the history of—or fate of—the object. These people are not campaigners for justice; they are mice in a maze following a trail of micro-rewards.

The effect of reparations will be an endless series of one-sentence summaries of colonial history bandied around by ill-informed opinionated individuals within an apathetic population, weakly opposed by demoralised historians. The truth and complexity of history is irrelevant in a superficial popularity contest. The actual fate of artefacts—possibly to be sold to enrich corrupt officials or fund a dictator's cronies—is not something to be dwelt on. Artefacts become tokens on a board.

Welfare of Artefacts & Scholarship

The reason many Chinese visitors come to the British Museum is because much of China's history was liquidated in the Cultural Revolution. Europe and North America have been relatively safe for portable treasures. Western museums are determined to protect and research artefacts from all cultures. We do not make a habit of destroying, suppressing or deaccessioning artefacts—at least while Identarians are kept at bay. This is not the case in societies where deeply entrenched enmities and political issues lead to the destruction of objects and the distortion of science by the parties which have custodianship of artefacts.

Centres of learning have developed, typified by the university museum, where students and scholars can develop knowledge through direct contact with artefacts and devise new scientific processes which allow conservation and non-

invasive analysis. This means that objects are cared for nowhere better than in Western museums, extending their existence and benefiting civilisation at large. Imagine a great numismatic collection which allows comparative analysis that brings to light influence of culture through conquest and trading. Then imagine that being broken up, with coins being returned to states roughly approximate to the geographic sites of manufacture. The loss is not so much to the museum or the specialists but all of us. Through the transfer of ownership the train of knowledge is broken. We lose the insights that derive from centres of learning which further the science through incremental yearly research. Western institutions make research available through publication and internet access. They are also easy to access through transport networks, with institutions readily making artefacts accessible to visiting researchers in a way that more political regimes do not. Western institutions make world culture accessible to the world's population.

Consider the conservation of items. Should a reparated artefact be given to a state enduring civil discord? What about the case of an artefact to be returned to Saudi Arabia? In Saudi Arabia, the dominant Wahhabi sect has destroyed many historical buildings connected to the life of Mohammed because of the potential idolatrous veneration of important earthly objects. If a reparation judgment assigned an artefact to an owner which we could expect to destroy that object, would the current holder be obliged to send that artefact to its destruction? That is an extreme case, but what about those countries that engage in harmful practices such as the over-painting or destructive alteration of artefacts to restore them? (The issue of our own museums engaging in such practices is ably scrutinised by the ArtWatch organisation.) What about those museums in developing countries which are not able to sufficiently protect items by using dehumidifiers, dim lighting and anti-pest measures? In many cases, if the welfare of

artefacts is the priority then Western museums are the safest places for them to reside.

In some cases, the act of relocation is hazardous. Some items are so delicate that to move them would cause damage. We have multiple examples of damage to even robust items moved by professional couriers using modern techniques between Western institutions.

Conclusion

To summarise the case against reparations: objects are safest and most accessible in Western museums; objects are best analysed by Western institutions; reparations will unfairly benefit many recipients; reparations will fuel politicking, sectarian division, international disputes, corruption and theft; reparated objects will not necessarily benefit the countries or populations they are given to; the implementation of reparations will damage objects; once started, reparations is a process that will be continuous and expensive, with irreversible results; any reparation process will be impossible to administer fairly and will be subject to counter litigation; reparations will not provide satisfaction.

Reparation is a process which implies that property—and by extension, the experience of appreciating that property and interacting with its culture of origin—is under the control of a national, sectarian or tribal group which has a claim to authority over that property in perpetuity. This entrenches the Identarian position—that experiences of peoples are discrete and that humanity is a divided population.

While my previous arguments against Identarian positions of quota programming, suppression of free speech and so forth have had strong and explicable ethical foundations, this argument against reparation relies on pragmatism. It rests on the basis that reparations are impractical, unworkable and unfair rather than unethical *per se*. Again, like tacit support for "diverse representation" and "affirmative action", the case for reparations is an extreme position supported by well-meaning

moderate people who have not thought through the implications. How can diverse representation be an "extreme position"? The extreme position of identity politics is that people should be classified by surface characteristics and treated collectively rather than judged on personal merit. The underlying idea is dehumanising. The extreme position of reparations is that history should be retroactively engineered to provide us with emotional gratification. The underlying idea is repugnant.

People who are in favour of the concept of reparations should consider if these are the principles deserving of their support.

On Identity Politics

This essay discusses the moral basis of identity politics and the narratives that are developed to explain the rationale for its principles. The following essay explains how these principles are applied in practice to cultural production.

The Perfectibility of Mankind

Jean-Jacques Rousseau formulated the concept that mankind's nature was to exist in an uncorrupted state of grace in a condition of pre-moral freedom, with individuals acting voluntarily in mutual co-operation. It was the ownership of property and the resultant need — enforced at first by the tyrant leader and later the government — that would perpetuate need and suffering, putting the free man in chains. Rousseau sees society as contrary to natural liberty.[96] It was this idea that Karl Marx attempted to prove with his analysis of capital. Both Rousseau and Marx considered man fundamentally equal and capable of happiness but made unhappy by society and deprived of basic necessities.[97] Society perpetuated this through inheritance and the maintenance of the family unit. If society could be altered to restore that natural balance then natural justice would be achieved.[98] However, to achieve the reforms necessary, Marx foresaw that collectivist action would be required. The aim of the abolition of the state would effectively occur with communism, the end point of a progression through stages of feudalism, capitalism and revolution (including tyranny) followed by socialism. Communism is the point when the plenitude of goods and services achieved through the maximisation of production, worker control of production, absence of inequality through the lack of private property, equality of individual power and worldwide peace between nations of workers in class solidarity render statehood

non-existent. Marx saw communism as a stateless society fulfilling man's potential in a setting which has had all inequality of property and power abolished.

Rousseau and Marx see the poverty of man both as an unnatural state and as a moral question to which a solution is both possible and necessary. All men are considered naturally equal. This contrasts to the liberal position of the English Enlightenment, which does not assume equality of man, but that equality of rights should be assigned to man. The rights include freedoms of association in religion and speech, to private property, civil and political rights, freedom from slavery and so forth. Marxist solutions to the "problem of inequality" require collective action, the curbing of free speech and association, the abolition of private property and inheritance, centralisation of communication, resettlement of populations and other means.[99] This places the Marxist as collective and authoritarian, in opposition to the liberal as individualistic and anti-authoritarian.

Marxism is presented as a compassionate alternative to inequity and inequality. It allows the supporter to view himself as the champion of the underdog.[100] If poverty is a moral problem then a leftist makes himself a moral agent by purporting to act to "solve poverty" by redistributing wealth. (Ultimately, in the state of communism, redistribution of wealth will become redundant because of the plenitude of goods. Wealth itself will cease to have meaning because there will be sufficient for all.) The person who rejects Marxism can be criticised as callous, even though a non-Marxist programme may benefit more people or make the economy more prosperous overall. Capitalism has been far more effective at alleviating poverty than socialism, yet capitalism is more frequently portrayed as heartless, degrading and unfair. What counts for many is not the effect of the programme but the emotional satisfaction of supporting that programme, especially for those individuals who pride themselves on acting morally and presuming to know what will benefit others.

Dialectical materialism massively simplifies complex systems. The motivation for Marxists to use simplified analysis is because they are goal-orientated. They intend to justify social structures that are geared towards equality and collectivism; clear results of simplified theories applied to complex systems are used to provide justification for these goals. Only in the late 1950s — when it became clear that capitalism provided even working people with subsistence level necessities — did Marxists change the goal from providing for the needs of the proletariat to outright equality. No longer is need the benchmark of a fair society, it is equality.

The left's understanding of society is essentially flawed by its presumption that equality is both natural and desirable. Human existence depends on genetic disparity which generates robust diversity through sexual reproduction. Favourable minor variations have a greater chance of survival and reproduction; unfavourable ones the reverse. These variations are minor at a population level but in individual terms the disparities are clearly noticeable in terms of physical and cognitive ability. Disparity is not only natural, it is necessary for the existence of all species dependent upon sexual reproduction. Nothing could be more unnatural to humanity than equality.

If you believe humanity is perfectible and see society as unequal and unjust then the status quo is immoral and unsupportable. There is a moral duty to act and those who prevent you from acting are immoral (or at least amoral).

Left/Right or Liberal/Collectivist?

It is common to see individuals switching allegiance between the far left, far right, libertarianism[101] and anarchism. This also happens with individuals raised in very strict religious conditions, who convert to other religions or to strong anti-theism. Why should this be? Is it that individuals have travelled great distances along the left–right political spectrum

that we assume exists or are there better ways to understand these changes?

In these cases, individuals crave the certainty of any strongly defined assertive position rather than face the ambiguity and uncertainty of agnosticism or simple indifference. The character of these absolutist political and religious positions is consistent although the aims, means and terminology of the dogmas differ. It is the certainty offered by dogmatism rather than any doctrinal tenet of a dogma that fulfils a psychological need of an individual. The existence of the framework is more important than anything supported by the framework. This allows us to see that individuals have not actually travelled far between positions. The individual transfers allegiance from one type of absolutist position to another as an indication of how he values strength of conviction and belonging to a community of shared values. The actual doctrinal differences between religions or political movements are almost irrelevant.

Although we have been discussing matters in terms of a left–right political axis, perhaps it is better to understand matters in terms of an individualist–collectivist psycho-social axis.

Fascism and socialism share many points of commonality. Fascist and socialist states are collectivist, anti-individualist, authoritarian, militaristic, utopian, anti-democratic and opposed to free speech. They scapegoat internal groups (the Jew and communist for the Nazi; the kulak and capital class for the Soviet socialist) and external parties (foreign socialist countries for the Nazi; capitalist imperialists for the Soviet socialist). They seek to exert a rational and standardised model over all aspects of public life, to be determined by scientists and implemented by teams of technocrats. They seek to extend influence over other states via revolution and colonization.[102] They favour centrally planned economies, with strategic industries under national control. They seek full employment as an economic goal. They regulate leisure along educationally

and economically useful lines through ostensibly voluntary organisations such as the Nazi Kraft durch Freude (Strength Through Joy) and Soviet Komsomol (All-Union Leninist Young Communist League). Main differences are policies on pay-and-price control and socialist abolition of private-property rights contrasting with Fascist preservation of private-property rights.[103] The title Nationalsozialistische Deutsche Arbeiterpartei of the Nazi party makes explicit the use of socialism towards overtly nationalistic (rather than inter-national) interests, with the main political focus of internally directed ethnic solidarity rather than externally directed class solidarity. Both systems rely on continual reference to ideals of another age. For the socialist, the reference point is a fictional future paradise of a scientifically organised society; for the Fascist, the reference point is a fictional past paradise of a pure-blooded people living in autonomy.[104] The socialist yearns for the future; the Fascist yearns for the past.

If the individualist–collectivist axis is a better description of the political spectrum, why write in terms of leftist political action?

It has not been an error or an expression of political bias to highlight and criticise actions by leftists, Identarians and feminists in culture in these essays. Collectivism of left and right varieties exists but because of the weakness of the far right in current Western culture, politics and wider society there is simply less of it to criticise if we take culture as our field of study. There is a multitude of movements, groups and indi-viduals of an authoritarian leftist disposition which have influence or control over elements of cultural production and reception. There is little notable cultural production in the West in recent decades that can be described as ultra-nationalist (collectivist far right) culture. Therefore most examples of collectivist politically-motivated interference in culture are leftist ones.

The "leftist" descriptor is used mainly because there is a common understanding of the aims and beliefs of the left and

right, even if those definitions are inaccurate and increasingly unhelpful. Identarians, feminists and racial activists commonly describe themselves as socialist or leftist and are understood that way in general discussion even though it is their authoritarianism that is most operative.

From Standpoint Theory to Justified Violence

When someone of a strong political commitment dismisses opposing views, it is a tactical move that can be demonstrated to be purely strategic, even hypocritical. The Identarian who dismisses opposition draws upon ideas which have roots in German 19th-century philosophy which seem to justify his position.

Standpoint theory originates from Hegel's master-slave dialectic.[105] Hegel stated that differing experiences of power structures (typified in his example by the master and his slave) present partial comprehension of the nature of consciousness. Each is incomplete but the slave understands more because his circumstances dictate he must not only understand his own position but also place himself in his master's position in order to anticipate the master's expectations of the slave's duties. Thus the slave has a broader conception of consciousness (and a greater insight into existence) than the master does because he understands the world through not only his viewpoint but the viewpoint of the master.

While Hegel's standpoint theory was developed to explore the implications of the dialectical approach within a philosophy of consciousness, it has been taken up with alacrity by 20th-century philosophical schools which have often had more literal interpretations and politically driven aims. Leftists wish to equalise power structures by assigning more power to the powerless and removing power from the powerful, using standpoint theory as a philosophical basis. In common terms, standpoint theory is often presented as members of oppressed groups knowing more than oppressing groups and therefore

having a greater understanding of existence. The corollary of that is that the standpoint of the oppressed has more epistemological and political validity. Justice demands the voice of protected classes must be promoted and accepted and the voice of privileged classes be suppressed and discounted. Thus the oppressed have authentic experiences and use speech to protest injustice and the privileged have partial experiences and use speech to impose injustice. Free speech is therefore contingent on the status of the speaker not a universal prerogative. Standpoint theory used to diminish the humanity of opponents. It makes suppression and violence — for violence inevitably follows — easier to do and easier to justify.

The Empathy Deficit

It is a frequent criticism that Identarians are concerned with surface diversity in demographic terms rather than diversity of thought and political outlook, with an observable bias in the preference for causes allied to the left. That is why industrious apolitical Asian-Americans, evangelical conservative blacks, right-leaning wealthy homosexual industrialists and so forth are not championed by Identarians. Within the movement, diversity of demographic traits is used to cover for the exclusion of intellectual dissent. Surface diversity is used to conceal the uniform leftist outlook that is advanced.

Much of Identarianism rests on the strictly unstated premise that Identarians (many of whom are white, middle-class, affluent and university educated) will exert control as authorised protectors of "marginalised" demographic groups. In return, members of these marginalised groups are expected to tolerate Identarian members of "privileged" demographic groups as "good allies" and — to a degree — acquiesce to their leadership. It is an audacious power play. It allows white affluent leftists to play moral arbiters while at the same time signalling submissiveness.

Recent scientific studies of moral psychology show that those individuals inclined towards liberalism have a narrower

moral foundation than individuals who become conservatives. That is, the leftist is very committed to assessment of care/harm and liberty/oppression, less to fairness/cheating and very little to loyalty/betrayal, authority/subversion and sanctity/degradation. The conservative cares as much as the leftist does about liberty/oppression, slightly less about care/harm and fairness/cheating—and also measures them in different ways. The conservative cares about loyalty/betrayal, authority/subversion and sanctity/degradation much more than the leftist does. The leftist often cannot empathise with a conservative, who is convinced of the importance of loyalty, authority and so forth. The leftist actively rejects "these concerns as immoral. Loyalty to a group shrinks the moral circle; it is the basis of racism and exclusion, they say. Authority is oppression. Sanctity is religious mumbo-jumbo whose only function is to suppress female sexuality and justify homophobia".[106]

To a leftist, the moral landscape of the conservative and moderate is incomprehensible because he has no equivalent. He simply cannot recognise moral objects on certain grounds as genuine. They must be cover for bias or even hatred. Thus it is easy for a leftist to dismiss the idea of a broad political spectrum having validity because it looks like accommodation with insincere grievances and invented reasoning. Such atavistic debris is what has prevented genuine fairness and equality that he cherishes so much. Compromise looks like weakness.

Ironically, for a movement which prides itself on empathy, it is individuals on the far left who have measurably less empathy for other viewpoints than moderate or conservative individuals.[107]

Victimhood and Selfhood

The victim narrative is central to identity politics. The victim narrative is that the natural state of man is to be free, content and equal. As Rousseau outlined, private property rights

established restriction, discontent and inequality, enforced by society. People born into inequality and poverty are victims of society. The failure of individuals is not due to individual circumstances, chance or agency but is caused by the power structures of society. The improvement of the conditions of these victims could not be effected on an individual basis but on a collective basis.

Once the victim narrative has been internalised by a subject, it can be called upon to explain all obstacles, setbacks and failure; it excuses incompetence, laziness and failure. The narrative acts as a comfort blanket, reassuring the subject he or she will never be responsible for failure. It protects the person from self-examination and self-criticism, offering instead a warm feeling of self-pity. It stunts the person because he/she expects externally imposed failure and never perceives problems as surmountable, and never comprehends the self as it actually is: an unending project of self-improvement. This creates the expectation of weakness and places the subject's vote in the hands of the politician who reinforces the victim narrative. The subject (who is prey to learned helplessness) and the politician/ activist (who inculcates that helplessness) mesh in a mutually sustained web of destructive self-sustaining dependency. In this worldview, victimhood is an inevitable attribute of individuals born into a system which exerts coercion upon its members and victimhood becomes synonymous with existence.

As soon as there becomes a social, career or financial advantage to being a member of minority group then there will be an incentive to pass oneself off as a member of a protected class. Bisexuals will describe themselves as homosexual or some more exotic type; mixed-race people will identify more as a member of the more protected class (or claim that mixed-race people are a forgotten minority shunned by larger racial groups); individuals will pass themselves as transgender when they are actually transvestite. Already "turf wars" have raged over definitions of groups and who might adjudicate such

questions. When victimhood becomes currency, it will be sought, stolen and traded.

The leftist considers himself as not only protector of the underdog but also an underdog himself. The activist who seeks to highlight injustice and reform society is subject to political repression because he threatens the vested interests of the powerful. He too becomes a victim. Victimhood is central to an activist's selfhood.[108] No matter how many key positions sympathisers hold, no matter how the majority of the media favours them, no matter how socially unacceptable outright bigotry is, the leftist considers himself to be a member of an embattled minority fighting on behalf of other minorities oppressed by a wave of institutionally sanctioned prejudice and the vested interests of the status quo. No amount of evidence about the actual situation will convince the leftist that this is not the situation. It is a moral conviction. Righteousness here is not a matter of being right or doing right but of feeling right. Once we understand that, we can see that evidence is largely irrelevant to the dogmatist.[109]

The leftist sees social justice as the remedy for inequality and poverty. Justice is based on individual acts and personal responsibility and is assessed in terms of the personal rights and responsibilities established in law. Social justice is to do with guilt, privilege and oppression allocated according to group identity. Actions of individuals are irrelevant. Social justice is actually mass injustice. Social justice cannot be anything other than unfair and cruelly arbitrary system of vengeance administered by the virtuous elite towards the goal of moral correction.

How Freedom from Fear
becomes Fear of Freedom

Collectivists distrust the individual. The individual is not the most important component in collectivist philosophy and ethics; additionally, the individual is prone to deviation, which

undermines the consensus demanded by collectivist politics. This comes to fore in discussions on hate speech. Over recent decades, huge changes in social attitudes have occurred. Homosexuality has gone from illegal to widely accepted (if not universally approved of) in less than 30 years. From queer bashing to Gay Pride is quite a distance. Openly gay individuals can live free from fear due to the rule of law and a general condition of tolerance in mainstream society. Identity politics seeks to advance minority groups not through only legal rights and general tolerance but by weaponising vulnerability. Protected classes do not need equality but rather preferential treatment. This may not be something which group members request. Self-appointed Identarian activists will battle on behalf of others unasked. These activists demand protected groups not be treated equally but protected from being treated as equal. As a vulnerable minority, any given group deserves near immunity from criticism from others because criticism is the genteel mask that obscures bigotry.

Every society polices boundaries of the acceptable through informal means and legal restrictions. Activists understand that they have to advance ideas by first defining them, then introducing them, then by making opposing ideas unacceptable. In the cause of identity politics, the chilling of public discourse comes about first through politeness and good intentions: the desire to reassure minorities that they are accepted; to protect the feelings of the "vulnerable"; to virtue signal[110] that society disapproves of hate. This sets the Overton Window in an increasingly narrow range. The Overton Window[111] describes the range of opinions accepted in public discourse for a certain society at any given time. Certain ideas are tolerated, accepted or popular; other ideas are marginal, radical; still others are unspeakable. In some cases, speech is not widely aired; in other cases, it may be banned or may lead to the speaker being fined or imprisoned. This is quite separate from matters of direct public safety, such as issuing threats of violence or encouraging criminal acts.

The opinions outside the Overton Window may be benign or even correct—such as the idea that disease can be caused by germ transmission, a view dismissed as crankish by medical authorities in the early 19th century. Other opinions may be considered so harmful they are banned. An example of outlawed speech in some European countries is the denial of the narrative of the Jewish Holocaust of the Second World War. The Overton Window applies to all societies. It is something activists learn to manipulate.

In identity politics, the identity of the individual becomes the primary determinant factor in how a person is judged, their loyalties, their social behaviour and their value. Yet it is still a collectivist ideology. Individuals have multiple traits and are judged in multiple axes of oppression.[112] Identity politics claims to serve the interests of individuals by addressing individuals through the most important characteristics. Rather than Marxist economic class analysis, identity politics uses multiple instances of identity-trait analysis to produce a supposedly more sophisticated assessment of the value and needs of an individual. Thus birth characteristics such as race, ethnicity, sexuality, sex and so forth are considered so critical to an individual's worth.

According to Post-Modernists, language is a field which is indicative of power systems, which Marxists have examined in their critiques of class dialectics. Furthermore, language not only reflects the shaping power of dominant classes, language itself is a tool of power. It defines how people express themselves and how expression is possible. With such ideas current, the Identarian finds widespread sympathy when he or she describes language as a means of suppression. When speech is not equivalent to violence but deemed actually to be violence— that is, it does actual measurable harm to the victim—then social pressure and, later, legislative force become legitimate means necessary to combat "hate speech".

In a society devoted to collectivist goals, once an overarching consensus of what is beneficial has been arrived at (be

that imposed, assumed, voted for, inherited or any way otherwise arrived at), then any speech or action which undermines the collective good can be legitimately suppressed. In a culture conditioned by identity politics, freedom to offend, freedom to express ideas outside of the Overton Window and freedom to challenge political conventions are seen as assaults on protected classes. Surely, when faced with hate speech attacking the very personhood of the weakest members of society, a just society should suppress that speech.

Today, many consider preventing "emotionally injurious" speech equivalent to protecting a person from physical assault. Free speech is seen not as a right (not that Marxists ever believed in a right to free speech) but as an activity which permits casual or deliberate bigotry leading to the humiliation and degradation of marginalised groups. The Identarian has a duty to regulate speech to prevent this situation. Identarians silence speech through social and legal force and call control "compassion". In an adroit and cynical shuffle, freedom of speech is trumped by freedom from speech.[113]

Political Instruction through Culture

Cultural production for the ideologue is a matter of moral and political instruction. The morally neutral cultural product (the still-life painting or the escapist superhero comic) becomes suspect precisely because it is a zone where politics can be evaded. It becomes a place for private enjoyment, separated from the productive work for society. It distracts the consumer from the moral work that must be done. Political-instructional cultural material uses enjoyment to the bare minimum, as a sugar-coating around the moral message of service and obedience that is to be conveyed. Even great enjoyment of a patriotic film or a novel can become an experience that is primarily emotionally gratifying. Ideologues must regulate enjoyment because of its tendency to motivate the individual towards private pleasure-seeking rather than civic obedience.

Enjoyment is not part of the extremist's moral-political lexicon. Enjoyment is dangerous because it frequently derives from material that is not ideologically pure or purely ideological. It makes the consumer satisfied and complacent when not all political goals have yet been achieved. Enjoyment can also come from the misinterpretation of politically correct cultural material. Regressive material is often enjoyable; consumption of material that is actually transgressive becomes the most exciting experience in a totalitarian society. Pleasure encourages the cultivation of private taste and personal values which cause "political deviationism", as Soviet socialists put it so accurately.

When observing a provocative public action by a prominent feminist in the art world, an acquaintance of mine commented that he thought the move was crass and ill-judged. He perceived the action in his own terms. He considered that, in her position, he would have put across a point in a more indirect or moderate manner or simply not have chosen this ground on which to make a political position. He did not realise that the point of an action of a political radical today is not to persuade or argue but to virtue signal to other group members. The radical does not seek to present a case but to provoke a reaction. The resistance which is met is automatically dismissed as a regressive response demonstrating an ingrained opposition to progress.

A Problem of Affluence

Identarianism uses the neo-Marxist class analysis applied to different axes of oppression and privilege and uses these quasi-scientific ideas to identify implicit societal biases that cause disparities in income, employment, crime, political representation and so on. It uses these interpretations as moral issues which must be addressed in order to enforce parity, mobilising factional groups divided along demographic traits. It has to portray differences resulting from multiple causes as all stemming from social oppression. It has to invent dragons to

slay. These dragons can never be slain because they do not exist. For as long as these dragons can be conjured then righteous warriors can be summoned by leaders who can exert influence over those warriors.

Today, the Western world — underpinned by liberal capitalist democracy — is a civilisation that is the safest, most prosperous, most secure, highest in social mobility, highest in life expectancy, lowest in crime, lowest in prejudice, most technologically advanced and healthiest that has ever existed. Compared to a century ago, and to even 50 years ago, material deprivation, racial prejudice, disparity in legal rights of citizens of Western capitalist democracies has been reduced to levels that are close to — or actually — tolerable to society at large. There are no dragons close at hand for secular leftists to slay. Poverty, injustice and barbarity exist — but they are inconveniently abroad, mired in complicated and obscure cultures, not susceptible to Twitter posts or Facebook likes. Furthermore, moral and cultural hypersensitivity makes the Western leftist fearful of inadvertent infractions. So how can a leftist prove his virtue? By discovering unmeasurable unconscious bigotry and undetectable structural racism everywhere around him and combatting it as ineffectively and publicly as possible.

The problem of battling Nazis today is a practical one — an enraged leftist simply cannot find one. The far right — those individuals adhering to beliefs including aggressive ethnonationalism, the superiority of the white race, plans to disenfranchise and repatriate Jews, ethnic minorities and migrants — has little significant social influence and almost no political power in Western democracies. Conservative nationalism does. Conservative nationalism is a component of far right ideology but it can and does exist separately. Insofar as the far right (and the associated but separate alt right)[114] has made advances lately, it seems to spring from responses to the leftist white-guilt narrative, affirmative action, the undermining of traditional values and institutions, the championing of mass migration, promotion of multiculturalism and — most

importantly—the arrogant certainty of leftists who dismiss all opposition to (and even questioning of) the preceding points as immoral and illegitimate. (In the USA, the prominence of Black Lives Matter may also have increased unease.) Faced by overwhelming support for, and acceptance of, identity politics in the West, it was inevitable that White Supremacists would create their own victim narrative and exploit leftist social activism to stoke fear and alienation among a demographically shrinking white population of high-immigration multi-ethnic Western countries.

Ethno-nationalism and race solidarity and bigotry were at a low in the 1990s. Since the rise of identity politics they have increased. Identity politics fosters bigotry. This happens in every area it seeks to remedy. Look at the example of racism. Identity politics fetishises race. It demands we see the world in racial terms. It states that demographic traits are at the core of identity and these define an individual's life experience. It stipulates that we class ourselves and others in exact racial and ethnic terms. It tells us we must discuss individuals in racial terms. It condemns those who prefer not to discuss race as deniers of essential racial truths. It insists the life experiences of individuals between different races are not on an individual level but on a racial collectivist level and that this division is unbridgeable; the experience of a member of a race different from ours is so profoundly different that it is unknowable and empathy is misleading projection. It says that there are differences in life experience across racial lines that are ineffable divisions that define humanity. It insists on the primacy of subconscious racial affiliation—which it describes as racial bias. It uses historical events to bolster the racial victim narrative.[115] It uses current events to bolster the racial-victim narrative.[116] It encourages emotional reactions to race: pride, shame, guilt, anger. It encourages looking at the world in terms of privilege and power, emphasising disparity. It demands distinctions in law between the ways races are treated, by instituting affirmative action and diversity hiring. It fosters racial solidarity. It

foments racial discontent. It rationalises racial strife by justifying racial violence (by oppressed protected classes against oppressor privileged classes) as natural inevitable reactions to oppression.

Identity politics is ideologically led quasi-scientific racial engineering "done for good not for evil".[117] Both the collectivist far right and far left are obsessed by race and seek to use the subject to advantage their position. The unacknowledged political position that identity politics advocates is to exacerbate racial tension to maintain their position of influence, all the time insisting they have the solution, while—when in power—never actually solving it.[118] Although Identarians may seriously believe they are combatting racial problems, the effect of their actions is to make themselves recognised experts on an insoluble source of strife which their actions are fomenting.

Rather than treat individuals on their personal situation, unique character, abilities and actions, identity politics demands we treat them as "racialised beings" and "queer bodies". Liberal universal humanist principles, which reduced racial discord until the 1990s, have been eclipsed by identity politics and leftist factional collectivism which has racialised and factionalised politics. Identity politics is to its very core collectivist, racist and dehumanising.

Post-Modernism as a Form of Decadence

Identity politics is a result of a cyclical phenomenon of social decadence. Decadence is a period of decline after a period of increasing stability, prosperity and regional hegemony experienced by a civilisation. Anomie is the condition that Émile Durkheim coined as a sociological term. He suggested that dislocation between an individual's aims and society's values resulted in insatiable dissatisfaction and aimlessness among individuals. Decadence is the growth of aimless dissatisfied individualism as the outcome of an extended period of material affluence, social stability and personal anomie.[119] The era of decadence is typified by a tendency towards over-refinement in

preference to plainness, artifice in preference to nature, exaggeration in preference to restraint, excess in preference to decorum, and personal selfishness in preference to civic duty. A serious division opens between the ruling class and the populace, leading to a separation of moral and ethical values and a breakdown of mutual trust leading to absence of combined action towards shared goals. There is a fascination with perversity and morbidity, a delight in flouting moral and social conventions and a desire to shock and titillate. The innate fascination with the bizarre and extreme criminality is no longer tempered by moral concern. There is the celebration of purely recreational sexual activity and a disparagement of the value of traditional family structures. Citizens can indulge in risky and anti-social behaviour because they live in a society which has—until that point—been stable and safe enough to permit minor aberrations on a small scale without them affecting the wider society significantly. It is a testing of boundaries, not least the Overton Window.

During decadent phases aberrant behaviour might not radically change but it does seem to become more accepted and widespread. Aberrant behaviour that existed before but was covered up by hypocrisy is now open—even contending for acceptance and parity in status with conventional behaviour. Witness the celebration of non-conventional behaviour, which is seen as adding to the richness of society. Non-conventional behaviour is not simply accepted but actually encouraged by many individuals and sections of society. Thus the structure that supports society comes to also incorporate non-optimal, non-productive and deleterious activity, activity that it cannot limit or remove because the ethics of acceptance (or apathy) have altered to such a degree that such limitation or removal is considered unacceptable.

The stability and success of a society determines the level of excesses that will be permitted. Some aberrations, if they are not overly harmful to the individual and society, will be permitted and may be deemed acceptable, with society adjusting

its norms to accommodate the new behaviour. The danger is that the excesses become too widespread and extreme and thereby destabilise society, especially at a time when there is a threat from outside (military invasion) or an existential threat from inside (the rise of a new religion or ideology). A lack of civic unity and the pursuit of pure self-interest blind people to the dangers of catastrophic collapse. This is why decadence is stigmatised beyond its associated moral infractions. It is seen as a contributory factor in the decline or destruction of a civilisation—weakening it from the inside at a time of other threats.

The decadent is essentially sceptical of the virtues of logic and rationality; he takes pleasure in thwarting or contradicting dominant ideas of progress. He pursues pleasure to a pathological degree. If he is not psychopathic he venerates the selfishness of the psychopath. He lacks empathy and rectitude. He mocks religion and the pious.[120] He has no respect for authority, loyalty or sanctity. He dallies in sexual abnormality and subverts gender roles, both partially in a motivation to disconcert others.[121] He enjoys undermining common ideas and standards so long as he reaps vicarious pleasure and suffers few consequences. This is flirtation with nihilism and taking pleasure in destruction.[122] Decadence is pleasure-seeking spurred by on a series of associated egotistic desires—cloaked as moral liberation—but it can only be enacted in an affluent and stable society sustained by systems working for the benefit of all, which is why decadence is parasitical in nature. Decadence cannot exist in subsistence societies, nomadic societies and periods of outright catastrophe. Decadence is essentially unproductive so it cannot exist for an isolated individual or within social units of very restricted size.[123] The decadent is the extreme example of a neophilic-inclined leftist in a neophobic-inclined conservative society. Is that definition of the decadent not a perfect match with that of a Post-Modernist theorist or a crusading Identarian living in a stable and prosperous Western democracy?

Identity politics draws power from—and encourages—the cult of the minority subset. It fetishises the minority: the immigrant, the religious minority, the homosexual, the transsexual, the individual who refuses to engage in productive work, the pioneer of transgressive sexual behaviour, the individual who agitates for revolution, the disrupter of the established order from which he benefits, the victim of real or invented injustice, the free rider. By championing evermultiplying gender categories (for example) Identarians actively seek to atomise society along as many axes as possible by fostering a proliferation of disunity. Remember that to an Identarian the existence of a demographic norm is oppressive. Hence there is a drive to destroy all norms, no matter how counterproductive or alarming this behaviour is. Leftist neophilic politics elevates—through standpoint theory—the (supposed) interests of minority subsets to the level of the greatest good. Identity politics takes it one step further by encouraging atomisation. The more minorities there are, the less likely any group can dominate and oppress. This is why Identarians not only adulate multicultural societies they seek to produce them by agitating in favour of mass immigration. (Always into the hated capitalist West, never the reverse.) The production of a factionalised society divided along demographic lines and locked in unending struggle is not so much the nightmare of the Identarian as it is his dream and his aim. To him this open division is only a manifestation of the oppressive power struggles that are surreptitiously hidden in more homogeneous societies. As an activist and ally, he will act as moral arbiter and get to assign positions to demographic groups in the "racial stack" or "privilege ladder". His cadre of social activists will dispense justice and enforce retribution, as the vanguardists of every revolution assume they will.

In artistic terms, Post-Modernism is a refutation of the ideals of progress embodied in Modernist art and thought.[124] It is the logical extension to the Counter Enlightenment.[125] It demolishes the stylistic coherence of Modernist art movements. It

separates Modernist art forms from the ideas from which they were derived and the aims for which the forms were originally used. Post-Modernism in art is largely cynical, obfuscatory, disruptive, ironic, detached, uncommitted, destructive and nihilistic. One can fairly describe the dominant character of Post-Modernism in art as "decadent anti-Modernism".[126]

Identity politics and Post-Modernism are the quintessential manifestations of decadence. They exist only because they emerge from a stable and successful civilisation; they scorn the civic virtue of unity of polity; they exploit transgressions that arise from decadence; they sow discord to entrench ideology and serve the status of their standard bearers; they cultivate novelty for novelty's sake; they discount the possibility and value of consensus; they are essentially negative, destabilising and destructive rather than positive, stabilising and constructive. They are parasitical.[127] The more society fails, the stronger they become, eroding a weakened core.

There is a derogatory moral connotation to the term "decadence" which derives from a) moral repulsion and b) civic opprobrium. The latter aspect is the most relevant to the preceding discussion of culture. I do not wish to suggest that all aspects characteristic of decadence are morally objectionable. In particular, the sexual choices of individuals are matters of indifference to me. Readers will have their own views on particular matters. I believe that a liberal Western democracy can absorb a certain degree of dissent and aberration and benefits therefrom. Liberal capitalist society is capable of accepting individuals of many different outlooks and behaviours without necessarily adapting itself to fully accommodate those individuals at a great cost to society. It is our duty to act as carefully, tolerantly and compassionately as possible without adulating victimhood, needlessly castigating our highly functional and beneficial social structures or undermining shared values which act as secure bases for our survival and prosperity. Not everyone is born equal. Not everyone achieves equality. Not everyone lives a happy life. Suffering is

inevitable. What makes suffering worse is the cruel promise of an illusory universal happiness.

The utopian goal of perfect justice has inspired more systematic destruction, barbaric executions, untold brutality and appalling genocide than every act of selfishness, greed, anger, covetousness and malice combined. The road to atrocity is collectivist action motivated by the victim narrative directed towards utopian idealism.[128]

Despite our own personal acceptance of unconventional behaviour—indeed, actually participating in that behaviour ourselves—we must recognise that the effects of the proliferation of such behaviour may have serious consequences on our ability to overcome challenges from our environment, economy or competitor societies. The very thing we most prize as the ultimate flower of our civilisation may prove to be a critical weak point. Blithely declaring that we would rather see our society destroyed or supplanted than compromise one iota on the rights of this group, the uncritical acceptance of that behaviour or the economic support for those activities is the very epitome of a statement made by the complacent in a land of plenty. I do not suggest there is an ideal formula for balancing tolerance and stability, pleasure and duty, neophilia and neophobia; I only urge that we recognise the risks of decadence as acutely as we do the risks of conformity.

On Cultural
Entryism and
Social-Justice
Activism

This last essay outlines the practice of cultural entryism in the
arts as an expression of Identarian ideology, as described in the
previous essay. It suggests that social-justice activism among
leftists inevitably leads to cultural entryism. It outlines how
elements discussed in previous essays—the desire to curb free
speech, the use of culture and cultural subsidies towards pri-
marily utilitarian ends, quota programming, the aim of over-
turning established traditions, the desire to enact reparations
and the power of utopian thinking—become explicit when
social-justice activists gain significant control in areas of culture
and have a chance to implement Identarian ideas. Comicsgate,
a prominent case from popular culture, is taken as an example.

Cultural Entryism

Entryism is the practice of a group of individuals sharing
common political goals and beliefs covertly entering an
organisation with the express intention of influencing, con-
trolling, sabotaging or destroying that organisation.[129] Once
within the organisation, that organisation can be influenced or
directed to further the infiltrating group's political goals. This
practice is most commonly seen in political movements. The
entering of the organisation need not be centrally directed, for it

requires only a shared understanding among the entryists of the goals of the infiltrating group's agenda.

Some of what we have seen in the arts in Europe, the UK and North America is a form of "cultural entryism". In these cases, it is not members of a party but loose affiliations of individuals sharing political beliefs and goals who enter cultural industries, academia and journalism. Activists feel no loyalty to employers, institutions, consumers, conventions or the ethos of the art form; their only loyalty is to their political cause. They often act unprofessionally in order to display their political commitment. They feel less bound to the ethical code of their profession than to their political ideas. These individuals feel a greater sense of loyalty towards their political allies than their colleagues. The entryists work to further a political agenda even if this damages the efficiency, income or reputation of the organisation. It does not matter if their employer loses money, because the activist feels no emotional or professional commitment to the employer; it does not matter if an institution's credibility is damaged because of a blatant political bias in programming or personnel hiring.

If the entryists find their goals cannot be advanced within an organisation or field, they will be willing to sabotage and destroy it. If an organisation is "unreformable" (i.e. the entryists find it uncontrollable or ineffective for advancing their political agenda) then it is considered irredeemable and deserving of destruction. In a time when changing careers and professions is common, entryists judge that leaving an industry is an option that carries not too great a personal cost. Sabotage, obstinacy and disloyalty are not penalised as heavily as they once were. Among the entryist peer group such actions are seen an expression of in-group loyalty.

Entryism in the arts is not something much discussed by the entryists themselves. If it is discussed, it is talked of in terms of "inclusion" and "representation". However, as the individuals suitable for inclusion are supporters of leftist social activism, it has the effective outcome of concentrating social-justice

activists in cultural fields, intent on rectifying perceived wrongs. An absence of critical skills and of independence of spirit among the entryists means in-group affiliation is more important than respect for the craft and tradition of the art form of their chosen field. (In the case of diversity-hire employees, there is another reason. Keeping a job when one is not highly competent may depend on support of an in-group.) Although entryism is not planned, the effect is the same as if it were. The participants share a worldview and a language; they have mutual goals; they use common tactics; they have a stated (if poorly defined) end state of absolute equality of outcome and unity of political thought.

Political purity is paramount. The art form is expendable. In-group identity and cohesion are strongly policed by the group.

Barriers to Cultural Entryism

We should not make the error of assuming that every area of culture is equally susceptible to the same tactics nor that entryism manifests itself in identical ways in every area. There are barriers to entry in all fields. These barriers vary greatly and each field has its own unique barriers to entry. The barriers to entry into the film-and-television industry are technical competence and high competition, in a field with a high turnover of participants. The barrier to entry into the art-history field is academic competence, in a field with relatively little competition and few commercial imperatives. The barrier to entry into the comic-book industry is technical competence,[130] in a field with high turnover of participants and great demand for commercial success. The barriers to entry into the fine arts are (generally) specialist training, qualifications and great personal motivation, in a field with high turnover of participants, a mixture of clear commercial imperatives and hidden non-commercial imperatives and intense competition. Art history demands great and deep understanding of the traditions and literature of the field; comic-book illustration demands

technical skill and knowledge of the conventions of the form but not necessarily great familiarity with the form's history; and so forth. Every field admits participants according to variable criteria. Some are more difficult to enter than others. However, once an area has entryists who are willing to prioritise politics over professionalism, entryists can assist less competent individuals over the barriers to entry. They permit entry to individuals for political reasons, making exceptions in the cultural field that are less possible in technical fields which require certification and measurable skills. From within the profession entryists can metaphorically offer a hand and help outsiders overcome barriers they would be unable to surmount alone. Although cast as inclusivity, it is effectively patronage which is done to strengthen a political group within a field. Barriers can also be lowered by entryists in an assault on "elitism".

It is true that professors in art-history departments, curators and some administrators in arts organisations are not recent arrivals to the field. Few could be described as entryists. Many have invested significant time and effort in learning the subject thoroughly and have a degree of respect for the traditions and accept the importance of maintaining the subject's integrity. They are, however, often sympathetic towards leftist ideas on matters of representation and inclusivity. Marxian art historians have existed in the academy for decades and, although they have clear political biases, they find in art history examples to be used to demonstrate the correctness of Marxian cultural analysis. Academics who use Marxian analysis did not have an active desire to censor, suppress and destroy art, more to highlight and critique it through a Marxian lens. Entryists into art history (such as there are) are neo-Marxists who are first and foremost social activists who see activism as an essential part of their in-group self-identification. They act to oppose art of oppression (royal-and-aristocratic portraiture, colonialist art, female nudes made by male artists, etc.) rather than simply criticise it. It is these individuals who feel political

considerations outweigh respect for the subject. The time-consuming business of passing examinations, completing at least two degrees and securing a position in publishing or university teaching prevent casual entryism and also inculcate a fair quantity of respect (if not approval) for politically unacceptable art, which mitigates strongly destructive tendencies. Those academics coming into art history via Critical Theory, gender studies, post-colonial studies and other channels present clearer cases of entryism.

It should be noted that many regional museums in the UK are under local-authority control and are run not by directors or keepers of art but by venue managers, some of whom have no art-historical background. Many are educated in the social sciences and are closer to social workers than to art historians. Some art-history professionals are feminists or have social-activist backgrounds in university study, especially if they have previously come into contact with Critical Theory. Many supporters of Identarian principles applied to the arts are not entryists. They have been working in their fields for a considerable time and are committed to their profession. They feel sympathy for poorly understood ideas of equality and representation and want to generally improve the common lot without realising the destructive aggression of the most devoted supporters of these concepts. They respect their subject and fail to see that many of their political allies despise that subject and wish to enact vengeance upon symbols of hated injustice.

Instances of social-justice activism seem most prominent in video games, comic books, film-and-television production, theatre, performance art, contemporary dance, board games, card games, children's literature, arts journalism; less prominent in the fine arts (sculpture, painting, printmaking), art history/writing, photography, adult fiction-and-verse writing/publishing, fashion, popular music; least prominent in architecture, applied art and crafts, art conservation, textile arts, classical music, folk music.

It seems that cultural entryism is most pronounced in fields of culture that:

1. allow the greatest breadth and flexibility of personal expression;
2. are newer industries, fields or institutions;
3. have fewer established customs, traditions and restrictions on expression;
4. have participants who are younger than in other fields;
5. have participants working in teams or groups rather than individually;
6. are appealing to women and have a higher proportion than average of female participants;
7. have significant groups of managers and administrative staff unconnected with the direct creation of the cultural product;
8. have lower barriers to entry for low-commitment/experience entrants than other fields do (see point 7);
9. feature participants as performers or publicly prominent participants;
10. have most direct contact between producer and consumer;
11. have commercial imperatives affected by public-media coverage;
12. are highly visible in the public media;
13. have closer ties to new political-activist academic studies than to established academic fields; and
14. have few channels, manufacturers and centres of excellence, all of which are subject to the influence of gatekeepers.

These indicators are independent of each other and contain contradictions. They do not all apply to specific cases. For example, a performance artist is self-employed (see point 9) so cannot be directly related to point 7, which highlights the opportunities for entryism into large organisations to fill positions which do not require specialist knowledge or

education. However, a governmental arts-funding organisation or a large museum — which funds performance artists — may have many cultural entryists working in it. Thus these indicators can operate indirectly and exert a cross-field influence relating to the spread of Identarian personnel and cultural products.

Virtually all social-activist changes inside a field of culture are results of collaboration between cultural entryists and sympathising long-established professionals. The acceptance of the entryists into particular areas can only be the result of decisions by gatekeepers. These gatekeepers may be sympathetic to the entryist cause. Gatekeepers may unwittingly accept entryists under the motivation of injecting younger and more diverse personnel into an industry in an effort to alter the public perception of the company or field or in an attempt to appeal to a demographically distinct group of potential consumers. Once entryists are in a position to hire like-minded colleagues then the field becomes increasingly under the sway of entryist action as the companies, institutions and university departments become staffed by entryists and colleagues who decline to oppose their ideals.

Cultural Entryism or Cultural Colonisation?

There is an alternative way of viewing the activity of effective cultural entryism — as colonisation of cultural fields. Colonisation is the takeover of an area through the concerted activity of occupants from another area. This can happen in culture as it can in geopolitics. This cultural colonisation has a two-fold purpose: firstly, it is an expansion of power and control through application of a colonising power's ideology; secondly, it nullifies a potential source of opposition from a neighbouring area.

It is possible to describe recent activity as colonialist expansion of leftist identity politics from university departments teaching subjects such as education, social science and the humanities (especially gender studies, queer theory, colonial

studies and Critical Theory) into neighbouring fields of cultural production. This is accomplished through infiltration of the top level (such as government organisations and funding associations), production level (such as professional bodies and companies) and consumption level (such as channels through which consumers and producers communicate: internet message boards, forum moderation, journalism, etc.). Internet forum moderators act as *zampolits* (political commissars) enforcing a political line. After forum users have seen dissidents be "dogpiled",[131] probated or banned by the *zampolits*, remaining members stop posting honestly or simply leave the forum. The top-level colonisers can claim to be acting on behalf of consumers because the communication channels have been co-opted. The enforced consensus in forums can be presented as a norm among consumers, thus reinforcing the illusion that the consensus is a true reflection of the customer base as a whole.

Colonisation is effected by an influx of outsiders at multiple levels, all intent on enforcing control and preventing concerted opposition. In these essays the entryism analogy rather than the colonisation analogy has been used because I think the former is slightly more accurate. However, one could expand upon the cultural-colonisation analogy to shed extra light on current cultural production.

Stages of Cultural Entryism

Here are the stages of Identarian social activism in the process of cultural entryism. Note that these are tactics rather than strategy. Tactics implies contingent short-term moves to achieve clear, definable results; strategy implies an overall plan, a detached view, a degree of self-knowledge and a chain of command within an organised group. I believe very few Identarians have a strategic view; however, Identarian activists are well versed on tactics.

1. *Identarians are possessed of absolute moral certainty.* This leads them to dismiss opposition as wrong, ill-informed or

hateful and arguing in bad faith. Opposition to social-justice activism is the perpetuation of a system which is unjust and evil. A system which is destroying lives and livelihoods daily must be subject to immediate radical change or outright destruction. This action is morally justified and a matter of urgency. Dissent from within activist groups may be considered betrayal. Internal purging and clique behaviour lead to the application of a tightening moral circle which excludes those not sufficiently committed or politically incompatible and more closely bonds remaining members.

2. *Identarians view culture as a social field which expresses the power dynamics of advantaged groups (privileged classes) and disadvantaged groups (oppressed classes).* This perspective is derived from Marx but is not primarily shaped by considerations of class and income but by markers of demographic traits: skin colour, ethnicity, gender, sexual orientation and so on. This worldview downplays individual agency in favour of seeing individuals as merely members of demographic sets who act, consciously or otherwise, to further the interests of their sets. Identarians seek to balance perceived injustice against certain groups by making these groups into "protected classes". Different standards apply to these protected classes.

3. *Identarians consider culture easier to influence than economics or politics.* Forms of economic Marxism are unlikely to gain considerable political appeal undiluted. Leftism in the forms of identity politics and social justice has greater political purchase within the general population, especially for younger people. Leftist activism implies economic Marxism (to an unstated degree) but many activists have little interest or understanding of the economic implications of enforced cultural change. Identarians are often indifferent to traditional political groups. In an atomised society, younger individuals (those most likely to be less informed, most idealistic and most likely to view the world in simplistic terms) are more drawn to the easy issues of supporting or criticising culture online rather than attending political meetings and marches and becoming involved with

traditional routes to political influence. Boycotts, Twitter harassment and social-media posting on cultural issues produce quick definite results, give the impression of influence and act as in-group signalling, all of which encourages repeated behaviour. Culture is very susceptible to social pressure in a way that political channels are not. Cultural change can happen in a matter of hours whereas political legislation is a lengthy and complicated procedure.

4. *Identarians see culture as a field in which to wage warfare against the groups which they perceive as powerful or oppressive.* Identarians seek to promote so-called minorities or protected classes by punishing apparently successful individuals from "oppressive classes". Post-Modernist subjectivism is used by Identarians to define aesthetics as purely an expression of a dominant class enforcing a convention upon unwilling and unconsidered excluded groups. Aesthetics is thus a parlour game played by the elite of a dominant class, with no value, no set of effective measurements, no basis in general consensus (consensus can only cover oppression and submission according to Marxist cultural analysis) and no compelling virtues. Thus all aesthetic considerations can be dismissed. The only aspects that matter in culture are a) the demographic sets of the makers and consumers of art and b) the propagandist and politically useful content of the cultural product, including the demographic-set representation of the protected classes.

5. *Identarians do not discriminate between high and low culture and target both for remedial activism.* Identarians (in line with other Post-Modernists) make no qualitative distinctions between high and low culture. High-culture targets are harder to infiltrate because of the difficulty and time needed to gain qualifications in required subjects; the rigid customs, forms, institutions and practices are hard to influence politically. However, administrative, personnel, public-relations and managerial jobs in high- or low-culture organisations are easy entry points for activists.

6. *Identarians engage in unco-ordinated cultural entryism.* People with social-activist inclinations (often inspired by university courses, some of which are avowedly instructional in character and seek to produce social activists) are often drawn to the arts in order to influence cultural production. Working to the same set of ideas, they act individually and in collaboration with others to further their agenda, regardless of the needs and conventions of their company, institution or art form. They hire candidates with similar outlooks to theirs and thus amplify the influence of their ideas in the field. They will also hire candidates from protected classes on the basis of demographic traits. These are "diversity hires".

7. *Identarian activists engage in political campaigns of patronage and sabotage within culture; these campaigns consist of a multitude of small actions.* Demands will include making certain words forbidden (to be replaced by alternatives) and making certain attitudes (real or perceived) punishable. This pressure will largely be through social media. At first demands will be small — relating to language, art work, representation, making small changes to existing characters and introducing new characters. If organisations agree then further demands, larger ones, will be made. There will be pressure on companies to fire individuals who act in ways that go against leftist ideas, banning fans, introducing quotas, demanding official apologies. The demands will be never ending and constantly escalating. The average individual in an organisation is often not prepared to counter these demands. The personal cost of using careful honest arguments to oppose Identarian arguments is to be condemned as uncaring, bigoted or reactionary. This is often too high a price to pay. Small encroachments are difficult to oppose because opposition can seem a considerable effort for small gain, especially if this has adverse personal consequences for the one opposing activism. Strong opposition to small advances can be portrayed as overreaction. Social-activist encroachments through incremental steps a) are hard to identify, b) are hard to oppose effectively, c) present difficulties

when opposition needs to be mobilised and publicity genera-
ted, d) present high-cost low-benefit outcomes for those
opposing them and e) exhaust opponents when presented
repeatedly.

8. *Identarians will attempt to control discussion of culture.*
Entryists will use positions in the traditional and online press to
shape discussion of culture, support activism within culture
and will consider themselves and their fellow commentators as
social activists. Entryists will moderate internet forums to
suppress dissent and even discussion—even reasonable
discussion without abuse or profanity.[132] Entryists will act to
suppress and misrepresent dissent.

9. *Identarians within cultural production will devise and imple-
ment quota programming.* This will include quota programming,
affirmative action, representation casting, equity hires and
other methods of altering the composition of organisations,
cultural products and consumption of culture. These actions
will at first be covert. Later, if quotas are not ruled illegal,
opposed from within an industry or found to be publicly
unacceptable, the quotas will become overt and tolerated or
officially sanctioned.

10. *Identarians will institute purity tests for producers and con-
sumers.* Participants in cultural production will be judged in
moral terms and expected to prove their loyalty to the
Identarian ideology through their work, private life and per-
sonal associations. Consumers will be judged likewise. If con-
sumers criticise the product then it is they who have failed the
culture not that the culture has disappointed them.

11. *Identarians will produce culture that furthers their political
agenda rather than the personal goals of creators, expectations of con-
sumers or the development of the cultural form.* Entryist producers
will create content to suit themselves not the consumer, insofar
as that is possible given the restrictions of their position and the
field. This is in line with centrally planned economies, where
types of production are planned before exact data on demand
is ascertained. This centrally planned cultural content is the

production of content that the producer believes the audience should consume as opposed to consulting the consumer or studying data on the popularity of certain cultural products.[133] Compromise in production will be resisted — even if a modulated product may receive a more favourable reception.[134]

12. *Identarians will blame the failure of diversity-hire creators on social bias not personal inadequacy.* Creators who are hired by Identarians on demographic traits are often unsuited for the positions they are given because the criteria for hiring are demographic traits rather than ability and experience in the field. To the Identarian employer the latter factors are either of little or no importance compared to the greater benefits derived of virtue-signalling due to hiring a candidate from a protected class. This does not apply to all candidates from protected classes, as some candidates have suitable skill and experience, even though they may be hired partly or mainly because of their demographic traits. The difficulties many diversity-hire creators will experience will be due to their unsuitability for their positions. Diversity-hire creators have no incentive to improve because they were not hired on the basis of competence. If a protected-class creator fails in terms of competence or has a notably lower professional and commercial recognition than non-protected-class colleagues, this will be portrayed as the outcome of systematic bias and societal bigotry. Furthermore, any failure of diversity-hire creators will reinforce the Identarian victim narrative of social marginalisation and exclusion. Success will not undermine the victim narrative (it is an exception, earned in the face of great opposition); failure will not undermine the victim narrative (it is proof of the overwhelming bigotry of society). Identarians use individuals as tokens, regardless of the suffering and embarrassment actually experienced by those diversity-hire creators who are promoted to positions beyond their levels of competence.[135]

13. *Identarians will become frustrated at their inability to control culture.* Culture derives its power through consensus and consumption by multiple individuals over prolonged periods of

time, which leads to the development of expertise, conventions and a canon. These develop through collaborative effort and are out of the control of any single authority or individual. When the open market and undirected cultural production and consumption do not result in sufficient advances of politically suitable culture and successful producers from protected classes, social activists will agitate for even more action and quotas. Every failure to advance the Identarian cause will be blamed on regressive conservatism and bigotry inherent in structures laced by patriarchy.

14. *Identarian propaganda, quota programming and diversity hiring will be noticed by consumers and will generate resistance.* When it becomes clear to consumers that political motivations trump artistic ones, general consumers will react negatively. They will criticise the product and boycott it and related products. There will be resistance towards the agenda of creators. There will be attendant cynicism—as is seen in cases of affirmative action in the USA—where all newly prominent members of protected classes in a field of cultural production will be seen (fairly or unfairly) as beneficiaries of politically motivated casting, quotas and hiring. This has the ugly side effect of stigmatising competent individuals from minorities who have earned their professional status through merit. Thus one of the outcomes of forced diversity is hostility towards not only Identarian creators but politically neutral and competent members of minorities in the arts.[136] Attempts to shield artistic projects that advance ideas supported by Identarians will likely have negative repercussions.[137]

15. *Failure will lead Identarians to attempt to discredit and destroy their own field of cultural production.* The inevitable failure of the creator who is promoted beyond his or her ability will be assumed to be an example of the intolerance and bigotry of consumers. The rejection of Identarian cultural products by consumers on the bases that the products lack nuance, complexity and cultural authenticity will be understood by Identarians as a rejection of their ideological message. If social

activism proves impossible or ineffectual in a field—or faces concerted effective opposition—then attempts will be made to undermine or discredit the field, which is considered a source of oppression. For a society to enjoy consumption of morally inferior products which have outcompeted morally superior products is insufferable for the activist creator. The creator will attempt to deprive consumers of their morally inferior pleasurable products.

For the socialist, the solution for the failure of socialism is always more socialism, never a reassessment of core principles. Likewise, for the Identarian, the solution for the failure of Identarianism is always more Identarianism.[138]

Social-Media Activism

The Identarian must act because not acting is collusion with oppression and injustice. The action may be as dramatic as demonstrating publicly, resigning from a job or bringing a legal action against an employer. The action may be as small as liking a Facebook page or reposting a Twitter comment. The ability for one person to instigate a barrage of abuse through social media directed at an individual or organisation gives even outsiders sufficient leverage to force withdrawal of products or the resignation of a creator. Posters on internet forums can cause "brigading" (organised action against an individual/organisation), spread misinformation, attract the attention of the press, mass flag videos/posts on social media, hack accounts and release private data. Firms may face concerted denial of service by hackers, which renders websites inoperable and disrupts business.

These groups may be numerically small but the disruption or bad publicity they cause can generate serious problems. Disconnection between an individual and a target through the impersonal (and sometimes anonymous) contact via the internet means social constraint is lessened and inhibitions weakened. An individual attacker can exercise disproportionate power, especially as part of a wider campaign, yet receives

little or no opprobrium. Often the impetus to express moral anger at a target comes without the realisation that hundreds or thousands of other people are acting in the same way. The attacker sees only him- or herself interacting with a target without a thought of the target receiving hundreds or thousands of criticisms from strangers couched in terms ranging from the polite to the threatening. When that criticism includes private information about the target or the threat of violence then the target is overwhelmed.[139]

The effect of much social-media activism can be predicted. Some cases "go viral" and have an impact much beyond what might have been expected.[140]

In late 2017 the Swedish H&M clothing chain promoted a new clothing line with publicity photographs of various child models wearing items, displayed on its website. One item was a sweatshirt worn by a black child. The slogan on that top read "The coolest monkey in the jungle". In January 2018, a single social-media activist used this photograph as *prima facie* evidence of racism within the company. The claim went viral and became a *cause célèbre* for Identarians and racial-activist bloggers. The campaign was covered by the mass media and soon boycott calls were circulated, furious moral criticisms of the firm made and threats made against H&M staff. Contracts were cancelled. In South Africa, branches of H&M had to close down for a day due to attacks on property by a black Marxist radical group. Shop displays were damaged and items stolen by individuals spurred on by moral anger. The firm withdrew the advert, withdrew the product, made repeated apologies and instituted diversity policies and new practices. The parents of the boy, an African couple living in Stockholm, gave an interview where they stated they did not consider the photograph to be racist. They then had to go into hiding after being threatened by leftists for not adhering to the victim narrative. One accusation of racism by one activist relating to a common affectionate phrase printed on a sweatshirt was enough to cause an international storm of anger and had serious financial

ramifications for a multinational firm. Sparked by a single social-media post, it was the victim narrative propagated by Identarians—and repeated by well-meaning liberals—that primed a damaging campaign of retribution via the online actions of ordinary people.

Having seen boycotts and divestment campaigns catch wider media attention, organisations have become hyper-sensitive to social media and internet media attention. Even though most of these campaigns do not take off and do not become widespread or financially effective, organisations must prepare for such campaigns. Press departments are very sensitive to them because they—the public relations depart-ments—are responsible for mitigating the negative impact on the company's profile. This makes organisations easy to intimi-date. Often the most effective way of mitigating threats is to accede to a demand, however contentious or ill founded. The constituency for free speech tends to be smaller, less vocal and less motivated than a mob of righteous race activists. The financial and publicity implications for displeasing supporters of free-speech are generally pitifully inconsequential.

It is easy to find examples of social-activist behaviour because of the proclivity for individuals to use social-media posting, especially on Twitter.[141] This is done to reach a wide audience both to shame targets and to signal in-group affiliation to fellow activists. Activists believe they are in the right and so feel little shame or self-reflection, in part because they block and mute criticism rather than engaging with it and accepting corrective views. The hiding or deleting of their posts seems to be as much a tactical position as an expression of genuine regret or embarrassment.

Cultural Entryism in Popular Culture

The pattern of cultural entryism and eruptions of conflict involving social-justice activists can be seen clearly in various events in popular culture. Four prominent examples are the

Sad Puppies campaign (2013–16), Gamergate (2014–15), Magicgate (since 2017) and Comicsgate (since 2017). The Sad Puppies campaign was instigated in 2013 by a few science-fiction creators and a group of fans protesting against trends at the Hugo Awards for science-fiction writing and art. The movement objected to what they saw as niche and literary works being rewarded in preference to more mainstream work. There were complaints that the awards were influenced by a "diversity agenda" to promote female and minority creators and characters. Fans organised to vote en masse for pulp works with no overt political agenda in order to antagonise the Hugo Award organisers and to make a point about intrusive political positions of creators, publishers and press. The Sad Puppies were dismissed by Irene Gallo, creative director of science-fiction publishing house Tor Books, as "right-wing to neo-Nazi" and "unrepentantly racist, misogynist, and homophobic".[142] Their nominations were nullified in the 2015 Hugo Awards by categories being adjudged "no award". Although almost all of their nominations lost, the Sad Puppies prevented other nominations from winning and drew public attention to the subject.[143] In 2016 several of the nominees supported by the Sad Puppies won awards. These nominees were not pulp science-fiction creators but were deemed less political creators. The voting system for the 2017 awards was altered to prevent the power of bloc voting.

Gamergate was an outburst of anger among consumers about games developers, publishers and journalists in the video-games industry who were discovered to have privately supported and promoted games without disclosing their ties to the public. There was also discontent about rumoured favouritism displayed by reviewers and journalists towards certain developers. One of the game developers was female and some of her supporters were female. Journalists in the industry characterised criticism by gamers as misogyny and resentment of women and minorities in the gaming industry. Journalists privately circulated a plan to condemn gamers as

irredeemably sexist. They made co-ordinated declarations that "gamers are over".[144] This co-ordination was later exposed. The critics of gaming journalism, entryist tampering with established franchises and overt political agendas in video-game production[145] and journalism became called Gamergaters.

Magicgate was a division within the community of players of *Magic: the Gathering* (MTG), a trademarked playing-card game produced by Wizards of the Coast (WOTC). The game includes trading cards, merchandise, online gaming and organised tournaments sanctioned by WOTC. The division opened up when a prominent gamer, Jeremy Hambly (who produces vlogs on gaming, especially MTG, as The Quartering and UnsleevedMedia), was banned for life from participating in tournaments and online play. He had his online card collection confiscated by WOTC. This followed accusations that Hambly had harassed a cosplayer. (A cosplayer is someone who attends tournaments and other public events dressed as a fictional character. Cosplayers can be amateurs who do this for free or for cachet or as a paid professional.) Hambly became the first MTG player to be banned for life without the possibility of appeal not for cheating or committing a crime. Hambly had previously attracted attention as a controversial commentator and provocateur. He had criticised WOTC's increasing focus on identity and sexual politics in MTG guidelines and public relations.[146] The evidence of supposed harassment was weak, largely consisting of internet memes, lewd comments made in private online discussions and public comments disparaging the role of professional female cosplayers in general. None of this was on WOTC-sanctioned boards or outlets but on social media. It seemed that Hambly's severe punishment was due to his unpopularity among some fans and his criticism of WOTC policies rather than an infraction of MTG guidelines.

Hambly's supporters were described as bigots and misogynists intent on making MTG a space "unsafe for female players". As "trolls", their criticisms of WOTC's involvement with identity politics could be dismissed as insincere. The

division between Hambly's supporters and WOTC supporters became more serious when Hambly exposed a number of criminals convicted of sex crimes who were, at that time, not banned by WOTC from MTG events. A number of paedophiles had judge status and therefore had access to child gamers through game stores and sanctioned tournaments. Hambly's vlogs named the individuals using data in the public domain and contrasted their MTG accreditation with his lifetime ban. After the campaign began, WOTC did ban some of the named individuals. WOTC was discovered to have altered its lists of MTG players and judges in order to retrospectively remove names of criminals from its internet records. Hambly campaigned for criminal background checks on judges, a proposition that WOTC initially resisted as impractical and costly.[147] On 2 August 2018, Hambly was assaulted in a bar by a fellow attendee of a gaming convention. The attacker confirmed Hambly's name then assaulted him without provocation. This is the inevitable outcome of the widespread Identarian conviction that speech can be harmful to the weak[148] and thus physical assault is a proportionate response to mild mockery or criticism. Legal proceedings against an individual accused of assault are ongoing.

One of the clearest examples of cultural entryism in popular culture is Comicsgate.

Comicsgate: A Case History

In their post-war heyday, American superhero comics were a limited range of low-cost items widely stocked in general stores and sold to casual readers; nowadays, comics are a broad range of more expensive items stocked in few specialist stores (and online) and sold to dedicated followers, often for the collector market. Despite shrinkage, by 2015 the comics market in North America was worth annually about $500 million in individual comic-book sales, excluding online and book sales. Executives at Marvel Comics, leading producer of superhero comics, were nervous about their readership. The typical superhero-comic

purchaser was a 40-year-old white male—a demographically shrinking and ageing profile not being replenished by new young buyers. Social activists told Marvel editors that their characters should directly reflect readers' identities in terms of gender, ethnicity, sexuality and even body-shape; only female and minority writers could authentically convey the experiences of these new characters; as there are few such creators in the industry, diversity hires could come from the young-adult fiction world. The existing array of white male superheroes needed to be diversified, preferably with the old characters being retired because they would otherwise present unhelpful competition for new characters. Progressive politics and social issues would pull in an untapped audience of millennials and Generation Z.

Although the leftist social activists in creative industries offered new alternatives, they also enacted extensive changes to existing properties. The approach was primarily destructive rather than creative. To an activist the status quo is actively oppressive therefore it must be reformed, controlled or abolished. Marvel, aware or oblivious of exactly what activist creators had in mind, acted on the advice it received.

Left-wing activism driven by identity politics and the traditional superhero culture are not a good fit. When activists appeared in editorial and writing roles, long-term fans suspected that entrants were not motivated by a desire to tell stories but to tear down much-loved characters. Many participants in the industry publicly expressed hostility towards mainstream staples, such as patriotism, capitalism, Christianity, the Republican Party and heterosexuality. The assertive politics of entryists (and their sympathisers among established professionals) contrasted starkly with the occasional storylines involving social awareness, empathic views of outsiders and tales of moral growth usually found in superhero comic books. The Identarian worldview is insistent and dogmatic. Neo-Marxism states that all areas of cultural production are influenced by dialectic struggles between social classes. Therefore

there is no area of social production which is not political. Areas that have traditionally been viewed as escapist, a place for aspiration and power fantasies (alternate universes and parallel worlds) are not exempt from politics. Indeed, the fact that these areas have traditionally been largely escapist, fantastical and free of party politics makes them special targets for activists seeking to wage cultural warfare.

Marvel, under the guidance of Axel Alonso, implemented a radical overhaul of existing properties and introduced new ones, starting in late 2014. Readers noticed dramatic changes to art: appearances of established characters altered, sometimes radically. Breast sizes diminished; androgynous body types began to proliferate; unisex clothing, haircuts and facial appearances became common. There was an explosion of gay, lesbian and bisexual characters. Ethnic-minority characters came to the fore. Female characters became assertively political. Social issues were the focus of more stories.

Superhero comics have always been political—up to a degree. Though broadly patriotic they have tackled thorny social topics and promoted an ethos of empathy and tolerance. Of the plethora of comic books and graphic novels (which cover a huge range of styles, subjects, tones and political outlooks), superhero comics are only a fraction. Like other comics, superhero comics address real issues but they also allow readers escapism and power fantasies; they operate by harnessing unreality to address reality. For male and female readers, superheroes have been paragons tempered by *believability* not necessarily *realism* and are often aspirational role models or romantic fantasies. To have superheroes who are unappealing in terms of both appearance and behaviour undermines the superhero formula. Readers could not relate to characters and did not want to.

Soon Marvel's roster of heroes appeared almost unrecognisable to long-time readers: Iceman was gay; The Hulk was a Korean-American; (one version of) Spiderman and Captain

America were black; Thor, Wolverine and Hawkeye were women; Iron Man was a teenaged black woman. Marvel editors approved overtly political positions. On one cover Bobbi Morse (Mockingbird) appeared wearing a T-shirt reading "Ask me about my feminist agenda". A comic centring on Black Lives Matter was written by a black writer who has advocated for reparations for slavery and who had no previous comic-book writing experience. The comic was cancelled due to poor sales. Outside of Marvel, Aubrey Sitterson wrote the IDW-published franchise of *G.I. Joe*, a bastion of American action heroism in a military setting. Sitterson, an avowed socialist, drastically changed the composition of the crack team to include diversity characters and unthreatening villains, thereby emasculating this symbol of American military pride in popular culture. He baited fans and made disparaging remarks about expressions of patriotic sentiment. Readers of the book identified Sitterson's actions as a distortion of the canon of *G.I. Joe* and saw his work as direct lampooning of the core audience and their beliefs. It is hard to interpret his actions as anything other than sabotage of a cultural flagship of patriotism. His run on the book was quickly terminated, apparently due to the dissatisfaction of Hasbro, licensors of the property.

America Chavez is an alien who identifies as a Latina lesbian feminist. She was written by Gabby Rivera, a Latina lesbian who (again) had no experience of comic-book writing before being given her own series. One of the most high-profile examples of progressive politics at Marvel is Kamala Khan. Kamala Khan is a Pakistani-American who takes on the role of Ms Marvel to fight injustice while adhering to Islamic beliefs. Ms Marvel was the creation of G. Willow Wilson, an American Muslim convert, and Sana Amanat, a senior executive at Marvel, also a Muslim. The comic met mixed responses and falling sales.

In an interview, black comic writer Christopher Priest explained the change in the industry that he observed after his retirement:

For years I would get a call every 18 months from either Marvel or DC where they would inevitably offer me a character of color, a black character or Latino character. I would politely decline and then pitch them on Potato-Man or Spud-Boy or whatever. They'd go, "Eh, we don't really know." […] Then 18 months later I'd get a call from Marvel or DC, and we'd do the dance all over again. So I got a call from DC, and they wanted to talk to me about Cyborg. I gave them the standard stump speech. I don't want to be a "black writer." When did I become a black writer? I used to be a guy who would write Spider-Man, Deadpool, and Batman. Why am I no longer qualified to write those characters? […] I later found out that Marvel and, to a lesser extent, DC moved into a trend where they were no longer hiring writers — they were casting writers. They're listening to chatter on Twitter insisting that only a black lesbian writer could write a black lesbian character, and that's nonsense.[149]

This tendency of casting writers reached a new level in November 2017, when activists noticed a visual resemblance between character Riri Williams and writer Eve L. Ewing, both young black women. There was a social-media petition to appoint Ewing as the writer of Riri Williams. Marvel privately acquiesced, something that was only announced in September 2018. The hiring of Ewing, a sociology author with no experience of comic-book writing, apparently proved problematic. The announcement was made only after a long period of intense coaching and rewriting of Ewing's scripts.

The anticipated new audience of SJWs,[150] who were supposed to have swelled the readership base, did not materialise. Sales of many Marvel titles dropped[151] while those of rival DC did so less. While top titles in 2017 sold as much as 300,000 units to retailers in North America, even wide promotion and some favourable publicity could not prevent sales of *Ms Marvel* (Marvel's flagship progressive title) dropping from 80,000 to 15,000. (Insiders state that 10,000 sales is the break-

even point.) Forty of Marvel's 104 new titles had been cancelled by April 2017.

Comic-book sales figures can be misleading. The sale-or-return model is not standard in comic-book distribution. Instead, stockists buy copies at discount and retail to customers. Sales figures are of numbers of copies shipped to retailers not those sold to customers, so copies bought by retailers but which remain unsold are still counted as "sold". Publishers sometimes send to stockists extra free copies of ordered titles. These extra copies are recorded as sales even though they are unrequested, not paid for and often go unsold. Apparently, there is pressure on retailers to order certain flagship titles alongside their regular orders. These practices artificially inflate sales figures, serving to disguise unpopular titles which are pushed for reasons of status, promotion and internal politics.

Marvel insisted online sales prove the popularity of new characters but it refuses to release figures.

Fans accused Marvel's entrant writers of virtue-signalling their identity politics by promoting surface diversity but creating characters with shallow personalities. Many writers and artists were inexperienced, especially in the field of superhero comics. Readers accused Marvel of hiring on the basis of diversity not ability, as many new writers were fiction authors with little aptitude for comic-book writing. It was noted that a great influx of young college-educated women, who had expressed little or no interest in superhero comics, had been hired as editors. They had few if any qualifications for the positions. Prerequisites for editorship of comics are a love of the genre and a commitment to taking time to learn the form's lore and conventions. A number of grammatical errors and continuity glitches in comics indicated new assistant editors were making basic errors. It was clear that there were very few barriers to entry for assistant editors and lower-tier management in comics and only a slightly higher level for writers and artists, which had allowed cultural entryism.

Fans claimed that new writers had drained fun and hetero-sexual romance out of comics. In videos,[152] blogs and forum posts fans explained that they felt patronised and requested strong stories, nuanced moral dilemmas and believable inter-actions between consistent characters. They objected to major changes to existing characters and expressed willingness to accept new diverse characters if they were well-written. It became evident (by considering the overall output of the new writers in all media) that many new writers were only inter-ested in seeing their own lives in their comics. Certain themes or stories dominated the outputs of writers and this influenced their work in comics. However, the tropes and conventions of superhero comics—not to mention the degree of imaginative scope needed—demand detachment and flexibility of authors of superhero comics. What works in a slice-of-life graphic novel does not necessarily fit with an action drama in a superhero adventure (using pre-existing characters) told in monthly instalments. The new authors were unable (or unwilling) to empathise with different political and social outlooks; they resisted doing research or risking imaginative flights which would allow them to inhabit situations outside of their lived experience.

In March 2017, David Gabriel (Vice President of Sales at Marvel) said, "What we heard was that people didn't want any more diversity. They didn't want female characters out there. That's what we heard, whether we believe that or not. I don't know that that's really true, but that's what we saw in sales."[153] The most politically committed Marvel editors, writers and artists responded negatively to criticism. Kelly Sue DeConnick (creator of the androgynous version of Captain Marvel) responded, "if you don't like my book, don't buy it".[154] Readers seemed happy to oblige her. Her *Bitch Planet* "sold" only 8,401 copies to stores in October. In an age of Twitter and instant public reaction, Marvel's decision to employ individuals who prided themselves on their social-media activism backfired painfully. Some writers spent more time on Twitter criticising

President Trump than promoting comics. Prompted by the mildest criticism, creators made profanity-studded denunciations against fans. There were multiple instances of creators publicly wishing violent death on critics, sometimes with specific details. These comments received "likes" and "retweets" rather than condemnation.

Examples of Twitter posts include Max Bemis (writer, Boom/Marvel): "i will say it though, if you choose to bully the oppressed into a life of depressive self reflection or eventual death, you're on my fucking shit list FOREVER, and will be only invited around to pleasure my hindquarters. #justsayin!"[155] Replying to a comment that enough Republicans might vote to prevent Trump winning election, Nick Spencer (writer, Marvel) wrote: "The polls are more than clear – there are not. Stop believing in the myth of the good Republican."[156] Alanna Smith (editor, Marvel): "Make no mistake even if Trump loses, we will remember who supported him."[157] Sophie Campbell (writer-artist, IDW): "If I had a magic button I could push that would magically kill all GOP [Republican] politicians in Washington, I would push it and then take a nap."[158] Ron Marz (writer): "Yes, I enjoyed the video of the Seattle Nazi get punched in the face. Very much. Freedom of speech is not freedom from consequences."[159] Patrick Zircher (artist, DC): "It's not really my job to persuade or convert anyone. It's not even my job to listen to complaints."[160] Jeff Lemire (writer, Image): "Comicsgate is based on fear, intolerance, bigotry and anger. The comics creators emerging today are too talented, too smart and too loud to be beaten by these weak people. It's time we all started standing up for one another."[161] Mike McKane (artist): "Comics are for everyone. Everyone except Comicsgate, they can die from dick cancer."[162] Zoe Quinn (writer, DC): "I don't care what kind of nerdy "gate" it is – they're on the losing side of history. Games, comics, anime – our nerd shit is for everyone. Bullies and bigots fuck off. Four years into the fuckers trying to tear me down and I'm still out here & supporting others. // Have each other's

backs when fuckers try and come for marginalised creators –
don't wait for anyone else to do it for you or make it easy if
you're able to lend a hand // Nazi nerds fuck off."[163] John
Layman (writer, DC/Marvel/Image): "I've made it crystal
clear to Nassir [Rabadi, Comicsgate-affiliated artist, who com-
plained to Layman's employers about his behaviour online]
and other Comicsgate losers I'm don't want anything to do
with fuckers who traffic in abuse & harassment of comics
colleagues. I don't need or want their money. Comicsgate can
fuck off. I maintain a higher standard for myself & my reader-
ship. // Now it turns out this human cum rag Nassir Rabadi,
this walking unflushed truck stop toilet, has invented that I'm
racist for not putting up with his shit, not kissing his stupid
Comicsgate ass. And has been making REPEATED calls to
Image to what...accuse me of racism?"[164] (All texts
uncorrected.)

Accusations of bigotry by Gabriel and others at Marvel cut
fans particularly deeply. Comic-book fans – self-described
geeks and nerds – have traditionally felt sympathetic towards
stories of struggling underdogs and overcoming prejudice.
Fans pride themselves on being open-minded and socially
liberal. Marvel was blaming industry decline on fans who had
sustained it through recession and dwindling audiences; not
only that, they were being smeared as racists and sexists.
Superheroes have been racially diverse for a long time and
there have been prominent female characters for decades. In
1966 Stan Lee invented Black Panther, a flagship character;
back in 1982 the first female Captain Marvel was a black
woman. DC Comics has had non-white heroes who have been
consistently popular and long-lived because readers liked the
stories and related to the characters. This, plus previous success
of minority-identity Marvel characters, suggested resistance
was not to diversity but to political grandstanding.

The suspicion was that new editors and writers had no
understanding of, or passion for, comics as a medium. They
had no emotional investment in seeing Marvel prosper; they

only saw it as a platform to push their social agendas and to secure positions in film and television.

On 28 July 2017, Heather Antos (assistant editor at Marvel) posted on Twitter a photograph of her drinking milkshakes with six other young female Marvel colleagues. Antos, a recent entrant at Marvel Comics, had become well-known to Marvel fans through her social-media profile and multiple posts in favour of Identarian viewpoints. When her milkshake photograph attracted a handful of critical comments there was a drive to present this as harassment. This resulted in a deluge of publicity and support for her, including group photographs of colleagues expressing solidarity. Despite enquiries about the nature of the harassment, no evidence was ever presented (apart from the publicly visible critical comments) that Antos had ever received threatening or intimidating contact because of the photograph. It became a publicity coup—albeit an inadvertent one—for social activists: any sarcastic, crude or negative comments made about Antos could be used as *prima facie* evidence of a huge reservoir of violent misogyny and therefore the necessity of promoting women to spite bigots.[165]

Angry that their objections about recent comics had been misrepresented, fans savaged Marvel. The turning point seems to have been New York Comic Con in October, when retailers berated[166] Marvel representatives, stating they had trouble selling (and explaining) new comics to customers. The failure of Marvel—the major publisher not only of superhero comics but of comic books in North America—was having a grave impact upon retailers. Despite diversification into areas such as toy, figure, video games, board games and merchandising, mass sales of popular superhero comics are still required to sustain finances of traditional comic-book shops which also sell independent comics, graphic novels, manga and *bandes dessinées*. Over 50 comic-book shops closed in the USA during 2017, with a dip in year-on-year sales of 10%, comparing December 2017 to December 2016.[167]

Marvel management finally took action. In November it was announced that Axel Alonso (who oversaw many of the controversial changes) would soon leave the position of editor-in-chief.[168] His replacement was Vice-President of International Marketing, C.B. Cebulski, who was seen as a more traditional comics fan. In November and December 2017, the new management of Marvel Comics culled many unpopular titles, some including the new "diversity" characters and books written by entrant writers.

In November 2017, the phrase Comicsgate (which was coined in the summer) became a widespread social-media subject as social-activist creators, editors and journalists launched attacks on Ethan van Sciver (who admitted to voting for Donald Trump) and Jon Malin (who merely stated he was not an SJW) and against traditionalist fans who made vlogs deriding leftist and Identarian comic books. Michelle Perez (writer, Image) tweeted: "richard c meyer, aka the diversity & comix guy. he did a 30 minute video about a comic book circular that featured an article of mine. hes a multiple divorcee piece of shit. hes a war veteran so of course he's a cryptofascist. unfortunately, an IED [improvised explosive device] didnt blow him up."[169] Richard C. Meyer, who produced vlogs as Diversity & Comics, was an ex-US Marine who had seen active service. His videos were very critical of identity-politics driven comic books. A number of Perez's colleagues refused to condemn the tweet. David Mariotte (associate editor, IDW): "Just to make this perfectly clear, if you send me a thing from Diversity & Comics or any of the other ComicsGate hate group, you're blocked/banned/etc. That sort of sexism/racism/homophobia/transphobia is unacceptable."[170]

Ethan van Sciver was targeted by a cyber-stalker who threatened him and his family. Gotham City Pizza, a comic-book store in Ormond, Florida, was vandalised the day after van Sciver did a signing there. Other prominent critics and non-leftist creators were prey to cyber-stalking.[171] Even established left-wing creators (such as Patrick Zircher) were smeared

by guilt through association when they engaged via social media with individuals of whom Identarians disapproved. Association with critics became an infraction punishable by campaigns of retribution. Activists targeted the most popular YouTube channels run by critics. Videos were mass flagged, copyright strikes filed, Patreon[172] accounts targeted for closure. On social media and websites, critics were slandered as Nazis, Ku Klux Klan supporters and ignorant bigots who were directing internet trolls to harass creators. Criticism of Identarian comic books in vlogs was largely directed at the products but there were some personal jibes at creators. The jibes ranged from the insightful and funny to the juvenile and mean-spirited; none amounted to threats. There were some calls to boycott titles made by activists who were aggressive and abusive on social media, but there were no calls to target personal attacks at these creators. Accusations by activists of harassment were not supported by evidence.

Industry insiders revealed to video critics that a small and informal clique of influential gatekeepers and tastemakers — including artists, writers, editors and journalists — were attempting to destroy professionals who refused to follow the anti-Trump and pro-Identarian agenda.[173] These revelations were partially confirmed in public by some clique members. Individuals involved were all minor and marginal players but were able to exert behind-the-scenes influence and mobilise small groups of supporters on social media to intimidate professionals. The clique mounted campaigns of personal gossip and slander, sometimes leading to doxing (revealing private details of individuals online) and threats of violence. This was done not only as a punishment but as a warning to others. Activists instigated "hit pieces" against opponents, written by sympathetic journalists working for specialist web-sites. These pieces could later be picked up and paraphrased by bigger outlets without fact-checking or corroboration. Activists directly attacked the finances of opponents by attempting to destroy their livelihoods. They acted as gatekeepers who

valued in-group loyalty above commercial success. Many of these activists disliked superhero comics, felt disdain towards readers and displayed no restraint in abusing people in vitriolic attacks on social media. Here was clear evidence that activist creators had no respectful sense of duty towards fans, employers or the conventions of the fictional universe they had inherited.

Those making critical videos and internet posts included female, black, Hispanic and gay comic-book readers; other critics were in mixed-race relationships and with mixed-race children. Accusations of racism, misogyny, xenophobia and homophobia became insupportable yet were still routinely and indiscriminately made against critics. To support comics that fans enjoyed, the hashtag #MoveTheNeedle was used. Fans who bought specific books recommended by video critics would take a photograph of the comics they bought and post the image on internet social media (primarily Twitter) using the hashtag #MoveTheNeedle to catch the attention of creators, publishers and retailers in order to demonstrate that buyers were committed customers and happy to support products they appreciated. It was a popular campaign and showed the positive side of Comicsgate supporters. Activist creators dismissed #MoveTheNeedle as cover for a hate campaign.

In February 2018 DC announced a new speech-code policy for employees discouraging abusive interaction with fans. On 20 February 2018, C.B. Cebulski announced a line-wide over-haul at Marvel Comics, restoring the classic versions of the most popular superheroes, retaining a handful of the new characters. It seemed as though the fans had regained the characters they loved. Subsequent announcements that social-activist writers would still write books for Marvel signalled that the company was struggling to appeal to two increasingly fractious sections of its readership. In March 2018 the Editor-in-Chief of IDW, a comics company which had heavily pandered to identity politics, departed after a drop in profits from 2016 to 2017 of 91%. That same month, Heather Antos announced she

was leaving the comics industry. As IDW's finances worsened that summer, founder and CEO Ted Adams resigned. The economic attrition of companies producing politically directed content against the wishes of its customers became undeniable. This led to the biting critical slogan "Get woke, go broke" to characterise the commercial failure of "woke" ("politically enlightened") policies in an open marketplace.

By August 2018 the consensus among readers of comics was that Cebulski was unable or unwilling to curb identity politics in Marvel. Activist creators who had had their books dropped for low sales and negative reader response (including Mariko Tamaki, Sina Grace and Magdalene Visaggio) were brought back as writers. Sana Amanat, Marvel's Director of Content and Character Development, was identified by commentators as the driving editorial force behind social activism and identity politics at the company. Amanat, an American of Pakistani Muslim heritage, studied politics at university and had little direct experience of comics creation when she joined Marvel. In numerous interviews she stated that she did not want the company to be "a boy brand" and wanted it to be a lifestyle brand.[174] She spoke repeatedly about representation, demographic diversity and using characters for political reasons. As sales figures continued to sink, it was clear that the political and social project of Amanat and like-minded creators and executives was non-negotiable, even if it alienated dedicated customers and casual readers.

Creators Richard Meyer, Ethan van Sciver and Mitch and Elizabeth Breitweiser launched self-produced comic books via Indiegogo, an internet crowd-funding platform. By July they had raised over $1 million dollars on three books. Selling tens of thousands of copies of their books directly to customers, they matched and surpassed many books produced and sold at lower cost by publishing groups, thus confirming there was a market for non-political action comics made by professionals who disagreed with the political agenda of Marvel Comics. Other creators who considered themselves excluded from

major companies also launched projects. Despite the impediments of shipping costs, deferred delivery and lack of conventional publicity and marketing, the Comicsgate producers showed that they were capable of producing material that customers wanted and for which they were willing to pay over the standard price. Having built fan bases, interacted with the public and having made books specifically to appeal to a mass readership, the Comicsgate traditional apolitical action comics outsold poor-quality political books by Marvel. Whereas activist creators angrily castigated readers who objected to political agendas and proudly discouraged them from buying books, stating "these books weren't made for you", Meyer announced "if you can read and you have money… you're my audience".

Although the American superhero comic-book industry is a market subject to unique conditions (most especially its wide reach but limited pool of publishers and creators), numerous instances of the activist tactics and behaviour in Comicsgate coincide with elements seen in other areas, namely: cultural entryism, importance of in-group loyalty (demonstrated through repeated public acts of support), use of purity tests for creators and consumers, gatekeeper cliques, hiring of fellow activists, action to suppress dissenting speech (be that in cultural products or in the reaction to those products), lack of loyalty towards employers, lack of respect for consumers, lack of civility, use of *ad hominem* attacks, lack of professionalism, absence of interest in the history of the cultural form, refusal to separate politics and art, use of culture as socio-political propaganda, disdain towards commercial success and popularity, distortion of beloved characters and dismantling of genre lore deemed politically objectionable, introduction of characters defined principally by demographic traits, dismissal of all criticism as bigotry, use of unsubstantiated claims of harassment, co-ordinated use of social media to ostracise and virtue signal, and routine misrepresentation of facts. The amount of deception and self-deception by Identarian activists in the

comics industry is evidence that any tactic is considered valid in a battle between good and evil. Activist aggression (apparent in the desire to humiliate opponents) reinforces the impression that moral vindication and vengeful retribution underlie Identarianism's ostensibly political agenda.

Failure of the Mainstream Media

One of the most eye-opening (and depressing) aspects of watching Comicsgate unfold in real time was the mainstream media coverage. Having seen the terrible writing, lazy editing and inadequate art of many of the social-activist comics (contrasted with the examples of good comics) and seeing the critical comments of fans, the subsequent caricature of vicious intolerant fans hounding talented creators because of their gender, sexuality or ethnicity became a salutary lesson in the failure of the mainstream media. In videos and online media, one could see the way specialist-press articles written by partisan journalists distorted the truth, turning reasonable and mild criticism of comics into a "hate mob". Newspapers echoed that social-activist narrative, using selective examples and misrepresentation. Editors and writers of the mainstream press displayed little attempt to understand the subject through research and factual sources. I read many newspaper articles about Comicsgate that were simply untrue. I write that as someone who is sceptical of conspiracy theories and supportive of the need to have a strong and varied mainstream media.

Some decades ago we recognised that journalists (like all of us) have implicit biases and that the media presents the truth incompletely, sometimes with an underlying political slant. One lesson drawn was that we as consumers should be on guard. However, there was no concomitant lesson drawn by journalists. Rather than struggling to maintain impartiality in order to present facts clearly, many journalists simply unshackled their biases. The understanding of implicit bias did not result in a move to encourage greater journalistic objectivity but an acceleration towards campaigning journalism and

expression of personal feeling. Today's journalists have ingrained assumptions about victim and oppressor classes, the unfairness of society, the prevalence of misogyny and other narratives commonly repeated but rarely backed by evidence. When presented with a story which apparently confirms those assumptions, journalists do not check sources in more than a cursory manner. Journalists of questionable professionalism, without adequate time to research and subject to relatively little accountability, accept stories at face value. In the torrent of online news, mistakes and omissions in unimportant stories or on low-traffic websites go unidentified. Stakes for a journalist making mistakes are low. Journalists in the mainstream media have become unwitting broadcasters of falsehoods which become purported evidence to support common narratives. Social-justice-activist journalism has generated a feedback loop.[175] The number of headlines asserting a generalisation seemed – alone – sufficient evidence to someone making a cursory inspection.

In a media era which is less about hard news and more about human-interest stories, lifestyle pieces and social commentaries, investigative journalism becomes a rarity on the margins of the average person's media consumption. Media outlets have little incentive to send reporters to cover subjects that require extensive research, multiple sources and fact checking. That is an expensive time-consuming operation that even a serious newspaper cannot afford in a time of straitened finances, falling sales and greater competition. There is a commercial incentive to present stories that are "clickbait" and which confirm readers' established prejudices.

It is not that there is a conspiracy to suppress stories; it is more that there is little incentive (professional and financial) for critical reporting to win out. As with most people, confirmation biases of journalists, editors and readers lead them to inter-pretations that fit their preconceived notions of what is true about society. There is an obvious conflict of interest between a journalist's professional commitment to provide factual

information as honestly as possible and his new socially sanctioned role as an activist who pushes a political agenda. In a time when many university humanities courses rely on Post-Modernist conceptions of standpoint theory, relativism and inter-societal factionalism, how can we not have a generation of graduate journalists who believe their business is to shrug off falsehoods about the existence of truth and objectivity and instead do whatever they can to advance social justice?

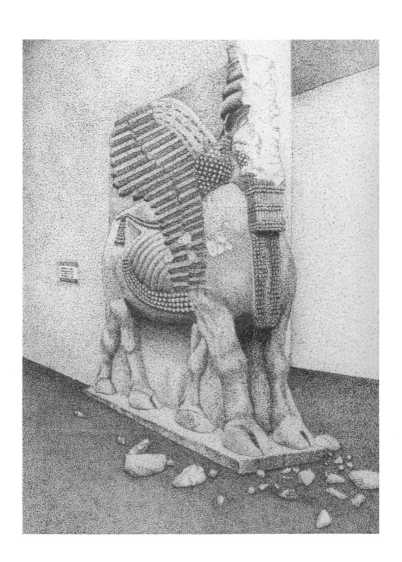

Conclusions

We have seen in these essays that a web of Identarian, feminist, leftist, new leftist, Marxist and neo-Marxist beliefs underpin assumptions and actions of some producers and consumers within cultural fields today. It is impossible to understand quota programming, opposition to free speech, leftist sympathy for Islamist terrorism and numerous manifestations of seemingly unconnected and ugly instances of tribalism within the arts in the West without understanding identity politics and feminism and—beyond that—the Marxian (and Marxist) cultural theories that generated them. It is important that we not see—for example—the push for reparations and feminist action to remove art from public display as unconnected incidents. They are deeply connected on political and philosophical levels and are closely allied. Although many activists within the cultural field do not understand the ideas animating their activism, for us to have a clear view we need to be aware of how politics has (albeit indirectly) shaped the mentality of activists, especially if we want to oppose their actions. I have only minimally sketched the origins of Post-Modernism and identity politics, and only insofar as they apply to activism in the arts. My aim in these essays is to highlight manifestations of identity politics within culture and to alert readers so that they may identify and understand instances of identity politics as they encounter them.

Artists should be free to produce what they consider necessary and significant. It therefore follows that artists should be free to produce bad art, politically disagreeable art and art that relies upon the crutch of identity politics to sustain attention and income. If art has merit or substance than it will survive and may even become valued and revered, but it is unhealthy and unproductive for us to judge art *a priori* on the

basis of the maker's demographic characteristics. Such an approach is almost entirely alien to the way art has always been valued and understood and is likely to promote and encourage production and consumption of art that lacks significant aesthetic content or value. The burden to scrutinise and discourage that approach must fall upon the critics, teachers, curators, museum staff and arts administrators rather than upon artists. Once professional artists are no longer rewarded for producing art which signals demographic characteristics of the artist as a promotion tool, production of such art will no longer be encouraged. Arts professionals can choose any criteria they want to judge art. This book makes the case that if they want art to be as rich and vital as possible — and for that art to be as high in quality as possible — encouraging art to be produced and consumed on the basis of identity politics is the least optimal choice. This point is doubly pertinent when we consider that considerable sums of taxpayer money are being expended to support art that is primary political — and which represents a view representative of a fraction of taxpayers.

Culture cannot but reflect the wider society within which it is produced. We only separate culture from society for the purposes of understanding something about the part without having to analyse the whole. There is no social attitude in artistic culture that is not present in some way in science, economics and other non-artistic cultural fields. I do not deny that political attitudes and assumptions pervade culture and its criticism. As an art critic, I have written on political and social factors pertaining to visual art. During my university studies I read Marxian, psychoanalytic, feminist and Post-Modernist cultural analyses in relation to art history. I do not reject them outright, finding elements of value in each. The existence of multiple interrelated factors means individual responses are so complex that taking any single socio-political interpretation as universal or dominant is both redundant and actually mis-leading. Complete systems of criticism cannot function

adequately; only hybrid systems can describe the complexity of art.[176] The evidence of my personal experience leads me to believe that the principle foundations of artistic meaning are derived from the visual qualities of art and our reactions to those. Art is essentially an aesthetic and personal experience. Social conditioning plays a part in our view of art but our responses to art are mainly personal and informed by psychological and perceptual factors.[177] Individuals who see every aspect of life as pervaded by social conditioning and reflective of power structures diminish reality by overlaying upon it universal systems. When everything is political nothing can be personal.

I do not have a particular political platform. Rather, I suggest it seems wise to criticise ideas based on bad logic and incomplete or faulty evidence and ideas which (when applied) lead to unwelcome outcomes. The mainstream media can play a valuable role by examining social assumptions sceptically, demanding evidence and stepping away from imposing a moral perspective on the news and so allow readers to reach their own conclusions. While pure detached objectivity in media coverage is impossible, it has huge value as an aspiration to be worked towards, which would curb the excesses of political bias. Individuals within the arts should apply their own scepticism to ideas of significant structural change on the basis of "progress", "inevitability", "inclusion" and "diversity": all words used to cover leftist activism. Acceptance of such arguments implicitly accepts the validity of dehumanising collectivist ideology. There may be merit in changes proposed but they must be judged carefully and individually. Support for change must be advanced with clear logic and evidence, not supported by sweeping assertions and emotional blackmailing. Resistance to such changes should not be just dismissed as unconsidered conservatism. History is replete with examples of tragic follies (slight and huge) which were accepted by societies as necessary and inevitable instances of progress simply because they were described as progress.

Had I been resident in Eastern Europe while writing this book, I might have been more concerned with right-wing collectivism—in the forms of nationalism, nativist isolationism and religious influence of Christian conservatives—during the development of my arguments. However, from the perspective of Western Europe and English-speaking countries, the preponderant source of conformity and restriction in the arts comes from the collectivist new left. Accordingly, I shaped my thesis to reflect this. I acknowledge that such rightist influences exist worldwide and that many of my concerns apply to both ends of the left–right axis.

There is reason to take heart. Observation, curiosity and honesty—with a dash of patient empathy—allow us to apply reasoned criticism to the politics motivating the activism that disfigures Western cultural production today.

Appendix

Against Identity Politics in Arts Programming

We, the undersigned, have been concerned by the rise of identity politics in arts programming, arts policy and critical attitudes towards the arts. Identity politics is a system of beliefs which prioritises surface characteristics of creators and consumers of art above the content of art. It is a dehumanising set of beliefs which divides people along racial, ethnic, gender, sexuality, religious and other lines. It demeans creators and consumers of art and encourages production of art that lacks the subtlety, ambiguity and richness of which art is capable. We oppose identity politics and affirm the following principles:

1) Art should be judged primarily on its intrinsic merit.
2) Artists should not be judged on their demographic characteristics but upon their merits as demonstrated through their production.
3) There should be no quotas (official or unspoken) along demographic lines regarding art programming, prizes, awards, bursaries, exhibitions and acquisitions, as well as the staffing of arts organisations.
4) Arts organisations should be staffed by individuals with sufficient competence, experience and personal attributes to

make them suitable for their positions. In their official roles, they should be committed to serve art and their organisation not their private political convictions.

5) Consumers of art should not be patronised but treated as individuals of unique tastes and interests. If members of the public choose not to engage with art then that is not a failure; it is the choice of individuals. There should be no targets for audiences in terms of demographic characteristics.

6) It is healthy for opinions of various political outlooks to exist within the arts. It is important for reasoned dissent to be heard in order to combat the emergence of an unhealthy political monoculture.

We believe that if these principles are applied then the arts — and public life more widely — will benefit.

Yours, etc.

This statement was published in The Jackdaw *no. 139 (May/June 2018) and subsequent issues. Early signatories were Alexander Adams (artist, critic), David Lee (editor), Jane Kelly (writer), Simon Tait (art critic), Donald Harris (painter), Elisa Hudson (artist), Dr Myron Magnet (editor), David Buckman (art historian), Dr Selby Whittingham (art historian), Michael Daley (artist, director), Dr Peter Wood (art historian), Dr Frances Follin (art historian, editor), Théophile Aries (musician), Lisa Snook (artist, art therapist), Roger Bates (lecturer, artist), Anthony Daniels (writer), Dr Eric Coombes (critic, philosopher), Sohrab Ahmari (journalist), Dr Glyn Thompson (art historian), Roger Gower (www.theuncommonspeaker.com), Nuala Murray (fine-art researcher), Toby Young (writer), Peter Clossick (painter), Professor Frank Furedi (sociologist, author), Judith Platt (art historian), Ashley Brown MD FRCS, Duke Maskell (director of Edgeways Books), Brian Lee (writer), Ian Robinson (literary critic, publisher), Malcolm Love (artist), William Varley (critic, writer), Neil P. Confrey (painter), Ruth Dudley Edwards (writer), Ian Lightfoot (art-and-design education adviser and*

lecturer), Angela Lemaire (painter, printmaker), Dr Wendy Earle (writer), Miriam Elia (artist), Dr Tiffany Jenkins (sociologist), Claire Fox (writer, radical), Dick French (painter), David Burnett (painter, critic), William Mackesy (artist).

About the Authors

Alexander Adams is a British artist and writer. He studied fine art and history of art at Goldsmiths College, London. His art has been exhibited worldwide and is in the collections of the Victoria & Albert Museum (London), National Museum (Cardiff), Walker Art Gallery (Liverpool) and other museums. His art criticism has been published in *The Burlington Magazine*, *The Art Newspaper*, *Sculpture Journal*, *The Jackdaw*, *The British Art Journal*, *Apollo*, *Printmaking Today*, *Print Quarterly* and other outlets. His poetry has been published in anthologies, broadsides and single-author volumes in the UK and USA. He was artist-in-residence at the Albers Foundation, Connecticut, in 2011. Alexander Adams is the recipient of the 2018 Artist Scholarship from the Francis Bacon MB Art Foundation, Monaco. He lives in England.

Theodore Dalrymple is a retired doctor. He wrote a column for *The Spectator* for 14 years and the *British Medical Journal* for six. He has published art and literary criticism for many years, notably in *The New Criterion* (NY).

Textual history

Six of the included texts were previously published (five in abbreviated forms and some lacking endnotes) in the following publications: "On Islamism and the Arts" was published as "Islamism and the Arts", *The Jackdaw*, issue 121, May/June 2015 (and published on *The Jackdaw* website and also (in a shortened form) as "Islamism and Identity Politics—a Destructive Mix" on the *Spiked Online* website, 14 August 2015); "On State Subsidies for Art" was published as "Why Are Artists Poor?", *The Jackdaw*, issue 134, July/August 2017; "On Quota Programming" was published as "New Order", *The Jackdaw*, issue 135, September/October 2017; "On the Western Canon" was published as "Canon Fodder", *The Jackdaw*, issue 136,

November/December 2017 and was republished (in a shortened form) in *The Salisbury Review*, vol. 36 no. 4, Summer 2018; "On Reparations" was published as "The Road to Reparations", *The Jackdaw*, issue 139, May/June 2018; "Against Identity Politics in Arts Programming" was published in *The Jackdaw*, issue 139 (May/June 2018) and later issues. The texts in this collection are the complete versions. "On Islamism and the Arts" includes the section "Fatal Attraction" written for this book, previously unpublished; "On Quota Programming" incorporates some material from the article "Trouble at the Tate", published at the *Spiked Online* website, 25 September 2017; "On the Western Canon" incorporates some material from the unpublished article "What Patriarchy?"; "On Identity Politics" was written for this book and is previously unpublished; "On Cultural Entryism and Social-Justice Activism" was written for this book and is previously unpublished, it incorporates some material from "Superheroes versus Identity Politics", published at the *Spiked Online* website, 1 December 2017.

The texts have been revised lightly and original textual errors corrected. References in the text to other essays use the conformed new chapter headings not the original essay titles. Extra endnotes have been added.

Acknowledgements

I would like to thank Theodore Dalrymple, for his introduction; David Lee, editor of *The Jackdaw*, for publishing much of this material in *The Jackdaw* and for checking the text of this book; Dr Anne Laure Bandle, for her comments regarding "On Reparations"; Douglas Ernst, for his comments regarding Comicsgate; Brendan O'Neill and Tim Black of *Spiked Online* for publishing parts of this text; Merrie Cave, literary editor of *The Salisbury Review*, for republishing "Canon Fodder"; Simon Casimir Wilson, for his thoughts on the essays as they were published; Donald Lee, literary editor of *The Art Newspaper*, Robin Simon, editor of *The British Art Journal*, and Michael

Daley, of *ArtWatch UK*, for their support. It should not be inferred that these individuals endorse any of the ideas in this book. The text, arguments and errors are my own.

Notes

When compiling these endnotes I had to balance the value of noting specific sources with the worthlessness of providing links to ephemeral social-media posts, videos and online articles on the internet which will soon become inaccessible. I have refrained from listing all sources, especially regarding Comicsgate, which I followed daily over many months as it occurred. My overall thesis is — as far as I know — original and developed in my own way, though some of my observations doubtless echo comments made by others. I have tried to note originators of ideas whenever I have remembered them. To those I unintentionally omitted go my sincerest apologies.

[1] Video interview, 10 June 2014, https://www.youtube.com/watch?v=MPaJueG2NPc [retrieved 2 August 2018].
[2] Speech, 16 October 2017, https://www.youtube.com/watch?v=bC_29j-_sRU [retrieved 2 August 2018].
[3] The term "leftist" covers adherents to the far left (Marxism, neo-Marxism, socialism, communism and variants), intersectional third-wave feminists (see the section "Identarianism" of the essay "On Quota Programming") and radical feminists (feminists who view patriarchy as endemic to Western civilisation and seek to effect extreme social change to combat it); also included are anarchists and supporters of identity politics. These terms are not synonymous with the left and not politically congruent. These groupings include strands which are not far left (sometimes not even leftist at all). However, the groupings share many points of commonality. "Leftist" is used in preference to "far left" because many supporters of identity politics are actually moderates and liberals who sympathise with leftist ideas, especially in terms of racial politics, social justice and so forth, even if they are not actual supporters of the left. When these individuals are acting in a leftist manner I describe them as leftist, even if they are not technically of the left or far left. Additionally, even though black nationalist and black separatists are technically authoritarian, collectivist ethno-nationalists and theoretically on the right in the political spectrum, they often act in concert with and draw ideas from the far left. Accordingly, I have

chosen to treat them as leftists.

4 Alternative adjectives are unsatisfactory: redefining "liberal" is problematic, as well as time-consuming in a short essay; "neo-liberal" refers to a specific school of economic thought; "illiberal" is merely an insult; "Politically Correct" is idiomatically awkward and has particular connotations of campaigning leftism (though a largely pejorative term, it accurately indicates genuine intolerance towards opposing political ideas); "post-liberal" is a workable though inadequate neologism indicating an outlook that claims to be liberal but no longer conforms to liberal founding principles (see the section "Identity Politics" below).

 2018 note: Having read Sohrab Ahmari's *The New Philistines* (Biteback Publishing, 2016), I would now call "post-liberals" "Identarians" (advocates of identity politics, not to be confused with European neo-nationalists who describe themselves as "Identitarians") or "leftists". Although these individuals are sometimes called "liberals" in American discussion, this is an inaccurate term which deviates significantly from a definition of liberal. That change in terminology is reflected in the other (later) essays in this collection.

5 "The West" is used to mean (very broadly) mainstream societies in Western and Northern Europe, particularly the UK.

6 *God is Great (no. 2)* (1991), presented to the Tate Gallery in 2005.

7 ComRes poll of British Muslims, conducted for the BBC, 25 February 2015: those who believe British law must be obeyed 93%; those who "have some sympathy for the *Charlie Hebdo* killers" 27%; those who say violence against publishers of [presumably offensive] images of Mohammed is never justified 68%, disagree 24%.

8 Consider the French attitude towards the *crime passionelle*, the crime of passion, where a defendant is judged to be less responsible for his actions due to a temporary loss of control caused by extreme emotion. People (including Pope Francis) have used *crime passionelle* as partial exculpation for the Paris and Copenhagen attackers, despite the fact preparation and premeditation rule out the prerequisite of instantaneousness of action in these cases.

9 It is worth noting that 1989, the year of the Rushdie fatwa, was the year when the descriptor "British-Pakistani" and "British-Asian" began to be superseded by "British-Muslim", as individuals began to see themselves as defined by religion rather than national origin. That is, they started to consider themselves first and foremost as Muslims in the UK rather than as Pakistani expatriates/descendants.

10 This last example may seem comical but it actually happened in Batley, Yorkshire, in 2003. A pre-emptive ban was imposed by a non-Muslim head teacher on all books featuring pigs in order to avoid offending Muslims. No complaint had been received and, much to the credit of local Muslims, they called the ban "misguided" and urged it be reversed. Identity politics encourages pre-emptive censorship, some-

thing that extremists exploit. See https://www.theguardian.com/uk/ 2003/mar/05/schools.books, retrieved 15 February 2015.

[11] Coleman and Bartoli note that within extremist organisations there exist individual differences of what is acceptable and desirable in terms of violent action, "Addressing Extremism" (2009).

[12] "*Halal*": permitted; "*Haram*": forbidden.

[13] See Sigmund Freud, *Beyond The Pleasure Principle* (1921).

[14] On the role of anger, insecurity, humiliation, lack of power and other aspects in the psychology of extremists see Arno Gruen, Peter Coleman & Andrea Bartoli. For a view of extremist violence as primarily tactic strategy see Eli Berman. Coleman & Bartoli also discuss extremism as strategy (*ibid.* endnote 11).

[15] In the case of the Boxer Rebellion in China, rebels believed they were literally divine and immune to bullets.

[16] The Islamist attacker experiences cognitive dissonance in holding two contrary views simultaneously: he considers that he is displaying exceptional devotion in martyring himself; and he bears no responsibility for the bloodshed which must inevitably result from the collision of blasphemy and the duty of a jihadist.

[17] See Edward Said, *Orientalism* (Pantheon, 1978) for a contentious view of the subject.

[18] Sam Harris, *The End of Faith: Religion, Terror, and the Future of Reason* (W.W. Norton, 2004).

[19] See also the section "The Empathy Deficit" in the chapter "On Identity Politics".

[20] Consider the cases of Frantz Fanon, philosophical theorist of the Algerian War, and Ali Shariati, an Iranian sociologist and political activist, both of whom established close ties with French Marxists whilst in Paris. They adapted Marxist ideas and strategies which were used successfully during various revolutions in the developing world. See the television documentaries by Adam Curtis for a socio-economic interpretation of Islamist violence and Western political exploitation of the politics of terrorism.

[21] For a discussion of leftist admiration for violent action, see note 171.

[22] For examples of far left anti-Semitic threats and violence see the emigration of Jews from Venezuela following anti-Jewish rhetoric of the socialist government and anti-Semitic attacks or threats in Sweden where Muslim and leftist groups are the principle perpetrators. See the paper: Lars Dencik & Karl Marosi, "Different Antisemitisms: On Three Distinct Forms of Antisemitism in Contemporary Europe—with a Special Focus on Sweden", June 2016, http://kantorcenter.tau.ac.il/ sites/default/files/PP%203%20Antisemitisms%20160608.pdf, retrieved 15 February 2018.

[23] Consider the Deobandi movement and Islamist Brotherhood party, which both came into existence to combat the influence of Westernisa-

24 tion and secularisation of Indian Muslim society and Egypt respectively. While the initiating impetus may have been reaction to Western influence, both movements have essentially religious character and now work against moderate and non-observant Muslims and are nothing less than movements asserting quasi-traditional interpretations of Islam.

24 Consider the 1979 Iranian Revolution. Two principle political factions took leading roles: the Islamists and the communists. They opposed the Shah as a corrupt and oppressive puppet of American Cold War foreign policy. Once the Shah was overthrown and Islamists had sufficient power, the Islamists liquidated their Islamo-leftists allies. The Communist Party of Iran was (and remains) a banned organisation in Iran. Islamists oppose capitalism as a guiding principle for civic life on religious not political grounds. Islamists advocate anti-capitalism and the principles of the French Revolution only insofar as that rhetoric furthers the Islamist cause.

25 The section "Fatal Attraction" was added for this publication.

26 "The world is my country, all mankind are my brethren, and to do good is my religion" — Thomas Paine.

27 For discussion of this transition in the context of the visual arts, see Paul Wood, *Western Art & the Wider World* (Wiley Blackwell, 2013).

28 Note that privilege is defined by academics in social science fields in different ways, sometimes very specific and not obvious ways. However, the term is commonly used by academics, students and social activists in ways that blur differences between privilege as a sociological term and a term in common usage. Leftists allow the term privilege to be used loosely and use it this way in general conversation but when pressed to explain privilege or to give concrete examples of privilege in everyday life they explain that the term has been "misunderstood". Leftists state that a concrete example of privilege is the inherited privilege of having a whole society "designed to serve men", with purported evidence for patriarchal privilege being given as the predominance of men in leadership roles and higher-paying jobs, without any co-variant analysis of the multiple causes of this situation. Privilege is thus used as an irrefutable factual charge to convict opponents but when it is subject to analysis by the ordinary person privilege is explained away as a subject too complex, too academic, too deep-rooted and too pervasive to be discussed in terms of actualities. It is hard not to conclude that "privilege" is a debating tactic and a strategic tool to effect change not a hypothesis derived from measurable evidence.

29 "A society in which people can avoid physical pain comparatively easily will produce people who are less prepared to deal with it." For discussion of censorship being deployed to prevent offence as an outcome of a safer and more regulated society, see Greg Lukianoff, *Freedom*

From Speech (Encounter Broadside, 2014).

30 The degree to which Marxist thinking accepts and refutes the notion of class loyalty as a form of hereditary class allegiance is something out of the scope of such a short essay.

31 See John Stuart Mill's analysis of the way dissent is silenced by social oppression, *On Liberty* (1859).

32 In the original publication, this paragraph was italicised.

33 Alexis de Tocqueville noted in *Democracy in America* (1835–40) that a vital restraint which prevents the imposition of the prejudices of the majority is "the antagonism of opinions", which can only exist in unfettered speech. *Democracy in America* was in part an examination of the dangers of the imposition of the will of the majority upon the minority, informed by the recent experience of the French Revolution.

34 Note that this essay argues only the utilitarian case for free expression; there is an entirely separate argument in favour of free expression as a human right; see Thomas Paine, *et al.*

35 On the wrongness of people suppressing opposition: "If the [opposing] opinion is right, they are deprived of the opportunity of exchanging error for truth: if wrong, they lose, what is almost as great a benefit, the clearer perception and livelier impression of truth, produced by its collision with error" — Mill, *On Liberty*, ch. II.

36 Lukianoff, *ibid.*

37 The religious extremist considers restriction on free speech a means of restricting a person from issuing heretical thoughts, which condemns the speaker and those he influences. The extremist considers this no liberty at all. Restriction aids the maintenance of virtue.

38 Post-liberal theory considers that not only actions but also words and even thoughts can be harmful. This is a totalitarian position, akin to religions which urge adherents to abjure sinful thought and political regimes which seek to control actions by training citizens to think correctly.

39 Consider this list of attributes of Muslim and Jewish fundamentalists compiled by Ronald Wintrobe: "Both are against any compromise with the other side; both are entirely sure of their position; both advocate and sometimes use violence to achieve their ends; both are nationalistic; both are intolerant of dissent within their group; both demonize the other side" — Ronald Wintrobe, *Rational Extremism: The Political Economy of Radicalism* (Cambridge University Press, 2009).

40 Feminism is a complex and wide-ranging area, consisting of a political movement, a set of shifting goals and an academic discipline with quasi-scientific processes. It has a long history and has changing and contradictory features and goals. It has gone through different historical phases. Even the definitions are disputed. When these essays refer to "feminism", the meaning is to a political movement acting primarily for the advancement of women's legal rights, social influence and income,

incorporating aspects of third-wave cultural feminism which originated in the 1970s, as it is widely understood and practised in Western society. It is considered a loosely affiliated pressure group of individuals (female and male) and organisations acting in factional self-interest, leftist in nature and underpinned by neo-Marxist ideology. It is not synonymous with women or female artists.

41 Interpretative commentaries on the Koran.

42 Wahhabism is an ultra-orthodox interpretation of Islam native to the Arabian Peninsula, which has been promoted internationally by the Saudi royal family.

43 The Victoria & Albert Museum removed an image of Mohammed by a Persian artist from its website in the wake of the *Charlie Hebdo* attack.

44 The editor of *The Independent* explained that he supported free speech but would not reproduce the cartoons because he could not put his colleagues in harm's way, thereby pre-emptively conceding ground to extremists.

45 The BBC has issued conflicting statements about whether or not images of Mohammed are prohibited for broadcast or simply avoided. The point is a moot one as the BBC does not show images of Mohammed, regardless of being the result of official guideline or unspoken consensus.

46 An example of *argumentum ad hominem*, an attack on the proposer of an idea rather than the idea itself.

47 This discussion centres on Islamist expansionism and largely omits discussion of the position of moderate Muslims. Do moderates wish to oppose the sectarianisation of the secular West or are they in favour of some (or all) additional restraints on free speech? There will be as many views on this as there are Western Muslims. It is worth remembering that many moderates suffer soonest and most from pressure and influence of Islamists in their own communities and families. This is especially true of adherents of Shia and Sufi traditions who are persecuted by Wahhabi extremists.

48 "The Prophet teaches that we could ally ourselves even with the atheists if it helps us destroy [the] enemy" — Ayman al-Zawahiri, deputy head of Al Qaeda, August 2002, talking about war with the USA. Whether or not this is a true interpretation of the Koran and *hadith*, it demonstrates the mindset of the Islamist with regard to collaboration for mutual benefit. See also the concept of *Taqiyya*, the practice of — and justification for — concealment of actions and motives of Muslims from non-Muslims.

49 Hans Abbing, *Why Are Artists Poor? The Exceptional Economy of the Arts* (Amsterdam University Press, 2014).

50 *ibid.*, p. 23.

51 *ibid.*, p. 104.

52 *ibid.*, p. 114.

[53] *ibid.*

[54] *ibid.*

[55] For government programmes which cause the results which are the opposite of the intended ones, see Thomas Sowell's analysis of US federal government welfare projects, *The Vision of the Anointed: Self-Congratulation as a Basis for Social Policy* (Basic Books, 1995, pp. 9–15).

[56] See Julian Stallabrass, *High Art Lite* (Verso, 2006).

[57] *ibid.*

[58] www.npr.org, 1 June 2017.

[59] 2018 note: Laura Gascoigne provides an update on this incident subsequent to the original publication of "New Order": "Since his report there have been further developments in the case of the Dakota Elders v Sam Durant. [...] Initially condemned to be burnt, the dismantled *Scaffold* will now be buried in a secret location." "The Art Police", *The Jackdaw*, no. 136, November/December 2017.

[60] *New York Times*, 21 March 2017.

[61] "Identarian" for the purposes of this essay (and later ones) refers to a person for the time he or she is largely in agreement with the principles listed here and acts as if he or she is committed to enacting these principles in society at large. Obviously, personal commitment varies according to the situation and over time. Indentarianism provides an ethical framework, moral certainty, an overarching narrative, a community (with a clear hierarchy) and a set of practical steps to advance the cause. It provides an all-encompassing worldview in the way cults and religions do, more so than many other political ideologies, which is why Identarianism exerts more of a hold on adherents than traditional party allegiance does.

[62] The neo-Marxist Frankfurt School posits that Western democracy gives rise to a totalitarianism of democracy (a variation of the tyranny-of-the-majority argument) which marginalises political positions which question the primacy of capitalist Western-form democratic social order. The society creates structures that neutralise structural criticism. The very moderation of democracy makes the suppression hard to resist. "The factual barriers which totalitarian democracy erects against the efficacy of qualitative dissent are weak and pleasant enough compared with the practices of a dictatorship which claims to educate the people in the truth. With all its limitations and distortions, democratic tolerance is under all circumstances more humane than an institutionalized intolerance which sacrifices the rights and liberties of the living generations for the sake of future generations. The question is whether this is the only alternative" (Herbert Marcuse, "Repressive Tolerance", 1965). To balance and advance a society, leftist intellectuals need the privilege of influence over societies consisting of a majority population which resists leftist political views. Consider also Marcuse's critique of Freudianism, which blames psychoanalysis as a route for the

enacting of widespread repression and forced conformity. Marcuse co-founded Critical Theory, a school of sociological and philosophical thought which gave rise to Post-Modernism.

63 For Identarian restrictions on free speech, see the Jordan Peterson vs. University of Toronto and Canadian Parliamentary Bill C-16, which regulates use of gendered pro-nouns to prohibit "discrimination".

64 Proof that this position is the outcome of emotion rather than logic comes from the common contradictory arguments in Post-Modernism: all cultures are equal; Western materialist capitalist culture is uniquely damaging and iniquitous. For more on the internal contradictions of Post-Modernism, see Stephen Hicks, *Explaining Post-Modernism* (Occam's Razor, 2011).

65 "When people want more, they call more 'justice'. But, when groups with a sense of grievance acquire power, whether locally or nationally, they seldom stop at redressing grievances and seldom exhibit impartial justice toward others. Nothing is more common than for previously oppressed groups to oppress others when they get the chance" — Thomas Sowell, *Preferential Policies: An International Perspective* (Morrow, 1990, p. 151).

66 "Marxian" is used to differentiate approaches to culture, politics and economics that draw upon Marx's theories and work but do not have a definitely pro-Marxist political position. A Marxian would analyse a situation using Marx's version of dialectic materialism without accepting the political implications (such as the necessity for socialism) that a Marxist would. While "Marxist" and "neo-Marxist" are demonyms, the demonym "Marxian" does not exist in any useful sense.

67 For more on this symbiosis see Paul Wood, *Western Art and the Wider World* (Wiley-Blackwell, 2013).

68 See the Critical Theory concept of art as a pacifier. Contentment and pleasure in art are seen as essentially complicit with a social system that enacts oppression. There is a suspicion of art which generates pleasure. According to Adorno the true work of art provokes unhappiness and anxiety and alerts the consumer to the conditions of social production through internal structural dissonance—Theodor Adorno, *Aesthetic Theory* (1970). See my "What is Critical Theory? (And Why Should I Care?)", *The Jackdaw*, no. 142.

69 A recent book surveying contemporary art (Alistair Hicks, *The Global Art Compass: New Directions in the 21st Century* (Thames & Hudson, 2014)) did not include a single reference to the visual appearance of the art discussed.

70 For a discussion of Identarianism in the arts, see Sohrab Ahmari, *The New Philistines* (Biteback Publishing, 2016).

71 *The Jackdaw*, nos. 106 and 109.

72 See pp. 508–9, Charles Harrison *et al.*, *Art in Theory, 1815–1900* (Blackwell, 2001).

73 The victim narrative is supported by the residual fallacy. The fallacy states that—for the example of social outcomes which do not reflect racial parity—after all control statistics are taken into account, any residual disparity must be the outcome of ingrained and persistent factors which cannot be measured, in this case, racial discrimination. The assignment of unmeasurable disparity in ways which support the victim narrative provides the narrative with fallacious support. See Sowell, *The Vision of the Anointed, op. cit.*, pp. 37–43.

74 Equality of outcome is easy to measure; equality of opportunity is almost impossible to measure. The fallacy is that outcome must mirror demographic distributions representative of a given population, without any explanation as to why this should be so.

75 Note the related concept of fairness. The concept is shared across the political spectrum but is interpreted differently. "On the left, fairness often implies equality, but on the right it means proportionality—people should be rewarded in proportion to what they contribute, even if that guarantees unequal outcomes"—Jonathan Haidt, *The Righteous Mind: Why Good People Are Divided by Politics and Religion* (Penguin, 2012, p. 161).

76 Maria Balshaw: "I don't strive for shows 50% by women because that's a feminist gesture, but because we want to refer to the world we live in" (*The Observer*, 2 July 2017). So, not an arbitrary quota, a justifiable quota.

77 Sowell, *Preferential Policies, op. cit.*, pp. 15–16.

78 For the costs incurred due to preferential discrimination and for preferential policies as a form of restriction of trade to prevent favoured groups from being outcompeted by disfavoured groups, see Sowell, *ibid.*

79 Multiple published interviews with MB and letter from Tate to AA, 26 June 2017.

80 For the example of the portrait of Juan de Pareja by Velázquez being bought by the Metropolitan Museum of Art, New York, in 1970 specifically to appease race activists, see pp. 210–4, Martin Gammon, *Deaccessioning and Its Discontents: A Critical History* (MIT Press, 2018).

81 Judith Burns, "Art history A-level saved at last minute", 1 December 2016, BBC News website, http://www.bbc.co.uk/news/education-38172253, retrieved 1 July 2017.

82 *ibid.*

83 http://www.agnewsgallery.com/fairs-exhibitions/lotte-laserstein-s-women, Anthony Crichton-Stuart, Director, Agnews, 8 November 2017.

84 See Friso Lammertse & Stephan Kemperdick, *The Road to Van Eyck* (Exhibitions International, 2013).

85 There is a problem of overlapping definitions in this section which I have chosen not to resolve in this text in order to faithfully represent the text as it was first published. The problem is this: Post-Modernism takes a multiplicity of views on the canon—opposing it, dismissing it,

setting up alternative canons, suggesting that canon formation is an expression of an illusory aesthetic consensus and so forth. Post-Modernism is thus chimerical and (in some respects) not authoritarian, however Post-Modernism underpins Identarianism, which is highly authoritarian in character. All Identarians are—knowingly or otherwise—Post-Modernists who incorporate elements of neo-Marxism, nationalism and ethno-nationalism; not all Post-Modernists are Identarians. They are thus not synonymous. It would be most accurate to recast this section as Identarian opposition to the canon. Post-Modernists do seek to undermine the canon but not necessarily because their opposition is that of frustrated authoritarians. The dualist character of Post-Modernism, which possesses both relativist and absolutist aspects, complicates the matter. Overall, the argument in this section is correct though if I were to rewrite it I would adjust the descriptors.

[86] Consider the observations of John Henry Merryman on two distinct legal treatments of cultural objects: cultural internationalism (as embodied in the Hague Convention of 1954), which speaks of the "the cultural heritage of all mankind", and cultural nationalism (as embodied in the UNESCO Convention of 1970), which speaks of "national cultural heritage". The former perceives items to be held for the common good, whereas the latter considers nations and peoples to have persisting rights (or at least interests) in items from "their" cultural heritage. This latter view overlooks the fact that the producers of artefacts of 2,000 years ago or more are in no way connected to the nation or people existing in the geographical location today. Obviously, identity politics leans heavily towards the UNESCO idea of "national cultural heritage". John Henry Merryman, "Two Ways of Thinking About Cultural Property", *American Journal of International Law*, vol. 80, 1986.

[87] Bénédicte Savoy, *The Art Newspaper*, February 2018, p. 5.

[88] See Alexander A. Bauer, "New Ways of Thinking About Cultural Property: A Critical Appraisal of the Antiquities Trade Debates", *Fordham International Law Journal*, vol. 31, issue 3, article 4, 2007.

[89] Ben Fenton, "Pardoned: the 306 Soldiers Shot at Dawn for Cowardice", *The Daily Telegraph*, 16 August 2006, http://www.telegraph.co.uk/news/1526437/Pardoned-the-306-soldiers-shot-at-dawn-for-cowardice.html, retrieved 15 February 2018.

[90] A 2002 paper in favour of reparations was entitled "Amending Historical Injustices".

[91] Sowell, *Preferential Policies, op. cit.*, p. 148.

[92] See note 80.

[93] Deaccessioning is the process of a public museum selling one or more items from its permanent collection, a practice which is considered unethical by some. Deaccessioning is prohibited for British museums in

almost every circumstance, as regulated by the Museums Association.

94 Adam Gary Lewis, "Ethics, Activism and the Anti-Colonial: Social Movement Research as Resistance", 2012, http://www.tandfonline. com/doi/abs/10.1080/14742837.2012.664903, retrieved 15 February 2018.

95 See Bauer, *op. cit.*

96 It should not be inferred that Rousseau was in any way an anarchist, anti-statist or libertarian. He advocated for collectivism and the tyranny of the state to enforce equality, even to the level of the death penalty.

97 The Nazi origin myth echoes the ideas of Rousseau. It stated that the Nordic people lived in harmony with nature and developing their culture in isolation, only to be weakened and corrupted by ideas imported from incompatible cultures (especially Jewry). The Nordic people were engaged in a primal battle for survival, which the Nazi party would prepare them for. See Johann Chaptoutot, *The Law of Blood: Thinking and Acting as a Nazi* (Belknap Press, 2018).

98 Contrary to Rousseau, Sigmund Freud is essentially pessimistic about human nature. He sees society as a system developed to control the instincts of the individual, which are potentially aggressive and selfish. Contrast to Wilhelm Reich's objections to Freudian theory, positing that subconscious urges are positive and that it is societal thwarting of those instincts that causes dysfunction. Reich aligns his ideas with Rousseau's idea of the happy man made unhappy by society.

99 Friedrich Engels and Karl Marx, *The Communist Manifesto* (1848).

100 "Across many scales, surveys, and political controversies, liberals turn out to be more disturbed by signs of violence and suffering, compared to conservatives and especially libertarians" —Haidt, p. 212.

101 Libertarianism is theoretically non-aligned on the left–right axis, and liberal and anti-authoritarian in character. In practice, the anti-statist American form of libertarianism is selfish individualism—actually a form of survivalism. It is an impractical contradictory ideology that is authoritarian in its refusal to countenance the necessary certainty of free individuals instituting a limited state for purposes of defence, protection, enforcement of property rights and legal contracts, paid for by taxation. Libertarianism, in its contemporary American form, is the short road to a period of barbarity followed by a dark age of pre-capitalist tyranny of strong-man regional feudalism.

102 For the ideological differences between internationalist and nationalist forms of socialism, see the conflict between left communism and socialism-in-one-country (Stalinism) of the 1930s and 1940s.

103 Albeit the preservation of private property rights in Nazi Germany was contingent on abeyance of the requirements of the war economy. For comparative assessment of Nazi and Soviet economies, consider also the conditions of war economies.

104 See endnote 97.

[105] Marx's approach is rooted in material dialectic theory developed from Hegelian philosophy.

[106] Haidt, p. 334.

[107] Haidt, pp. 334–5.

[108] See also Nietzsche's master–slave dichotomy, where the slave rationalises his impotence by fetishising his failure to act, subservience, weakness, etc. The intelligent slave understands that this is mere rationalisation and this realisation breeds anger, resentment and nihilism.

[109] Haidt asserts rationalisation is often a post hoc justification for an instinctive cognitive-emotional reaction. Evidence is assembled to support the rationalisation. Even when the rationale is proved to be wrong, the subject will not generally change his position, proving that the rationale is not the cause of a decision but a justification. Jonathan Haidt, *The Righteous Mind: Why Good People Are Divided by Politics and Religion* (Penguin, 2012).

[110] Virtue signalling is the social signing of a signaller's moral virtue, usually through a purely symbolic act of supposed kindness, solidarity or anger. The act is relevant only in that it allows the signalling to like-minded individuals of a virtuous signaller. "Those who disagree are seen as being not merely in error, but in sin" — Sowell, *The Vision of the Anointed, op. cit.*, p. 3.

[111] Also called the "opinion window". See "*åsiktskorridor*" in the context of Swedish society, which prioritises politeness and consensus. Swedish commentators on the left state that this *åsiktskorridor* does not exist, others that it is a far right concept which should be discredited.

[112] See the discussion of intersectionality in "Identarianism" in "On Quota Programming".

[113] See Jonathan Haidt & Greg Lukianoff, *The Coddling of the American Mind* (Allen Lane, 2018).

[114] The "alt right" is a contested term describing a loose association of individuals opposed to leftists, political correctness and the mainstream press, often posting provocative jokes and comments in support of nationalist and right-wing causes. This tendency came to the fore in the USA over 2015–16, during the course of the campaign for the Republican nominee for the presidency, during which the alt right supported Donald Trump. Subsequent to that election, the alt right has been seen as taking a harder racist and nationalist line, shedding many casual or "ironic" supporters.

[115] "The lingering effects of slavery" are often cited when black poverty in the USA is discussed. See Thomas Sowell's many arguments for the injurious effects of the welfare state since the 1960s measured against the position black Americans in the 1940s, discrediting the idea that recent problems are a historical legacy.

[116] In the USA, police shootings of black individuals are cited by Black

Lives Matter and mainstream media as instances of systematic racial oppression. For a statistical breakdown of police shootings which disproves an anti-black bias in police shootings, see Nick Selby, "Police Aren't Targeting and Killing Black Men", *National Review*, 17 July 2017, http://www.nationalreview.com/article/449505/police-arent-killing-black-men-out-racism, retrieved 15 February 2018. See also writings by and interviews with Larry Elder, Coleman Hughes and others.

117 For parallels between identity politics and ideological quasi-science, see Lysenkoism. Lysenkoism was developed by Trofim Lysenko in the USSR. It started from a Marxist ideological position and posited that genetics were subject to dialectical laws of progress and that the traits acquired by biological organisms were inheritable, positions that preceded (and were contraindicated by) scientific measurement. Compare to the blank-slate thesis regarding human psychological development, which is supported by leftists. See Steven Pinker, *The Blank Slate: The Modern Denial of Human Nature* (Penguin, 2002).

118 "Political parties and interest groups strive to make their concerns become current triggers of your moral modules [innate moral responses to stimuli]. To get your vote, your money, or your time, they must activate at least one of your moral foundations." The implication is that political groups use biological instincts to generate support. Haidt, p. 156.

119 Durkheim considered economic change to be an (indirect) instigator of anomie. I do not see that as a factor in cyclical decadence but I do see anomie as contributing to decadence on an individual level.

120 Consider the issue of the "free rider" — the individual in society who benefits from the system but contributes as little as possible. If a system of co-operation works well then a few free riders may be permitted without a serious cost. If there are too many free riders who do not collaborate for the benefit of the group then that group activity ceases to make economic sense and it breaks down, causing the group as a whole to suffer. One use of religion is to discipline the free riders. An omniscient god who sees all cheating and oath breaking can punish the individual. If the group believes moral infractions can lead to divine retribution then they enforce moral codes. This internal and external moral policing benefits group collaboration and in-group loyalty. The decadent believes in no god (or in scorning god) and is the typical free rider — one who can only exist so long as the rest of society continues to maintain itself through collaborative work.

121 See Camille Paglia's *Sexual Personae: Art and Decadence from Nefertiti to Emily Dickinson* (1990) for an analysis of sexual behaviour and gender roleplaying as a symptom of cultural decadence.

122 Compare the anarchist and the decadent. The anarchist is destructive and disruptive and seeks to overturn society to allow a new more natural order of voluntary associations within a stateless society. The

decadent is destructive and disruptive but he does not seek to destroy society, he merely wishes to engage in disruption and perversion for his own pleasure, not as any part of a wider programme. It is against his best interests to cause society to become so dysfunctional that it prevents comfortable pleasure seeking. The anarchist is utopian; the decadent is cynical.

123 The role of capitalistic individualism in its Western form as a cause of decadence is disputed. See the arguments of the neo-conservative school of Leo Strauss in relation to nihilism arising from individualism in a liberal secular democracy.

124 Modernist art contains different strains. There are strands (including De Stijl, Purism, Modular Constructivism and many lines of abstraction) which claim to derive from rationalism and empiricism and are explicitly directed towards social progress and political ends. There are other strands (starting with Romanticism, continuing through Symbolism and Surrealism) which are considered a revolt against the rationalism of the Enlightenment. Within the latter grouping, I consider there to be many elements which have rational goals and the intention of advancing society. Take the main Breton branch of Surrealism. It harnesses the irrational to rational ends: personal liberation (i.e. emotional catharsis), pseudo-scientific examination of the subconscious mind (akin to psychoanalytic analysis) and political goals (advancement of the Parti communiste français). Even the Bataille-*Documents* branch of Surrealism has similar elements. This is a complex matter but I suggest two things: firstly, that Modernism is essentially an extension of the Enlightenment; secondly, that Modernism is constructive, positive and socially directed, even in the case of self-directed motivations.

125 The Counter Enlightenment can be seen as originating from Kant, extending through Hegel, Marx, Kierkegaard, Nietzsche and Heidegger. It asserts that—contrary to tenets of the English liberals—the nature of truth is hidden to rational inquiry and that, ultimately, science cannot ascertain truth as it is simply a summary of systems derived subjective interpretations of sensory data.

126 Decadence in art manifests itself in two manners: a) decadent subject matter and decadent interpretation of conventional subject matter; b) anomie, epitomised by detachment of form and meaning. The Decadent Movement (c. 1880–1900) was libertine in character: morbid, perverse, hedonistic, unnatural, individualistic. It overlapped somewhat with Symbolism and Art Nouveau. It typifies the first tendency. The second tendency, the detachment of form from meaning, is present in Post-Modernist art (1970 onwards). Conceptual art (Piero Manzoni) and appropriation (Elaine Sturtevant) are other examples of artistic anomie. Gustav Klimt can be viewed as a decadent artist who combined both manners in his subject matter and his use of non-Western styles

detached from its original function. Periods of decadence are characterised by prevalence and widespread influence of decadent art. Examples of decadent art can be found in many periods not best described as decadent.

127 The term "parasitical" is not derogatory here; it is accurate description. Post-Modernism could only arise as a (primarily) anti-Modernist movement in the wake of Modernism and in a civilisation in a decadent cycle. Post-Modernism functions like a parasite in that it takes without sustaining and relies on the health of the core while weakening the core and serving only itself. It is no more derogatory to describe Post-Modernism as parasitical than it is to describe a parasite as parasitical. The parasitical aspects of identity politics are described in the main body of the text.

128 See especially Isaiah Berlin, "Two Concepts of Liberty" (1958).

129 An example of outright leftist entryism not in an area of cultural production is the Atheism+ movement. This was a case of leftist social activists attempting to take over the existing atheism movement. In 2012 a large number of entryists in the atheism movement—along with some supportive established figures—asserted that a lack of belief in deities necessarily entailed a series of leftist social beliefs, such as gay rights, feminist goals, environmentalism and race activism. The majority of the atheism movement (a loose group of individuals of varying political outlooks interested in debunking religion and working to detach government from religion) rejected the idea that atheism had specific political implications. The entryists, led by prominent feminists, split from the other atheists and formed the break-away Atheist+ movement, which asserted that atheism alone was not an effective platform and that atheism entailed (and could be advanced through) leftist activism. Relentless purity tests, application of exclusionary privilege standpoint theory, zealous banning of dissenting forum members, general infighting and neglect of atheist-related discussion soon reduced the Atheist+ movement to irrelevant rival splinter groups.

130 Richard C. Meyer advanced an idea a commentator had given him that due to cost-cutting measures social-justice activists had gained a foothold in the major companies because they were willing to work for very little, mainly for social kudos, in-group status, gatekeeper power and political influence. Wages for major companies (especially Marvel) are now low, in some circumstances practically zero. Once competent professionals with moderate views were undercut by less competent political activists, the bar of quality was lowered enough to permit less skilled political activists to fill roles that would previously have been taken by skilful professionals. Thus economic factors may have played a major (even dominant) influence in making commercial companies vulnerable to cultural entryism.

131 See note 139.

132 Some internet forums commonly banned discussion of Gamergate and Comicsgate, partly because of the acrimony caused by arguments but also because reasonable reservations undercut the narrative of concerned fans actually being racists and bigots.

133 An idea advanced by author David V. Stewart in relation to American studio movies with explicitly progressive political slants.

134 One should distinguish between centrally planned cultural production and avant-garde cultural production. Abstraction of High and Late Modernist periods of fine art was the outcome of experimentation and a sequential development of practice and theory and was thus a logically implicit "development of the cultural form" even though no market for the products existed when the first ones were made. Propaganda is made for a (usually mass) public audience and is centrally planned; avant-garde experimentation is made for a tiny (usually private) audience and is derived from personal experimentation, relying on untested ideas shared by a few cultural producers working in private, some of whom work in parallel fashion unaware of their colleagues' advances. We can say that propaganda needs mass consumption to be effective and avant-garde art is effective even without any appreciable audience. In economic terms abstraction was also a pioneering of a product created before any proven market existed. The subsequent popularity of certain abstract art proves that there is a viable economic and cultural market for consumption of a product which was unknown and not in demand at the time it was pioneered. There are other differences not given here.

135 "[At University of California, Berkeley] more than 70 percent of black students *fail to graduate*. Tragic as this is, it is hardly surprising, given the admissions patterns. Of 312 black students entering Berkeley in 1987, all were admitted under 'affirmative action'" criteria rather than by meeting the standard academic criteria." For the widespread problems and counter-productive effects of affirmative action (diversity hiring), see: Sowell, *Preferential Policies, op. cit.*, pp. 107–112, and many of his other writings and interviews.

136 For an example of this see the severe adverse fan criticism of *Star Wars: The Last Jedi* (2017), which was commonly seen as promoting a progressive agenda. It was marketed as a pro-women pro-minorities production by the studio. For various reasons the film disappointed fans, who turned on the studio, scriptwriters and director. Criticism (and abuse) was directed towards female and non-white actors involved in the production despite widespread consensus among more neutral observers that the actors were competent.

137 See the controversy over the 2018 film *Black Panther* by Marvel/Disney studio, a largely black-cast film set in Africa. There was a small social-media campaign to give the film a low audience rating, as an anti-Marvel move by DC fans resenting the good critical responses given to

Marvel films. Favourable reviews of Marvel films disgruntled some DC fans who consider themselves mildly antipathetic towards Marvel products. This plan was presented by online media as racist trolling. While some of the supporters of the plan made racist comments, many were simply fans wanting to score points against the product of a perceived rival company. Media outlets and websites took action to prevent negative criticism of *Black Panther*. Some sites disabled the reader/viewer comment function on articles about the film. The film was provocatively championed by White Supremacists and the alt right. Wakanda, the fictional African country featured in the film, is a traditional, militaristic, autonomous, isolationist, anti-immigration, prosperous ethno-state completely controlled by its native population—an ideal model for a white American ethno-state. Contrast this to *Blade*, released in 1998 and featuring a black actor as a superhero lead in a mainstream studio film. *Blade* did not rely on race-based scripting and promotion nor did it generate a racialised media reception. *Black Panther* demonstrates the way cultural production and consumption have fallen under the sway of Identarian principles of the victim narrative and racial division. These guided the production of the film, led to its promotion along overtly racial lines and informed its critical reception. See also the promotion of *Red Tails*, the 2012 film with a mainly black cast. It was marketed specifically to black American audiences. Support for it was presented by supporters as an issue of racial solidarity. See also the promotion of *Ghostbusters* (2016), with an all-female lead cast. Support for the film was presented as an issue of gender solidarity. Positive reviews of the lacklustre film may have been motivated by gender politics rather than being evaluations of the film's merits.

138 "Partisans [having their biases apparently confirmed] got a little hit of that dopamine. And if this is true, then it would explain why extreme partisans are so stubborn, closed-minded, and committed to beliefs that often seem bizarre or paranoid. Like rats that cannot stop pressing a button [to receive stimulation], partisans may be simply unable to stop believing weird things. The partisan brain has been reinforced so many times for performing mental contortions that free it from unwanted beliefs. Extreme partisanship may be literally addictive"—Haidt, p. 103.

139 Mass criticism of an individual on social media is called "dogpiling".

140 The causes of viral phenomena on the internet are complex and not properly understood. See the paper Pöyry, Laaksonen, Kekkonen & Pääkkönen, "Anatomy of Viral Social Media Events" (2018), https://scholarspace.manoa.hawaii.edu/bitstream/10125/50160/1/pa per0273.pdf, retrieved 15 February 2018. This paper covers the methodology of constructing algorithms to measure viral social-media events. Research indicates that every emotive or moralising word increased the chance of retweet by 20%, incentivising the increase in the

emotional extremity of messages. Messages are retweeted by political supporters. The most extreme politicians are those who gain the most followers on social media. All of these factors mean that polarisation of the population on social media is increased over time.

141 Twitter is a platform favoured by Identarians and feminists. Platform administrators have a policy of banning far right activists and alt right trolls as "hate speech" whereas it is less quick to ban Antifa and leftist users. Valerie Richardson, "Twitter political bias seen in Project Veritas video", *The Washington Times*, 16 January 2018, https://www.washingtontimes.com/news/2018/jan/16/Twitter-political-bias-seen-project-veritas-video/, retrieved 15 February 2018.

142 https://www.dailydot.com/parsec/tor-tom-doherty-irene-gallo-sad-puppies/, retrieved 15 January 2018.

143 https://www.npr.org/2015/08/26/434644645/how-the-sad-puppies-won-by-losing/, retrieved 15 January 2018.

144 http://www.slate.com/articles/technology/bitwise/2014/09/gamer gate_explodes_gaming_journalists_declare_the_gamers_are_over_but_ they.html, retrieved 1 December 2017.

145 "Video games can and should be put to work for leftwing politics at this moment of cultural and political uncertainty […] Liberal influence has failed to turn video games into a force for progressive politics […] Gaming is at the kind of crisis point that literature was at in the early 20th century: it needs a structural renovation" (Alfie Bown, "Video games are political. Here's how they can be progressive", *The Guardian* online, 18 August 2018). This is one example of many calls by social-justice activists for gaming to be used to further radical left-wing aims.

146 This was later confirmed by a leaked (and authenticated) document to support a new set of cards released by WOTC for MTG. The document states "*Magic* has adopted 'they' as the preferred third-person-singular pronoun for a player, replacing 'he or she'", *Dominaria Release Notes*, WOTC, last modified 31 January 2018, p. 5.

147 It should be noted that parties on all sides of these controversies acted in anti-social and provocative ways. A motivating cause was the use of Patreon and Maker Support, internet services which allow creators (usually producing content for the internet) to receive monthly funding from subscribing supporters. Claims of harassment, entreaties to support advocates and escalation of internet feuds involving creators with these accounts were used to raise sums substantial enough to be living incomes for prominent figures.

148 Consider the common statements that criticism of an individual or group is "dehumanising", "invalidates the subject's existence" or "denies a person's lived experience". Once the analogy is made equating criticism to actual violence—as it is in exaggerated race-activist claims that absence of representation is a form of social geno-cide or obliteration of a group's existence—then criticism is no longer

speech but an action that is urgent and dangerous. There is a moral imperative for speech-causing-violence to be opposed with violent resistance. See note 171.

149 Chase Magnett, "Christopher Priest on Being Black in Comics and the Industry's Future", *comicbook.com*, 23 February 2018, http://comicbook. com/comics/2018/02/23/christopher-priest-interview-black-comics/, retrieved 25 February 2018.

150 "Social Justice Warrior" — a derogatory term applied to supporters of identity politics and diversity casting, leftist in political outlook and deeply involved in popular culture. The term applies especially to internet activists. Some Identarians have claimed the term SJW as a badge of honour; others have rejected it. Critics of cultural entryism in superhero comics have widely used the term SJW and use the term "SJW Marvel" to apply to Marvel from late 2014 onwards. Late 2014 is the launch date of *The Unbeatable Squirrel Girl*, a flagship Identarian comic and viewed as the first overtly diversity-inspired lead character at Marvel Comics. Alternative terms include "keyboard warriors" (highlighting the importance of social-media activism) and "social justice peacocking" (emphasising virtue signalling).

151 Source: www.comichron.com, a website with detailed monthly breakdowns of comic books shipped by Diamond Distribution to comics stores in North America.

152 For producers of videos critical of social-activist comics see in particular those channels called Douglas Ernst, Diversity & Comics, Mim Headroom, Yellow Flash, Nerkish, Just Some Guy and That Umbrella Guy.

153 https://icv2.com/articles/news/view/37152/marvels-david-gabriel-2016-market-shift, retrieved 1 December 2017.

154 https://www.youtube.com/watch?v=wNzhvFNOsN0, interview with Kelly Sue DeConnick, retrieved 1 December 2017.

155 Twitter, 12 February 2018, 7:31 AM.

156 Twitter, 2016.

157 Twitter, 16 October 2016, 1:04 PM.

158 Twitter, 26 September 2017, 2:20 AM.

159 Twitter, 19 September 2017, 7:06 AM.

160 Twitter, 17 August 2018.

161 Twitter, 22 August 2018.

162 Twitter, 28 August 2018, 6:39 PM.

163 Twitter, 28 August 2018.

164 Twitter, 21 September 2018.

165 See Adam White, "Female Marvel Comics editor harassed online for milkshake selfie", *The Telegraph*, 31 July 2017, http://www.telegraph.co. uk/books/news/female-marvel-comics-editor-harassed-online-milk shake-selfie/, retrieved 1 December 2017, for an example of media coverage without evidence of threats or intimidation against Antos.

166 https://www.newsarama.com/36750-retailers-become-heated-over-marvel-variants-diversity-in-closed-doors-nycc-panel.html, retrieved 1 December 2017.

167 Rich Johnston, "Fifty Comic Stores That Have Closed Since January 2017", *Bleeding Cool*, 19 January 2018, https://www.bleedingcool.com/2018/01/19/fifty-comic-stores-closed-since-january-2017/.

168 George Gene Gustine, "Marvel entertainment names new editor-in-chief", *The New York Times*, 17 November 2017, https://www.nytimes.com/2017/11/17/books/marvel-entertainment-names-new-editor-in-chief.html, retrieved 1 December 2017.

169 Twitter, 20 February 2018.

170 Twitter, 23 February 2018, 6:02 PM.

171 This is associated with the leftist adulation of violent "resistance", recently typified by the (initially) sympathetic media coverage of Antifa violence directed towards events, speakers and event organisers with which they disagree. Antifa (from "anti-fascist action") explicitly advocates violence against far right groups. When Antifa violence on American campuses was criticised, some broadcasters and public figures defended Antifa as equivalent to American soldiers fighting to liberate German-occupied Europe in 1944–45. The far right speaker Richard Spencer was assaulted by an Antifa activist during a television interview filmed on the street during President Trump's inauguration, January 2017. Thereafter the meme of "punching Nazis" became a common phrase used by American leftists to show their opposition to the far right. It was a simplistic visceral response which combined strong imagery, a clear moral stance and admiration for violent action. The conflation of metaphor and literal action in the "punching Nazis" phrase is a common one on the political left, which adulates revolutionary Russia and Cuba, Civil War Spanish Republicans, Kurdish fighters and Palestinian protestors. The refusal of committed leftists to detach themselves from the authoritarian Antifa displays a degree of approval for violent action which, indirectly, encourages moral anger to find expression in direct action. (It should be noted that American mass media coverage of Antifa action became markedly less sympathetic over late 2017 and early 2018. Antifa's riots became seen as an unjustified overreaction to speakers such as conservative commentator Ben Shapiro.)

172 See endnote 147.

173 An anonymous Marvel insider wrote to Meyer as follows: "Just like the SJWs in comics, the SJWs in video games can scare off an organisation with two dozen tweets and a few hundred 'likes'. As it is in comics, these tweets from fringe outsiders are shared by a couple of rabid SJW pros and used in an SJW article hit piece. This is precisely how the whackos have been trying to take down [Ethan] van Sciver and [Jon] Malin. […] They know it only takes a few hundred retweets/'likes' to

get a publisher's attention or a *Bleeding Cool* [specialist comics website] article. If some 'legit' website runs an article about it the accusations magically become real. I think that's why Darryl Ayo [social-media activist] kept tweeting about Ethan. He wasn't so much obsessed as persistent. He was looking for the right tweet to go viral and catch the attention of pros. He knows how the game works. He knew that calling Rich Johnston [journalist] a coward would result in the much needed article on *Bleeding Cool"*, 8 February 2018, https://www.youtube.com/watch?v=d_Ps9kTlH80, retrieved 15 February 2018.

174 Marwa Hamad, "Sana Amanat: Marvel is not a boy brand anymore", *Gulf News*, 11 March 2017.

175 See also the idea of an "echo chamber", where narrow-spectrum social-media interactions within a group of like-minded participants lead to affirmation of mutual views and exclusion of contrary views.

176 I believe that the best approach to art criticism is Syncretic Criticism, which incorporates aspects of New Criticism yet rests on a base of Formalist criticism and traditional art history. For a discussion of Syncretic Criticism see my article "The new art critics should mind their language", *The Art Newspaper*, no. 222, February 2011. Syncretic Criticism is called "Synthetic Criticism" therein.

177 For my views on the political content of art and the significance of cultural conditioning in the production and reception of culture, see the following art reviews by me: "Kitaj Redux", *The Jackdaw*, no. 106, November 2012, discussion of erotic art in the second part of "Athletic Congress... in Belgium", *The Jackdaw*, no. 109, May 2013, "Zurbarán: Art and Morality", *The Jackdaw*, no. 115, May 2014, and many others.

CPSIA information can be obtained
at www.ICGtesting.com
Printed in the USA
BVHW031539210419
546107BV00001B/108/P